A perfect painting is like a mirror of Nature,
that causes things that are not there to appear,
and that deceives in an acceptable, amusing,
and praiseworthy way.

—Samuel van Hoogstraeten, *Inleyding tot de hooge schoole der schilderkonst*, Rotterdam, 1678

A Mirror of Nature

*Dutch Paintings
from the Collection of
Mr. and Mrs. Edward William Carter*

JOHN WALSH, JR.
and
CYNTHIA P. SCHNEIDER

LOS ANGELES COUNTY MUSEUM OF ART
MUSEUM OF FINE ARTS, BOSTON
THE METROPOLITAN MUSEUM OF ART

EXHIBITION ITINERARY

LOS ANGELES COUNTY MUSEUM OF ART
OCTOBER 13, 1981 – JANUARY 3, 1982

MUSEUM OF FINE ARTS, BOSTON
JANUARY 20 – MARCH 14, 1982

THE METROPOLITAN MUSEUM OF ART, NEW YORK
APRIL 7 – JUNE 20, 1982

LIBRARY OF CONGRESS CATALOGING IN PUBLICATION DATA

Walsh, John, 1937–
A mirror of nature.

Bibliography: p.
1. Painting, Dutch—Exhibitions. 2. Painting,
Modern—17th–18th centuries—Netherlands—
Exhibitions. 3. Carter, Edward William, 1911–
—Art collections—Exhibitions. 4. Carter,
Edward William, Mrs.—Art collections—Exhibitions.
I. Schneider, Cynthia P. II. Los Angeles County
Museum of Art. III. Title.
ND646.W26 759.9492'074'019493 81–6069
ISBN 0-87587-103-8 AACR2

Published by the Los Angeles County Museum of Art
5905 Wilshire Boulevard, Los Angeles, California 90036

Copyright © 1981 by Museum Associates of
the Los Angeles County Museum of Art

Contents

Preface

The Los Angeles County Museum of Art takes great pleasure in presenting the splendid Mr. and Mrs. Edward William Carter Collection to the people of Los Angeles for the first time. The distinguished collector, first President of the Board and a longtime friend and supporter of the Museum, and his wife are sharing with the community a visual experience of the finest order: thirty magnificent Dutch paintings from the seventeenth century. It is their singular dedication and sensitive spirits, supported by an intelligent curiosity and a limitless energy, that have shaped this extraordinary and very personal collection of masterpieces now assembled for this exhibition.

Edward Carter has brought his remarkable talents and seasoned judgment to a wide range of projects and commitments. A man of vision and dedication as well as perseverance, he has long been aware of the crucial need to include aesthetic experience in daily life. At a time when great private collections are being dispersed and many masterpieces are no longer available to be enjoyed freely by the general public, it is a major event in our cultural history to see the Carters' unique and specialized group of Dutch paintings on display in a public institution.

Edward and Hannah Carter have chosen their works of art with care and discrimination. For many years, they have given freely of their knowledge, enthusiasm, and time, to friends, experts, and scholars alike. Thus it is not with nostalgia that we speak today of past acquisitions; rather, we look forward with genuine interest to the continuing growth of their collection.

The organization of this exhibition has been a fortunate collaborative enterprise involving the staffs of the Los Angeles County Museum of Art, the Museum of Fine Arts, Boston, and The Metropolitan Museum of Art. I would particularly like to thank my colleagues Jan Fontein and John Walsh of the Museum of Fine Arts, Boston, and Philippe de Montebello and Sir John Pope-Hennessy of The Metropolitan Museum of Art for their support of this important exhibition.

EARL A. POWELL III
Director
Los Angeles County Museum of Art

The Carters are constant visitors to Boston and New York, so it is fortunate and appropriate that their paintings be exhibited in both cities. They have often discussed possible acquisitions with members of our curatorial staffs and have often lent recent acquisitions to the Metropolitan. To see this entire collection of Dutch pictures now brought together in our galleries fills us with admiration and envy. Both the Museum of Fine Arts and The Metropolitan Museum of Art have exceptionally fine collections of seventeenth-century Dutch painting, owing largely to the discrimination and generosity of such private collectors as Robert Dawson Evans and Zoe Oliver Sherman in Boston, and Benjamin Altman, Michael Friedsam, Jules Bache, and Mr. and Mrs. H. O. Havemeyer in New York. Mr. and Mrs. Carter's Dutch pictures are of comparable quality, and there is not a single painting in this exhibition that would not be a welcome and significant addition to any public collection. Few people in any period accomplish what the Carters have done and continue to do: to assemble the best possible paintings in a clearly defined area of interest. Moreover, they have broadened and deepened their own expertise, moved swiftly when important pictures came to light, and not hesitated to exchange lesser paintings for greater ones. The impressive result speaks for itself.

We are most grateful to Edward and Hannah Carter for agreeing to lend the collection to the East Coast following its Los Angeles exhibition—cheerfully allowing the walls of their beautiful house to remain practically bare for more than half a year—and to our colleagues at the Los Angeles County Museum of Art for so skillfully managing the organization of the exhibition.

JAN FONTEIN
Director
Museum of Fine Arts, Boston

PHILIPPE DE MONTEBELLO
Director
The Metropolitan Museum of Art

Acknowledgments

The authors are grateful above all to Mr. and Mrs. Carter for the privilege of studying the collection, for their hospitality, and for their constant help with the work. Earl A. Powell III, Myrna Smoot, Larry Reynolds, Scott Schaefer, and many others on the staff of the Los Angeles County Museum of Art made this transcontinental project go smoothly, for which we are most thankful. We depended often on the judgment and experience of Ben Johnson, former Conservator of the Museum, whose knowledge of the collection is uniquely valuable. Charles Moffett of The Metropolitan Museum of Art arranged practical matters for his institution and worked most cooperatively with us. Our research was conducted in large part at the Rijksbureau voor Kunsthistorische Documentatie, The Hague, where J. Nieuwstraten, G. Kotting, and W. van de Watering were generous with help, as was Rupert Hodge of the Witt Library of the Courtauld Institute, London, and the staff of the Frick Art Reference Library in New York. We are grateful to Thomas J. Schneider for the photographs taken in Amsterdam and Delft. We had welcome advice on various matters from Seymour Slive, Clifford Ackley, William W. Robinson, Alice Davies, Arthur K. Wheelock, Jr., M. S. Robinson, and Pieter Schatborn, in addition to those whose aid is credited in individual entries for the paintings. The manuscript was prepared in Boston with the constant help of Patricia Loiko and Helen Hall. Edited in Los Angeles with skill and forbearance by Jeanne D'Andrea and Stephen West, the catalogue was designed in Lunenburg, Vermont, by Freeman Keith of The Stinehour Press, who taught us a great deal about books while allowing us to help with the layout, and was produced in Connecticut to the rigorous standards of The Meriden Gravure Company under the supervision of William Glick.

J. W., Jr.
C. P. S.

Foreword

Seymour Slive, Professor of Fine Arts and Director of the Fogg Art Museum at Harvard University, wrote in a recent letter:

Frits Lugt, in his lifetime, the peerless connoisseur and distinguished collector of seventeenth-century Dutch art, frequently comes to mind during my memorable visits in Los Angeles with Ed and Hannah Carter. Their painting collection is the kind he loved—and coveted— most: miraculously well preserved, cabinet-size Dutch pictures of the highest quality that fit perfectly in the intimacy of a home.

Lugt comes to mind for yet another reason when I am with Ed and Hannah. He had nothing against the study of art history. However, he was convinced that formal art historical training was not a prerequisite for acquiring the connoisseurship needed to build a great collection. For him connoisseurship was a gift, just like any other artistic talent. If the aptitude is there of course it can be developed, but rather by personal effort than instruction. I can think of little better proof of Lugt's maxim than the distinctly personal collection Ed and Hannah have made of outstanding Dutch pictures during the course of the last decade-and-a-half.

Professor Slive's statement is typical of the reaction of Dutch specialists and museum professionals to both the paintings and the extraordinary level of connoisseurship and decisiveness of action essential to assembling so many "textbook examples" of Dutch seventeenth-century landscapes and still-life paintings at a time when works of this quality had become so remarkably scarce.

Edward W. Carter was already a leader of national distinction in business, cultural, and civic activities when he began to form the collection. Born in Maryland in 1911, he has resided in Los Angeles since 1920. In 1932 he was graduated from the University of California at Los Angeles, where he majored in economics and philosophy; in 1937 he received an MBA with Distinction from the Harvard Graduate School of Business Administration. Eight years later he became head of the Broadway Department Store in Los Angeles which over the years evolved into Carter Hawley Hale Stores, Inc., now a nationwide merchandising organization that operates numerous distinguished department stores, fashion specialty stores, such as Bergdorf Goodman and Neiman-Marcus, and the country's largest bookshop business. In addition to being chairman of his company, Mr. Carter is the director of six other major American corporations.

Mr. Carter's contribution to the educational and cultural life of California and the nation has been a significant one. He is now in his thirtieth year as a Regent of the University of California and as a trustee of Occidental College, having served as board chairman of both. A longtime trustee of the Stanford Research Institute and The Brookings Institution, he is also a founding trustee of the National Humanities Center. At Harvard, he has been a member of several Overseers Visiting Committees, currently including that of the Fogg Museum. Chairman of the board of the Los Angeles Philharmonic Association of which he has been a trustee for twenty-eight years, he is also a director of the San Francisco Opera. Worthy of special note is Mr. Carter's role in the creation and subsequent development of the Los Angeles County Museum of Art. He was founding president of the Museum and chairman of both the fundraising and the building committees that launched the institution twenty years ago. During the intervening years he has been chairman of the board and chairman of the Acquisitions Committee. He is at present chairman of the new Development Committee responsible for raising the funds for the construction of two new wings.

Mr. Carter purchased his first two paintings in 1956 and 1957, a van Goyen river scene and a Jacob van Ruisdael mountain landscape, both later exchanged for other pictures. Two paintings still in the collection, *A Yacht and Other Vessels in a Calm* by Willem van de Velde and *Landscape with a Footbridge* by Meyndert Hobbema, followed in 1959 and 1962. Ed Carter's marriage in 1963 to Hannah Locke Caldwell of Philadelphia, who shared his interest in works of art, was a stimulus to further acquisitions. During the 1960s the Carters added four more Dutch pictures, a Flemish still life, and three nineteenth-century French pre-Impressionists. The latter were subsequently replaced by an extraordinary, colorful Fantin-Latour still life, a superb, shimmering late Corot landscape, and an exquisite eighteenth-century view of Venice by Francesco Guardi, all in the collection although not included in the present exhibition.

Ed and Hannah Carter had bought pictures largely to embellish their home until the end of the 1960s. At that time they changed their objective and initiated a long-term program of "acquiring the most representative collection of the finest quality seventeenth-century Dutch landscapes, seascapes, architectural interiors, town views, and still lifes in this country" with the stated intention of enjoying the collection during their lives and of bequeathing it to the Los Angeles County Museum of Art. Accordingly, their tempo of collecting was accelerated with the result that twenty-seven of the thirty paintings included in the present exhibition were purchased between 1970 and 1981.

The Carters were aided in their quest by collectors, scholars, and museum personnel, many of whom became close friends. Among these was Wolfgang Stechow, a frequent visitor, whose *Dutch Landscape Painting of the Seventeenth Century* became

The earliest landscape in the collection is a winter scene by Avercamp (cat. no. 1), one of the artist's most delightful. Its droll anecdotes and extensive view recall Pieter Bruegel; and its atmosphere anticipates the development of more ostensibly realistic landscapes by Avercamp's younger contemporaries in Haarlem, Esaias van de Velde, van Goyen, and Ruysdael. Esaias van de Velde's little painting of about a decade later (cat. no. 25) beautifully exemplifies this development. The vantage point is lowered and the view is divided, as though by accident, between a cottage on one side and the frozen canal on the other. The painter's touch is now soft and versatile, capable of evoking with marvelous economy the textures of earth, bark, ice, and clouds. The air has thickened, giving the vivid sense of actual conditions outdoors that is the great contribution of Esaias and his Haarlem colleagues in these years of new possibilities for landscape painting. The other winter scene in the collection, by Aert van der Neer (cat. no. 17), has no trace of the quaint flavor of Avercamp or the modesty of Esaias van de Velde. Our attention is drawn first to the pyrotechnics of the clouds, shot through with color by the slanting sun, and then to the deep landscape in which the human beings are skillfully integrated. By the middle of the seventeenth century the repertory of effects available to the landscape painter had grown further, and taste had again moved from the relatively austere to the elaborate. This shift in the style of winter landscapes typifies changes in the other genres as well, as the Carter paintings demonstrate clearly.

Nowhere are the changes more dramatic than in seascape. Jan Porcellis's remarkable picture (cat. no. 18), as gray as a Whistler, exemplifies a general movement in the 1620s and 1630s toward the exploitation of atmospheric effects and the suppression of much else. Prominent in it are the big shifting cloud formations that made such an impression on Porcellis's contemporaries and helped make possible the development of the majestic skies in such pictures as the Carters' superb van de Cappelle (cat. no. 7). Like van der Neer, van de Cappelle regularly used much of his picture surface for an ever-changing spectacle of clouds—now ominous, now benign—which plays the major part in setting the tone of the picture. Here the treatment of the sky is unusually ambitious and the nuances of tone and atmosphere unusually fine. This picture is easiest to appreciate when one compares it to a later seascape in the collection, the Willem van de Velde (cat. no. 27), which is so much more vivid and explicit. No less a virtuoso painter than van de Cappelle, van de Velde had different interests, especially a sailor's precision in details of ship construction, rigging, and maneuvering. It is a surprise to turn from van de Velde's finely painted showpiece to his little beachscape (cat. no. 26), so modest and casual in effect, which directs attention to the comings and goings of tenders while the presence of the fleet of great vessels in the distant anchorage is only hinted at by masts and yards peeping over the jetty. In this informal mode van de Velde is free to use his softest, most suggestive brushwork and to capture the brightness

of light on the beach. Willem's brother Adriaen, normally a painter of landscapes with animals, also painted a few beach views that resemble his brother's in technique but are otherwise very original. Willem's sunny picture contrasts sharply with the curiously proto-Romantic beachscape by Adriaen in the Carter collection (cat. no. 24), which has an elegiac quality that derives from its stillness and the effect of declining light.

There are three city views, the earliest a startling picture by an artist who evidently never painted another like it, Adam Pynacker (cat. no. 20). Since it gives very little topographical information, we do not yet know for certain where the scene was set, if indeed it is not imaginary. But its composition makes it as vivid, as nearly a *tranche de vie*, as any cityscape we know. Just the opposite is Gerrit Berckheyde's extensive view down the Nieuwezijds Voorburgwal in Amsterdam (cat. no. 2): its fidelity to the scene can be measured by comparing Berckheyde's other versions, which show the canal at different stages of its busy history of construction and reconstruction. Jan van der Heyden painted a number of other views of the Herengracht, but when they are compared with the great Carter painting (cat. no. 13) they reveal the poetic license he took with the city, for buildings have been moved freely from one location to another. This does not diminish the impression of utter truth they give, but forces the realization that truth for the Dutch artist is often of a somewhat different order than mere faithfulness to the appearances of the real world.

The Carters' painting of Dordrecht and the Merwede by Jan van Goyen (cat. no. 11) embodies the sensibility fundamental to most Dutch landscape in the first half of the century: a preference for domestic subjects, an eye for fine gradations of tone, and a vigorous application of paint. No longer is the weather merely a given of the season, but now it shifts subtly from picture to picture, as it had in seascapes by Porcellis; it is a well-tuned instrument for the artist to play in many keys. Van Goyen's broad panorama, one of his most successful works, shows the profile of Dordrecht, which everyone in the artist's time would easily have recognized. In van Goyen's frequent paintings of the subject it underwent many changes, however, like the Herengracht in the hands of van der Heyden, while retaining its general shape and its unmistakable place by the broad river. Here it is part of an ambitious, lofty view that is animated by commercial traffic and by the great fleecy clouds that float above everything.

Salomon van Ruysdael, van Goyen's contemporary and co-creator of the tonal *ars nova* of the 1620s and 1630s, is represented by one of his loveliest paintings (cat. no. 22). Like many other pictures in the collection, it represents the subject most characteristic of the artist, a river with a ferry laden with animals and people. His cheerful vision of benevolent nature contrasts sharply with that of his nephew Jacob, who can claim to be the greatest Dutch landscape painter. Jacob van Ruisdael's *View of Grainfields with a Distant Town* (cat. no. 21) has a power and complexity that induces very different feelings from those of the paintings of the earlier generation. The shifting patterns of

light and shade cast by the clouds are used so dramatically to emphasize the field of ripe grain and another already harvested that there is a suggestion, common in Ruisdael's pictures, of eternal truths: the fruits of human industry and the bounty of nature. Another landscape specialist who manipulated the drama of light in a way that lends gravity to his compositions is the panorama painter Philips Koninck, whose sensibility derives in part from the romanticized landscapes of Rembrandt. The little panel in the Carter collection (cat. no. 16) has a brooding intensity and grandeur of conception that belies its small size. Its techniques, if not its heavy mood, are echoed in one of the interesting rarities in the collection, the panorama by Anthonie van Borssom (cat. no. 3), in which the sharp outlines and clarity of the view account for a slightly naive flavor.

In 1973, having already bought a fine small panel by Hobbema, the Carters had the unusual opportunity of acquiring the companion piece from which it had been separated a decade earlier (cat. nos. 14a, b). The two were meant by Hobbema to hang near one another, for the compositions are complementary in many subtle ways. Despite their diminutive size they are remarkably rich and elaborate landscapes, full of the variety and vibrant life that made Hobbema such a hero to Constable and the Barbizon painters.

Native scenery makes up most of the landscape subjects, but not all. There are two pictures by Dutchmen who went to Italy, were seduced by the Campagna and its painters, and returned home to paint for their countrymen visions of the ageless harmony of man and nature under the warm Italian sun. The principal exponent of this idyll was Jan Both, whose large landscape in the Carter collection is among his finest (cat. no. 5). Just as van Goyen rearranges the Dordrecht skyline and van der Heyden moves houses in Amsterdam, Both feels free to put a well-known bridge and tomb where he needs them for pictorial reasons, in the midst of mountainous country, where they are admired by travelers and sketched by an artist. Both's warm, tinted light, almost an emblem of Italy in the work of northern painters, made a great impression on Dutch artists after the painter returned to Utrecht in 1641. The influence is felt in the work of Aelbert Cuyp, who never saw Italy but became one of the most sympathetic painters of Italianate scenery. His *Flight into Egypt* (cat. no. 10) is saturated with warm sun that becomes a sign of God's benevolence toward the fugitives. In this instance the Carters did not hesitate to have a religious subject, so unobtrusively is the Holy Family included among the peasants who inhabit the timeless landscape.

A few painters went farther afield than Italy and brought more exotic scenery home to the Netherlands. None traveled farther than Frans Post, who spent eight years in Brazil and then thirty years at home painting scenes of the New World (cat. no. 19). From the first glance there is no doubt these are Dutch paintings, despite the palms, jungles, and plantations, for they are composed and painted in a style derived from

Haarlem masters. Yet the best pictures by Post, like the wonderfully crisp and luminous Carter panel, have a surprising simplicity and directness that embody some of the wonder felt by Europeans at the strangeness of the new land.

Landscapes were painted in every country, but only in the Netherlands did artists represent the interiors of their churches and create an independent genre out of the subject. We are seldom certain what the artists and buyers saw in these pictures beyond the beauty and the pleasurable deception (to use Hoogstraeten's idea) of the illusions of space and mass they conjure up. In the case of Pieter Saenredam, the most important architectural painter of the first half of the century, there are sometimes topical allusions, often a good deal of piety or of pride in the monument, and always a fine sensitivity to light, colors, and textures. The little panel in the Carter collection, which shows the merest corner of a church empty of human presence, is entirely a document of the building and its effect on the spectator. The view is carefully manipulated to give only a meaningful hint of the vast Gothic choir beyond the low Romanesque aisle. The ambitious Emanuel de Witte, the greatest church painter of the second half of the century, was little affected by Saenredam's modesty, although he learned much from his predecessor. His youthful masterpiece, newly rediscovered (cat. no. 28), places the spectator unexpectedly close to the ambulatory columns of the Nieuwe Kerk in Delft so that he must infer a good deal about the structure of the building, although he is given a glimpse *à la* Saenredam of the lofty nave beyond. The onlookers show their respect not for the sanctity of the building—the once-Catholic church had long since been converted to a Calvinist meeting-place—but for a monument to the founder of the state, William of Orange. The painted curtain, imitating the real curtains hung in front of paintings, lends a note of solemnity as it contributes to a tour de force of illusion. De Witte's later view of the Oude Kerk in Amsterdam is simpler (cat. no. 29), recalling Saenredam in its spaciousness, although it is more characteristic of de Witte in the lively play of clear light falling on the whitewashed walls and columns and in the marvelous transcription of the blurred view through the high window.

The Carters' still lifes include fine examples by two of the leading painters of modest, so-called "monochrome" compositions, Heda and Claesz. Similar in their sturdy construction and geometric clarity, both were painted for a sober, refined taste whose only parallel is to be found in Spain. The objects in Heda's picture (cat. no. 12) were perfectly common, yet a few carried messages for the contemporary viewer: the pipe and the watch, for example, are emblems of transitory human life. Claesz.'s simple meal could be a lesson in temperance, as sparing of pleasures as the painter's technique is sparing of color. Another still life is an even more extreme exercise in restraint, the little picture of a bowl of *fraises de bois* by the enigmatic Zeeland painter Adriaen Coorte (cat. no. 9), who seems to have been as far removed from artistic fashion as his still lifes are from the world around. Coorte's refinement is evident in the

xxii

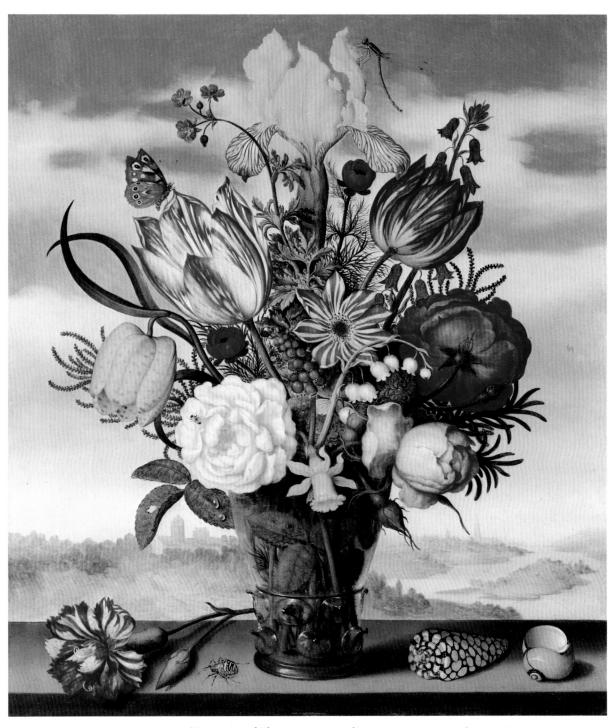

AMBROSIUS BOSSCHAERT *Bouquet of Flowers on a Ledge* 11 x 9 in. (catalogue 4)

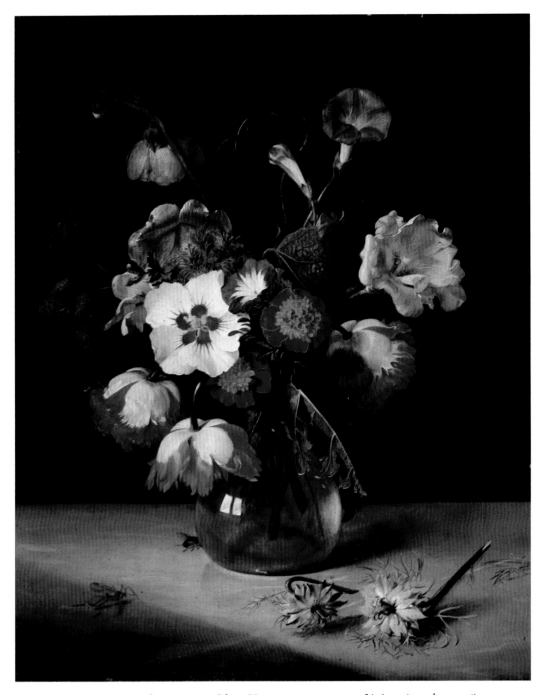

DIRCK DE BRAY *Flowers in a Glass Vase* 1671 19 x 14³/₈ in. (catalogue 6)

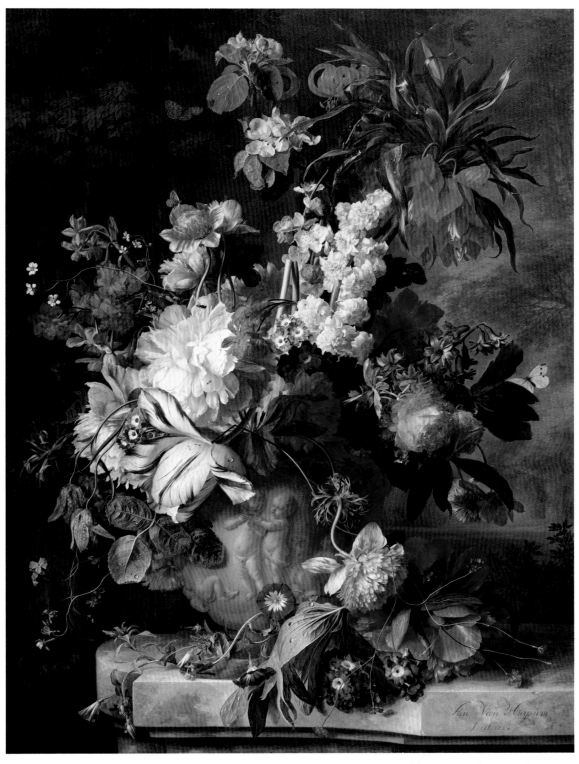

JAN VAN HUYSUM *Bouquet of Flowers in an Urn* 1724 31 ½ x 23 ⅜ in. (catalogue 15)

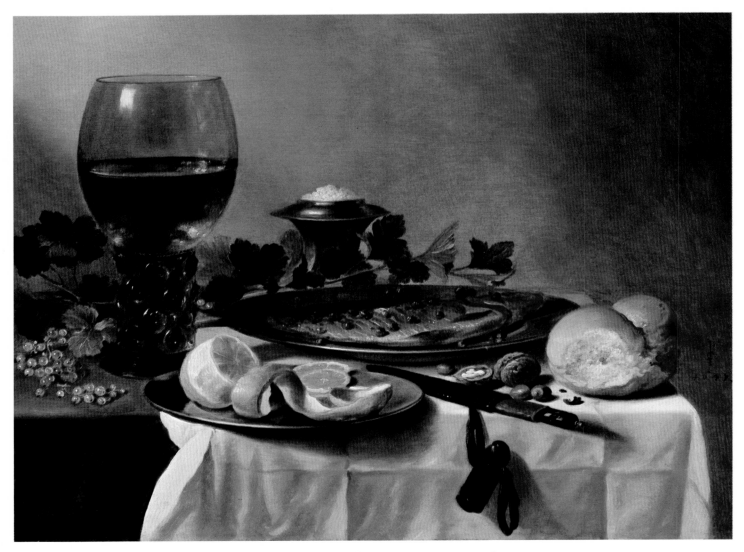

PIETER CLAESZ. *Still Life with Herring, Wine, and Bread* 17 1/2 x 23 1/4 in. (catalogue 8)

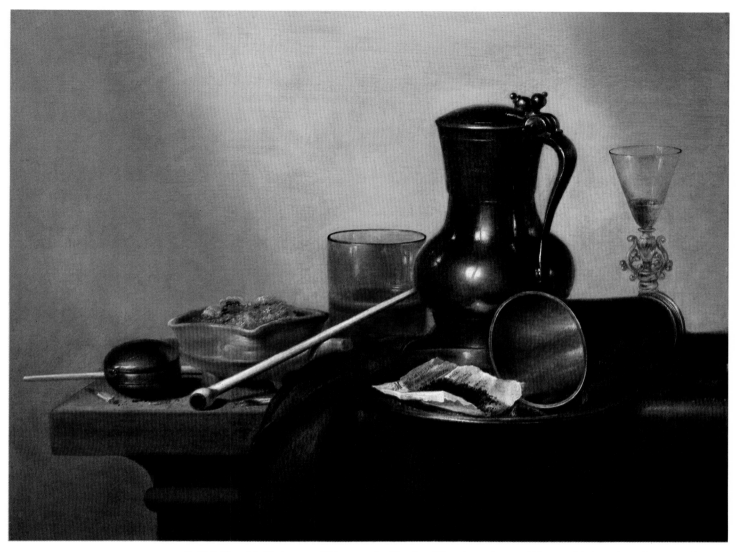

WILLIAM CLAESZ. HEDA *Still Life with Tobacco, Wine, and a Pocket Watch* 1637 16½ x 21½ in. (catalogue 12)

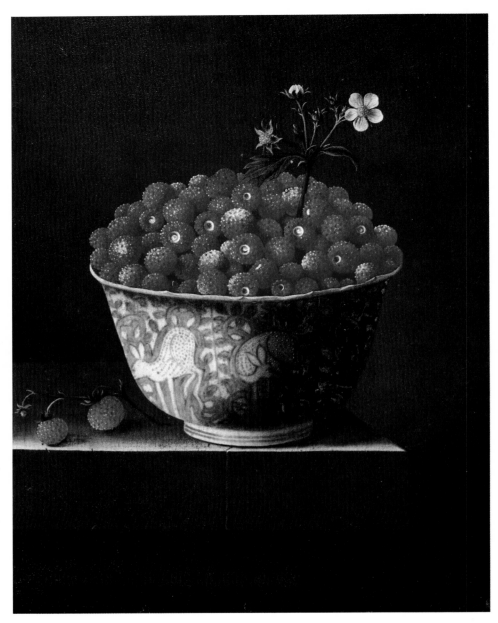

ADRIAEN COORTE *Wild Strawberries in a Wan Li Bowl*
1704 11⅝ x 8⅞ in. (catalogue 9)

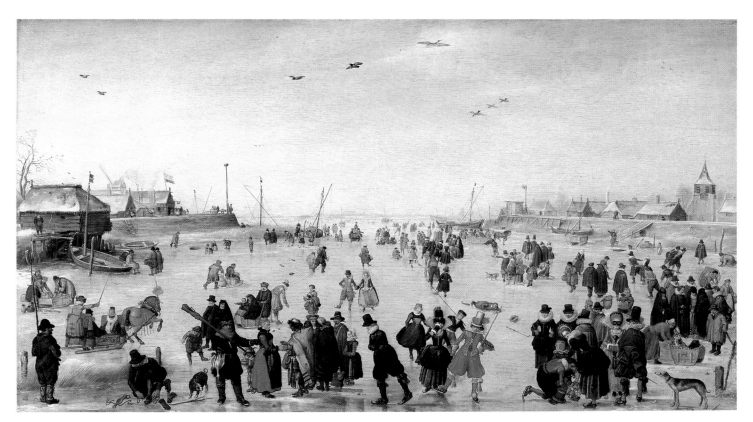

HENDRICK AVERCAMP *Winter Scene on a Frozen Canal* 14¹/₂ x 25³/₄ in. (catalogue 1)

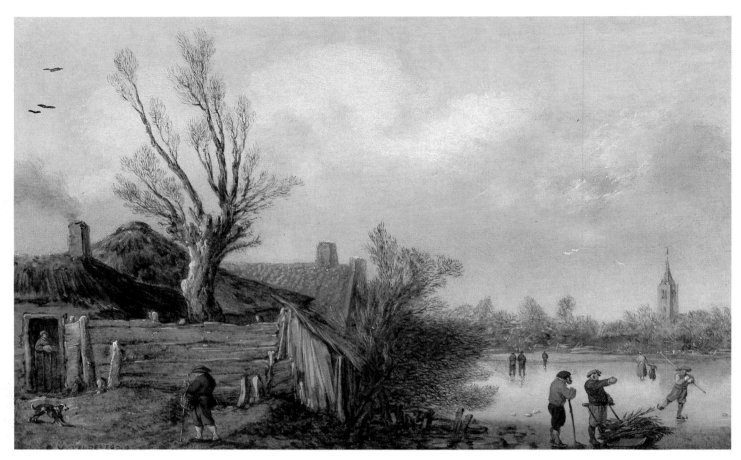

ESAIS VAN DE VELDE *Winter Landscape* 1629 8³/₄ x 13¹/₈ in. (catalogue 25)

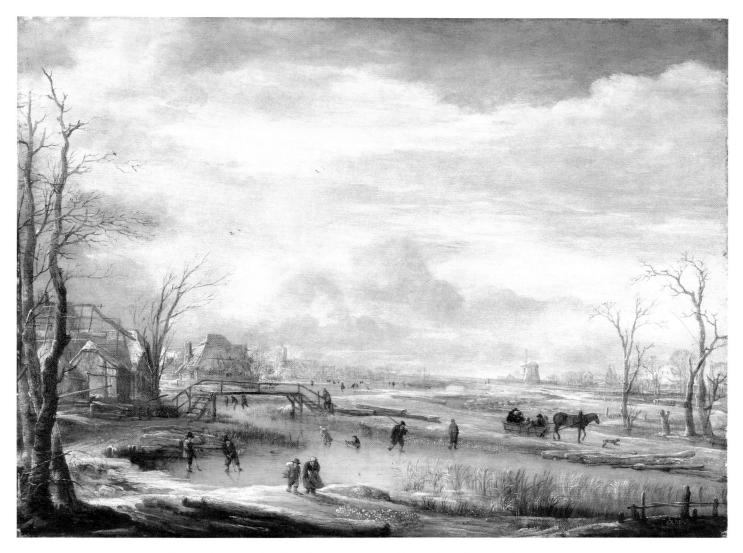

AERT VAN DER NEER *Frozen River with a Footbridge* 15 x 19¼ in. (catalogue 17)

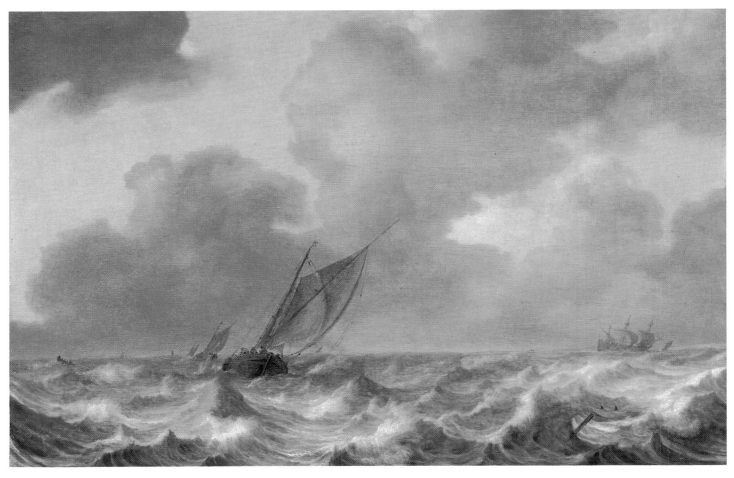

JAN PORCELLIS *Vessels in a Moderate Breeze* 16¼ x 24¼ in. (catalogue 18)

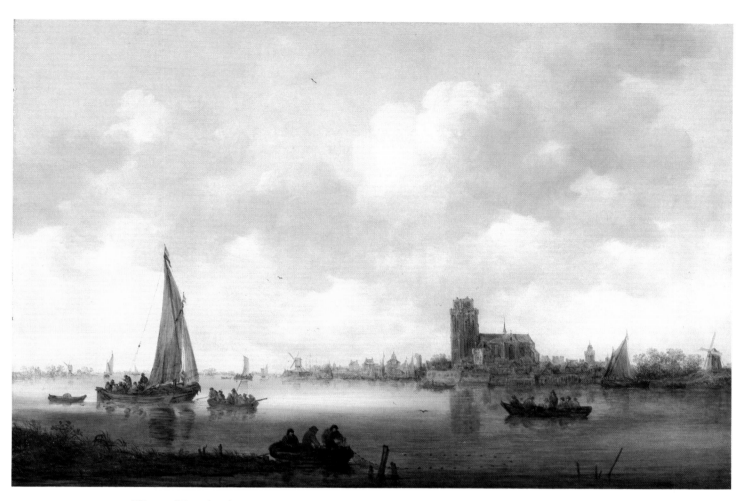

JAN VAN GOYEN *View of Dordrecht* 1645 25 1/2 x 37 1/2 in. (catalogue 11)

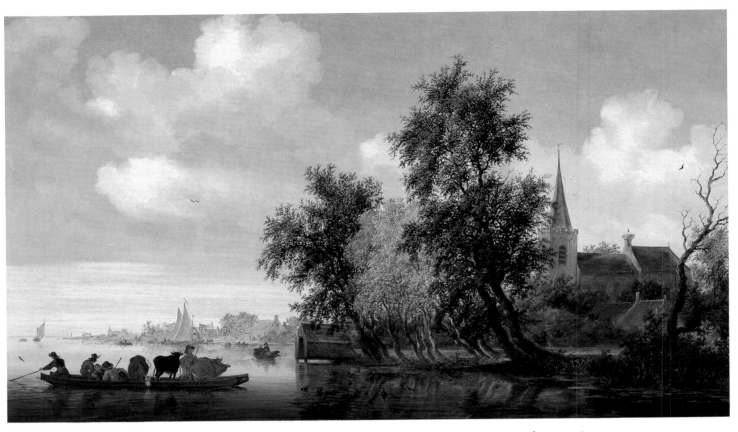

SALOMON VAN RUYSDAEL *River Landscape with a Ferry* 1650 20½ x 32⅞ in. (catalogue 22)

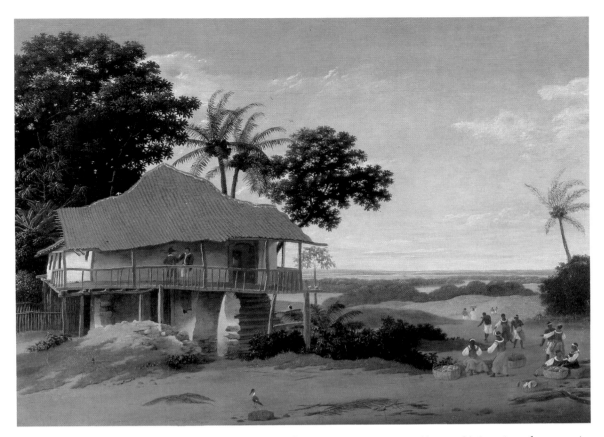

FRANS POST *Brazilian Landscape with a Worker's House* 165? 18¹/₄ x 24³/₄ in. (catalogue 19)

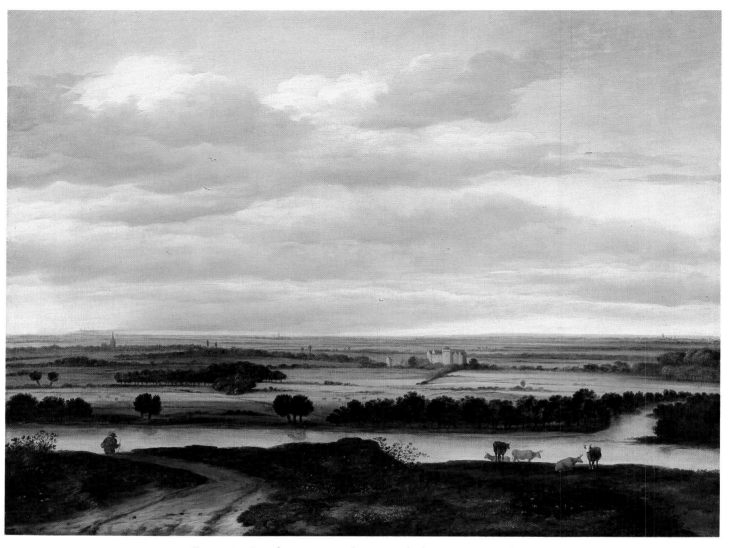

ANTHONIE VAN BORSSOM *Extensive Landscape near Rhenen with the Huis ter Leede* 20¼ x 26 in. (catalogue 3)

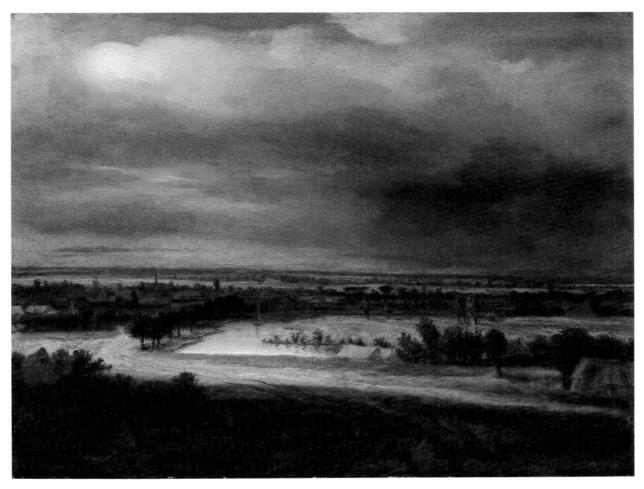

PHILIPS KONINCK *Panoramic Landscape with a Village* 11 ½ x 14 ¼ in. (catalogue 16)

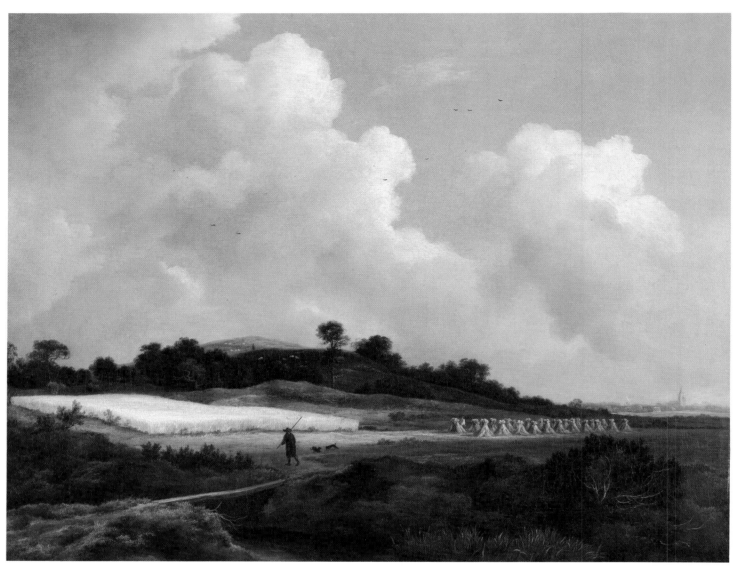

JACOB VAN RUISDAEL *View of Grainfields with a Distant Town* 20¼ x 25½ in. (catalogue 21)

MEYNDERT HOBBEMA *Landscape with Anglers and a Distant Town*
9⁷/₈ x 12⁵/₈ in. (catalogue 14a)

MEYNDERT HOBBEMA *Landscape with Footbridge* 9³/₄ x 12⁵/₈ in. (catalogue 14b)

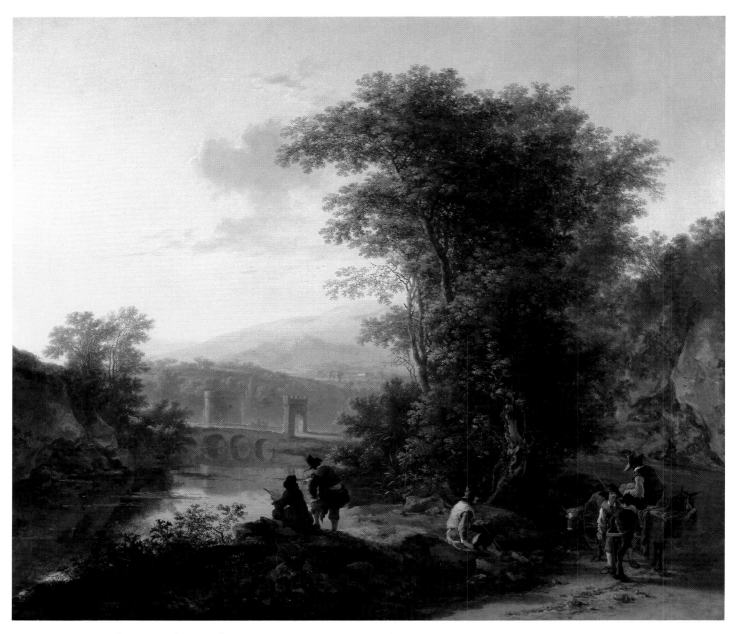

JAN BOTH *Landscape with a Draftsman* 41 ⅛ x 46 ½ in. (catalogue 5)

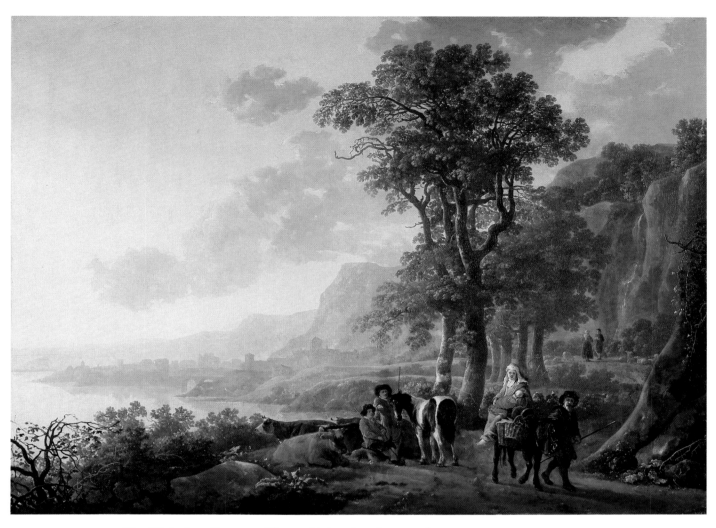

AELBERT CUYP *The Flight into Egypt* 26³/₄ x 35³/₄ in. (catalogue 10)

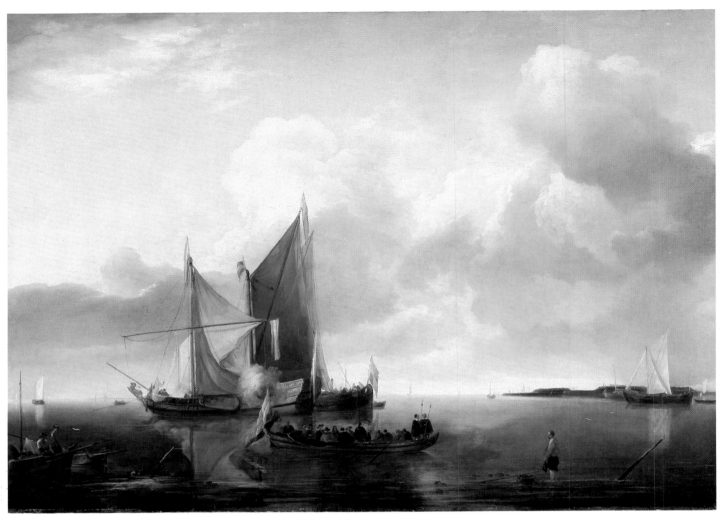

JAN VAN DE CAPPELLE *Ships in a Calm* 30^{1}/$_{2}$ x 42^{1}/$_{4}$ in. (catalogue 7)

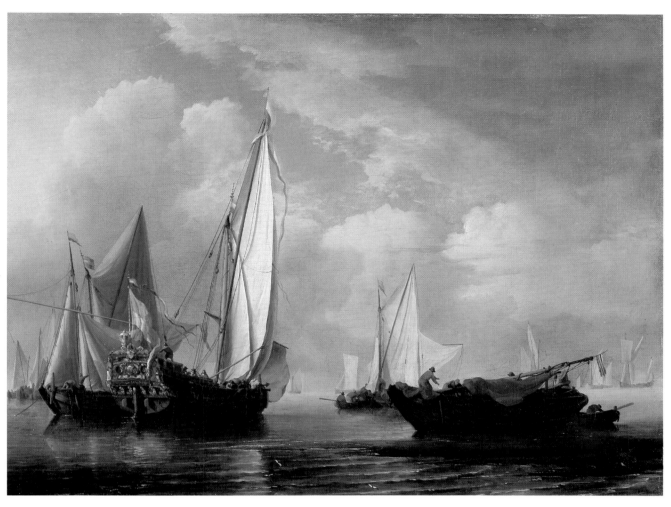

WILLEM VAN DE VELDE THE YOUNGER *A Yacht and Other Vessels in a Calm* 1671
13 ¼ x 17 ⅜ in. (catalogue 27)

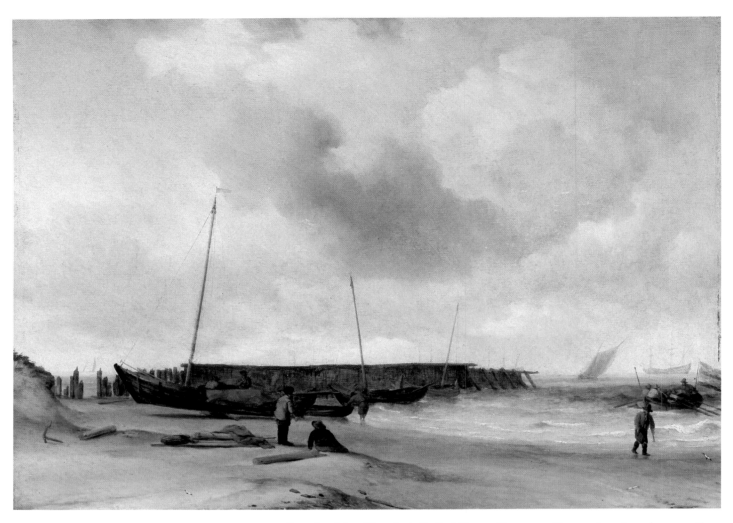

WILLEM VAN DE VELDE THE YOUNGER *Beach with a Weyshuit Pulled Up on Shore* 12³/₈ x 17 in. (catalogue 26)

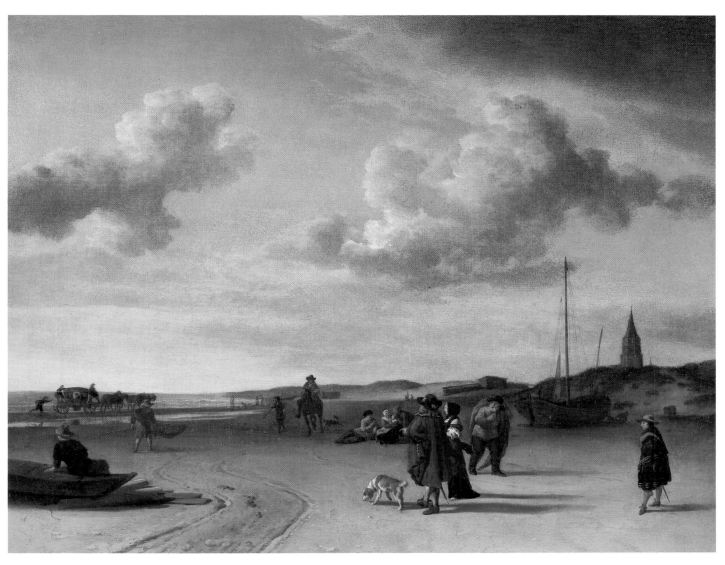

ADRIAEN VAN DE VELDE *The Beach at Scheveningen* 1670 15½ x 19¾ in. (catalogue 24)

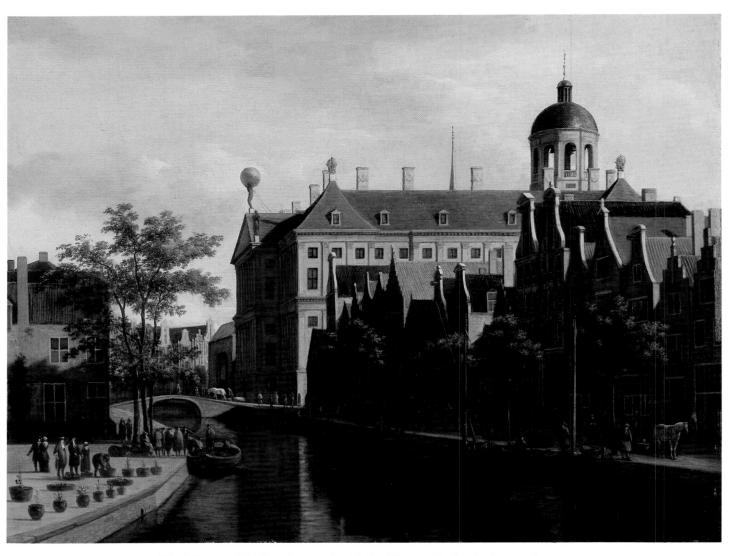

GERRIT BERCKHEYDE *The Nieuwezijds Voorburgwal with the Flower Market in Amsterdam*
14¹/₂ x 18³/₄ in. (catalogue 2)

JAN VAN DER HEYDEN *A View of the Herengracht, Amsterdam* 13 ¹/₄ x 15 ⁵/₈ in. (catalogue 13)

ADAM PYNACKER *View of a Harbor in a City (Schiedam?)* 21³/₄ x 17⁷/₈ in. (catalogue 20)

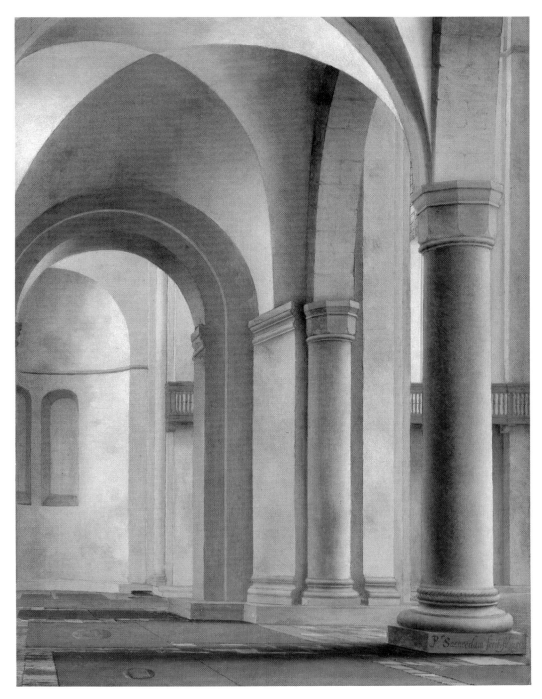

PIETER JANSZ. SAENREDAM *Interior of the Mariakerk, Utrecht*
1651 19⅛ x 14⅛ in. (catalogue 23)

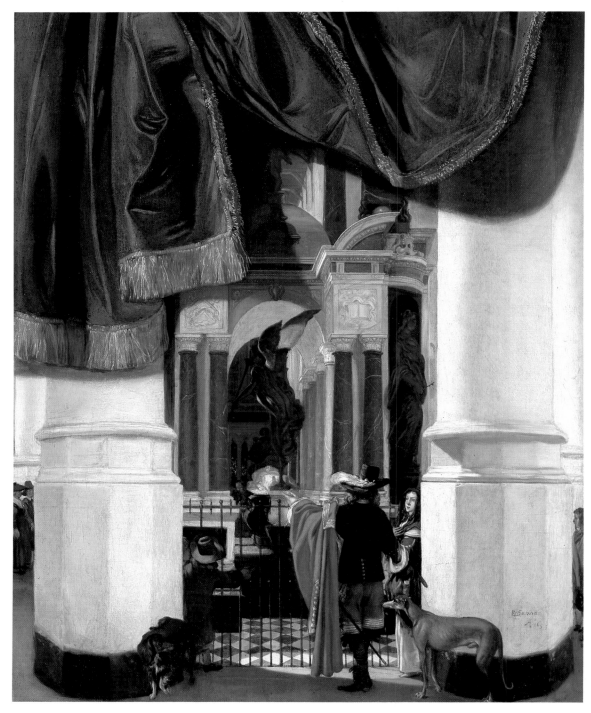

EMANUEL DE WITTE *Interior of the Nieuwe Kerk in Delft with the Tomb of William the Silent*
$32^{3}/_{8}$ x $25^{5}/_{8}$ in. (catalogue 28)

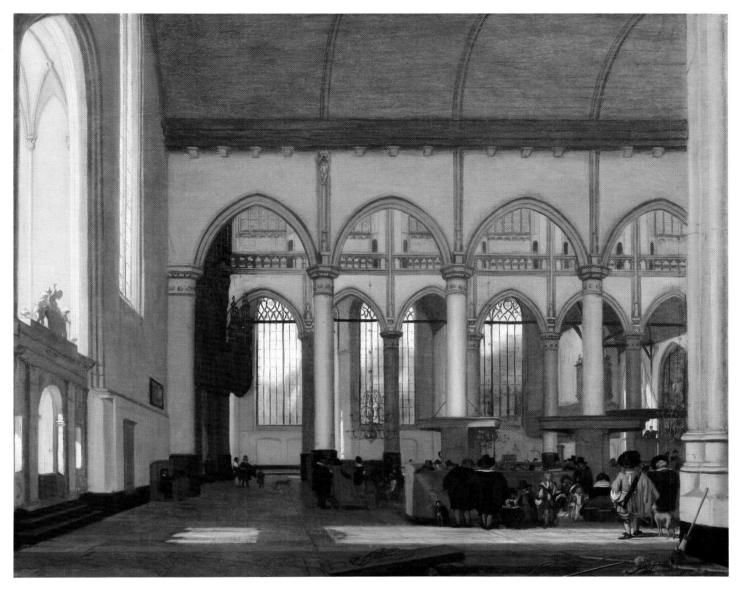

EMANUEL DE WITTE *Interior of the Oude Kerk, Amsterdam* 18⅛ x 22⅛ in. (catalogue 29)

CATALOGUE

ABBREVIATIONS

Bergström, *Dutch Still-Life Painting*
> Ingvar Bergström, *Dutch Still-Life Painting in the Seventeenth Century*, London and New York, 1956.

Blankert, *Italianiserende landschapschilders*
> Albert Blankert, *Nederlandse 17de eeuwse italianiserende landschapschilders*, 2nd ed., Soest, 1978.

HdG
> C. Hofstede de Groot, *Beschreibendes und kritisches Verzeichnis der Werke der hervorragendsten holländischen Maler des XVII. Jahrhunderts*, 10 vols., Esslingen a N. and Paris, 1907–28; English trans. of vols. 1–8, London, 1908–27.

Smith, *Catalogue Raisonné*
> John Smith, *A Catalogue Raisonné of the Works of the Most Eminent Dutch, Flemish, and French Painters*, 9 vols., London, 1829–42.

Stechow, *Dutch Landscape Painting*
> Wolfgang Stechow, *Dutch Landscape Painting of the Seventeenth Century*, London, 1966.

Thieme-Becker
> Ulrich Thieme and Felix Becker, *Allgemeines Lexikon der bildenden Künstler von der Antike bis zur Gegenwart*, 37 vols., Leipzig, 1907–50.

Hendrick Avercamp
1585/86–1634

Hendrick Avercamp spent most of his life in the provincial town of Kampen. His family moved there in 1586, the year after he was baptized in Amsterdam. He seems to have left Kampen only for his training in the Amsterdam studio of Pieter Isaaksz., a Danish history and portrait painter. By 1614 Avercamp had returned to his native town, where he seems to have resided until his death in 1634. Known in his lifetime as "de stomme van Kampen," the artist was a mute. Avercamp specialized in outdoor genre scenes, especially winter scenes on the frozen canals of Holland. His best-known paintings are characterized by a wealth of incidental detail and by brightly colored costumes. Most of Avercamp's landscapes continue the tradition of the Flemish followers of Pieter Bruegel the Elder, notably David Vinckboons, Hans Bol, and Jan Brueghel, who painted outdoor scenes seen from a bird's eye view and marked by a high horizon and a variety of local color. Avercamp also painted more sparsely populated winter scenes with unified compositions and atmospheric effects that anticipate later developments in Dutch painting, yet no clear evolution from one type of landscape to the other is apparent in his work. On the contrary, he seems to have painted in both styles simultaneously and to have switched back and forth at will. Dated paintings by him are known from 1608, 1609, 1620, 1626, and 1632.

A prolific and talented draftsman, Avercamp produced highly finished watercolors and lively, summary chalk sketches. His drawings in all media provided a source of ideas for his paintings; they were executed as independent sketches, however, rather than as preparatory studies. Avercamp's close followers were his nephew Barent Avercamp and Arent Arentsz., called Cabel.

I

Winter Scene on a Frozen Canal

Signed on sled, right: HA (joined)
Oil on wood, 14½ x 25¾ in. (36.8 x 65 cm.)

Collections: Graaf Jan Carel Elias van Lynden, The Hague; by descent to Ridder Johan Willem Frederick Huyssen van Kattendijke (1844–1903), The Hague; by descent to Graaf J. M. D. van Lynden, Lisse, by 1929; by descent to Gravin A. E. van Limburg Stirum, Lisse; [Nijstad Antiquairs, Lochem]; Sidney J. van den Bergh, Wassenaar; [G. Cramer, The Hague, 1972].

Exhibitions: The Hague, Gothisch Paleis, *Catalogus van oude meesters te s'Gravenhage ten behouve der watersnoodlijdenden*, 1881, no. 70; London, Royal Academy, *Dutch Art 1400–1900*, no. 81, repr.; The Hague, Koninklijke Kunstzaal Kleycamp, *Oud-Hollandschen en Vlaamsche Meesters*, 1929, no. 1, repr.; Brussels, Exposition Universelle, *Cinq siècles d'art*, 1935, vol. 1, no. 701; Rotterdam, Museum Boymans, *Kunstschatten uit Nederlandse verzamelingen*, 1955, no. 40, pl. 44; Laren, Singer Museum, *Kunstschatten. Twee Nederlandse collecties schilderijen*, 1959, no. 24, fig. 15; Leyden, Stedelijk Museum 'de Lakenhal,' *17de eeuwse meesters uit Nederlandse particulier bezit*, 1965, no. 4, fig. 1; Metropolitan Museum of Art, New York, 1972.

References: A. Bredius et al., *Amsterdam in de zeventiende eeuw*, vol. 3, 1901–4, The Hague, p. 96, repr., p. 98; *Beeldende Kunst* 17, Amsterdam, 1930, nos. 43, 43a, repr.; Clara J. Welcker, *Hendrick en Barent Avercamp, schilders tot Campen*, Zwolle, 1933, pp. 87, 205, no. S23, pl. x, rev. ed. by D. B. Hensbroek-van der Poel, Doornspijk, 1979, pp. 87, 207, no. S23, p. 214, no. S58.1, pl. x; A. B. de Vries, "Schilderkunst," *Sprekend Verleden*, Amsterdam, 1959, pl. 6; Eduard Plietzsch, *Holländische und flämische Maler des XVII. Jahrhunderts*, Leipzig, 1960, p. 86, fig. 146; A. B. de Vries, "Old Masters in the Collection of Mr. and Mrs. Sidney van den Bergh," *Apollo* 80, 1964, pp. 355–57, pl. III; A. B. de Vries, *Verzameling Sidney J. van den Bergh*, Wassenaar, 1968, p. 16, repr.

The Carter panel is one of Avercamp's more ambitious winter scenes. Like others of its type, it presents a delightful panorama of fashionable and humble amusements on the ice. The freezing over of Dutch canals was less rare in Avercamp's time than in our own,[1] but it was an event nevertheless, causing people of all classes to take to the ice

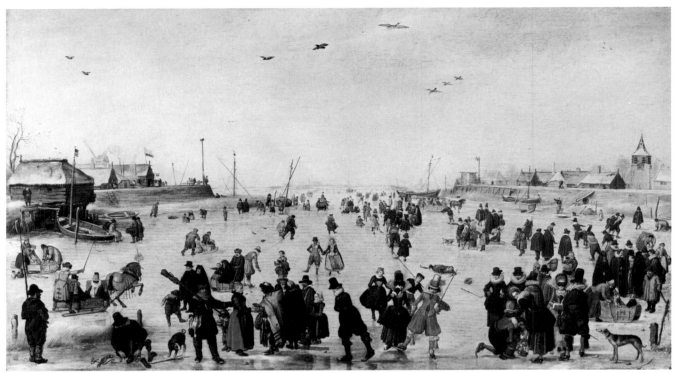

for pleasure or profit. There was fishing, *kolf* (the ancestor of the game played on grass), sleighing, promenading for the older, poorer, or less agile, and above all skating for the more energetic. Skaters could shed their capes and coats and show their indoor finery, giving color to the spectacle. Avercamp's painting, rich in lively incidents and amusing details, invites a careful inspection.

Just to the right of center (fig. 1) the boy with the girl in the red pinafore, a provincial from the north to judge by her costume, peer with keen curiosity at the couple in front of them, who are decked out in the height of fashion. Another sympathetic touch is the child on a sleigh with his

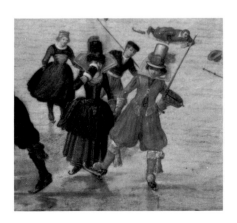

FIGURE 1.
Winter Scene on a Frozen Canal (detail), about 1620.

mother, pointing with delight at the gaily caparisoned prancing horse pulling a sleigh with elegant fur-clad passengers (fig. 2). But all is not pleasure: behind the provincial couple a skater has taken a bad fall and bleeds on the ice (fig. 1).[2] A hunter directs attention to a gypsy fortune-teller and her companion (fig. 2), both with babies in papooses, who are performing for several well-dressed customers including another young woman in northern provincial costume.[3] To reinforce the traditional associations of fortune-telling with the fortunes of love, Avercamp garnishes the episode with a little boy blowing on coals, not only a plausible detail in a winter scene but also a common symbol of the heat of love.[4]

The man with his back turned and the woman wearing a mask on the far right of the Carter painting (fig. 3) have been identified as the king and queen of Bohemia on the basis of their resemblance to figures in a drawing in the Teylers Museum (fig. 4) bearing an inscription by Ploos van Amstel that gives the subjects as the "King of Bohemia and his wife, drawn from life" and that dates the sheet 1621.[5] The exiled king of Bohemia, Frederick V, and his family took refuge in Holland in 1620; in 1626 they visited Kampen with Amalia van Solms, who had arrived as Queen Elizabeth's principal lady-in-waiting and had married the stadholder of the Netherlands, Prince Frederick

4

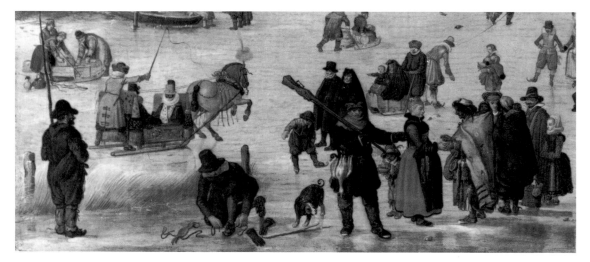

FIGURE 2.
*Winter Scene on a
Frozen Canal*
(detail), about
1620.

Hendrick in 1625. The same group, with the young woman and the two young boys behind her, also appears in another painting by Avercamp (fig. 5).

Although it has generally been accepted in the past, there is good reason to doubt Ploos van Amstel's inscription.[6] If it is correct, then the woman with a muff and a mask in the drawing and the paintings must be Elizabeth, and the man to her left facing inwards, the Elector Palatine. Even taking into account the fact that she wears a mask, the queen does not at all resemble her portrait in such certain representations of the royal couple as Adriaen van de Venne's grisaille of 1628 depicting the pair departing for the hunt.[7] Her face varies slightly in all the representations by Avercamp but is always more full and round than that of the queen in van de Venne's painting. In the related skating scene (fig. 5) the artist eliminated the profile view of the "king" and substituted a man seen from behind, a change that is perfectly in keeping with Avercamp's capricious use of his sketches but an unlikely treatment for a famous sovereign.

It has been further suggested that the young woman to the right of the royal couple in the drawing (fig. 4) and in the other painting (fig. 5) is Amalia van Solms, shown as the queen's lady-in-waiting, and that in our panel she appears as the princess of Orange and skates with the man in the orange suit.[8] Amalia, however, has quite a different profile in a painting by Rembrandt that was recently identified as her portrait:[9] a pronounced forehead, long broad nose with a slight bump, and full chin, all of which contrast sharply with the features of Avercamp's woman, whose forehead and nose make a long continuous curve and whose chin recedes. The decade between the drawing and Rembrandt's portrait of 1632 cannot account for these differences of structure. In short, there is ample rea-

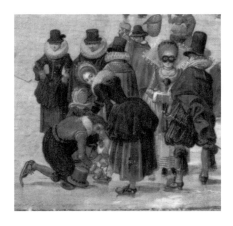

FIGURE 3.
*Winter Scene on a
Frozen Canal*
(detail), about
1620.

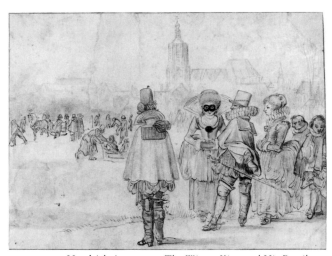

FIGURE 4. Hendrick Avercamp, *The Winter King and His Family on the Ice*, about 1620. Ink and watercolor on paper, 7 1/2 x 9 1/2 in.(18.9 x 24.1 cm.). Haarlem, Teylers Museum.

5

son to doubt that any of the royal personages is represented in any of Avercamp's pictures. It seems more likely that these people are patricians in fashionable dress, familiar types but individually no less anonymous than their middle-class and peasant counterparts.

The identification of the royal couple in the Carter painting has, in turn, given rise to the idea that it commemorates their visit to Kampen in 1626 and therefore dates from that time or later.[10] Even if the painting did show the king and queen of Bohemia, however, there would be little to identify it with a specific event—no recognizable place, and none of the usual acknowledgments of a royal visit. Dated pictures—and, to a lesser degree, costume—are more reliable evidence for dating the painting.

The sharply outlined and solidly painted figures, and the absence of landscape elements in the near foreground, suggest that the picture was executed about 1620.[11] The paucity of dated paintings by Avercamp and his erratic development make his chronology difficult to chart. Precocious early works[12] were followed for ten years by more archaic compositions, and progressive tonal landscapes were contemporaneous with multi-colored, heavily populated festivals on the ice.[13] The Carter painting is similar to a landscape dated 1620,[14] in which several sharply defined figures are spread across an open foreground, and smaller figures skate into the distance where a faint, slightly raised horizon line is visible. The organization of the Carter painting, employing a frieze of different types disposed across the foreground, is unusual in Avercamp's work. The figures recede into the distance in diagonal patterns in the Carter panel, in contrast to the apparent randomness of the landscape dated 1620, but the same method is followed in the other painting with the so-called "Winter

King" group (fig. 5). All three are probably contemporary in date. The costumes, to judge from styles worn in the great cities of western Holland, date from about 1615–20; in provincial Kampen, however, it is to be expected that fashions changed more slowly than in the larger cities.

Many of the figures in the Carter painting recur in other works by Avercamp, sometimes in identical positions. The hunter, for example, again singles out an important incident in the landscape in The Hague (fig. 5)—the beggar looking at the elegant passengers in the fancy sleighs; and the hunter also appears in a drawing in the Rijksprentenkabinet, facing left and pointing into open space.[15] Similarly, the dandy in orange in our painting is the subject of a fluent pen sketch in Windsor Castle; in the sketch he skates alone with his left arm akimbo and his weight on his right foot.[16] Avercamp's drawings, whether rough sketches in chalk or pen, or finished watercolors, were evidently not made in the process of preparing paintings. Rather, he seems to have built an enormous repertoire of studies and drawings from which motifs could be used in various contexts in his paintings.

Avercamp's oil technique, clearly visible in the very well preserved Carter panel, resembles that of his watercolors. In both media he outlines the figures with a sharp, unbroken line, and then fills in the color. He manages to carry some of the looseness and spontaneity of the watercolor technique into oil painting, yet at the same time he exploits the body and depth of oil paints to record with great precision the luster of materials and every detail of costume. This fusion of the vitality of one medium with the capacity for illusion of another lends Avercamp's colorful pageants, such as the Carter painting, their special combination of richness and liveliness.

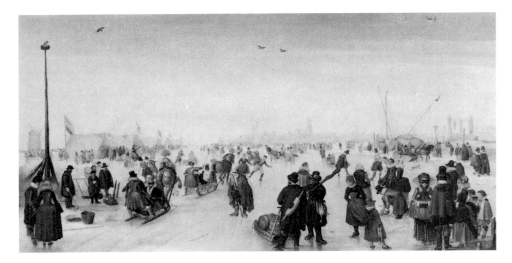

FIGURE 5. Hendrick Avercamp, *Winter Scene Near Utrecht (?)*, about 1620. Oil on canvas, 18½ x 35 in. (47 x 89 cm.). The Hague, private collection. Photograph courtesy of the Mauritshuis, The Hague.

1. From the end of the fifteenth century to the mid-nineteenth century Europe experienced unusually cold winters (Evert van Straaten, *Koud tot op het bot*, The Hague, 1977, pp. 10–13). The Thames and the canals of Venice froze over during this time (Washington, D.C., National Gallery of Art, *Seventeenth Century Dutch Drawings from American Collections*, exh. cat., 1977, pp. 17–18). Today the canals in Holland freeze only once every few years; in the seventeenth century they were frozen for part of each winter.

2. A beggar in the center of a contemporary winter scene (fig. 5) also injects a serious note into a happy scene.

3. Fortune-telling gypsies appear also near the tents in the *Winter Scene Near Utrecht (?)* (fig. 5), and in a drawing in Hamburg of a summer scene (Welcker, *Avercamp*, no. S14, repr. pl. 11; T118, pl. 38). On the basis of style the drawing seems to be a late work, executed after the Carter painting. Before Avercamp, Jacques de Gheyn had made drawings with gypsy fortune-tellers (J. Richard Judson, *The Drawings of Jacob de Gheyn II*, New York, 1973, pl. 104), and the Master of the Winter Landscapes had included gypsies in his paintings. See Edith Greindl, "Contribution à la connaissance du style de Gysbrecht Leyten," *Pantheon* 31, 1973, pp. 254–63 (with earlier literature), and M. L. Wurfbain (Leyden, Stedelijk Museum 'de Lakenhal,' *Geschildert tot Leyden anno 1626*, exh. cat., 1976–77, pp. 90, 91, 96), who identifies this artist as Carel Liefrinck the Younger. The motif was adopted by other Dutch contemporaries of Avercamp such as Dirck Hals and Jacob Duck.

4. Braunschweig, Herzog Anton Ulrich-Museum, *Die Sprache der Bilder*, exh. cat., 1978, nos. 15, 32, 33; Amsterdam, Rijksmuseum, *Tot lering en vermaak*, exh. cat., 1976, no. 28. The dead bird hanging from the hunter's belt may be yet another instance of the well-known pun of *vogelen* (fowling, copulating) often embodied by dead fowl and hunters in seventeenth-century Dutch erotic genre (see E. de Jongh, "Erotica in vogelperspectief," *Simiolus* 3, 1968–69, pp. 22–74), but the same figure appears repeatedly in Avercamp's paintings and drawings without any apparent erotic allusions.

5. Welcker, *Avercamp*, no. T 46, p. 245; J. Q. van Regteren Altena in *Cent dessins du Musée Teyler, Haarlem*, exh. cat., Paris, Musée du Louvre, 1972, no. 63.

6. A. B. de Vries (in *Verzameling Sidney van den Bergh*, no. 16) doubted the identification of the figures as the royal family and believes that they are simply wealthy persons who contrast with the more simple types around them. Leo van Puyvelde (in *The Dutch Drawings in the Collection of His Majesty the King at Windsor Castle*, London, 1944, no. 18) tentatively identifies Elizabeth and the Elector Palatine in the Windsor drawing *Gentlefolk in a Horse-Drawn Sleigh*.

7. Amsterdam, Rijksmuseum, inv. no. A958.

8. Van Regteren Altena, *Cent Dessins*, no. 63.

9. Paris, Musée Jacquemart-André (A. Bredius, *The Paintings of Rembrandt*, 3rd. rev. ed. by H. Gerson, London, 1969, no. 99). Cleaning in 1965 revealed that it is a pendant to Gerard van Honthorst's portrait of Frederick Hendrick, dated 1621 (H. Gerson, *Rembrandt Paintings*, New York, 1968, no. 112).

10. Welcker, *Avercamp*, pp. 87, 89; van Regteren Altena, *Cent Dessins*, no. 63. Van Regteren Altena dates the Teyler drawing to 1621, seeing the St. Jacobskerk in The Hague in the background, while Welcker dates all the supposed representations of the Winter King and Queen to 1626.

11. The exhibition catalogue *Schilderijen van oude meesters*, The Hague, 1881, no. 70, records a date of 1622 on the Carter panel. There are no other subsequent references to this date. If it was ever on the picture, it has since disappeared.

12. *Skating near a Town*, 1609, location unknown (Stechow, *Dutch Landscape Painting*, fig. 166).

13. A more progressive landscape is the *Canal with Skaters outside the City Walls* (Welcker, *Avercamp*, no. S28, pl. 9), datable according to Stechow to the late twenties or early thirties (*Dutch Landscape Painting*, p. 86). The Carter painting and the privately owned ice scene (fig. 5) illustrate the colorful type.

14. Oil on wood, 29.5 x 44.5 cm., location unknown (Stechow, *Dutch Landscape Painting*, fig. 164).

15. Welcker, *Avercamp*, no. T118. The hunter is also the subject of a summary chalk sketch in which he leans on the tip of his rifle (T13).

16. See Welcker, *Avercamp*, no. T147, where the figure is identified as Jacob Roelofsz. Steenburgh; and Puyvelde, *Dutch Drawings*, no. 26. Other examples of figures in our painting that recur in other works are the pair on the right with the man tying the woman's shoes, repeated in drawings in Dresden and Amsterdam and in paintings in Washington, D.C., Utrecht, and Voorburg, the last with a different woman (Welcker, *Avercamp*, nos. T103, T23, S28, S33; the Washington painting reproduced but not catalogued); and the couple with the girl in the red pinafore skating behind the dapper young man in orange, repeated in the paintings in Utrecht and Voorburg (Welcker, *Avercamp*, nos. S28, S33) as well as the *Winter Scene Near Utrecht (?)* (fig. 5).

Gerrit Berckheyde
1638–1698

Gerrit Berckheyde was born in Haarlem in 1638. He probably received his training from his older brother Job (1630–93), who painted church interiors, domestic interiors with figures, Italianate landscapes, and some townscapes. The two brothers traveled to Germany, where they visited Cologne, Bonn, and Mannheim, and they worked for a short time in the court of the Elector Palatine in Heidelberg. By 1660 they had returned to Haarlem, where Gerrit joined the guild in that year. He remained in his native city until his death in 1698. Aside from a handful of landscapes and church interiors, Gerrit Berckheyde painted exclusively town views. His style is more refined from the 1670s on, when his colors become pale and cool and his figures tall and elegant. His scenes of Holland are topographically accurate, but his paintings of Cologne, which are composed more freely, were probably based upon sketches made on the spot in Germany and executed later in Haarlem. Very few of Berckheyde's drawings have survived; of these, most are preparatory studies for paintings. There are dated works by Berckheyde from 1668 until 1697, the year before he died.

2

The Nieuwezijds Voorburgwal with the Flower Market in Amsterdam

Signed on canal bulkhead, lower right: Gerrit Berck Heyde
Oil on canvas, 14½ x 18¾ in. (36.7 x 47.7 cm.)

Collections: H. Becker, Dortmund; Mrs. E. F. Dunn (her sale, London, Sotheby, April 6, 1949, no. 72; [Minken, London]; [P. de Boer, Amsterdam, 1952–59]; J. van Duyvendijk, Scheveningen; [Thos. Agnew and Sons, London]; [Newhouse Galleries, New York, 1973]; Edward W. Carter, Los Angeles, 1973–76; [Robert Noortman, London, 1976].

Exhibitions: Utrecht, Centraal Museum, *Nederlandse architectuurschilders*, 1953, no. 10, pl. 48; Dortmund, Schloss Cappenberg, *Meisterwerke alter kunst*, 1954, no. 54, repr.; New York, Metropolitan Museum of Art, *The Grand Gallery at the Metropolitan Museum*, 1974–75, no. 115, repr.

References: J. C. Ebbinge-Wubben, *The Thyssen-Bornemisza Collection*, Castagnola, 1969, p. 35, no. 30; *Weltkunst*, October 15, 1974, p. 1623, repr.

The view is northward from the Weessluis up the Nieuwezijds Voorburgwal. On the left is the Flower Market, one of several markets that occupied the broad quay on the west bank, and looming in the background is the newly built Town Hall. The canal was filled and the bridges demolished in 1883–84 to form a wide street, and today, although some seventeenth-century buildings remain, the view is very different.

Berckheyde's scene contrasts the charm of an older Am-

sterdam neighborhood—buildings of varied size and shape, modest scale, and lively commerce on the streets—with the awesome presence of the grandest structure in the Netherlands. Designed by Jacob van Campen, begun in 1648, constructed on more than 13,000 piles, and completed about 1665, the Town Hall was intended as a symbol of Amsterdam's power and prosperity. The building is seen from the side and rear, a relatively unusual viewpoint for it in paintings, so that the most prominent feature is

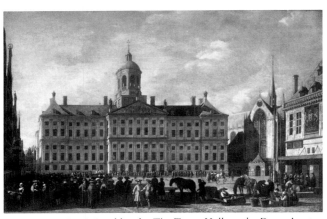

FIGURE 1. Gerrit Berckheyde, *The Town Hall on the Dam, Amsterdam*, 1673. Oil on wood, 16⅞ x 24¾ in. (43 x 63 cm.). Amsterdam, Rijksmuseum (on loan to Amsterdams Historisch Museum).

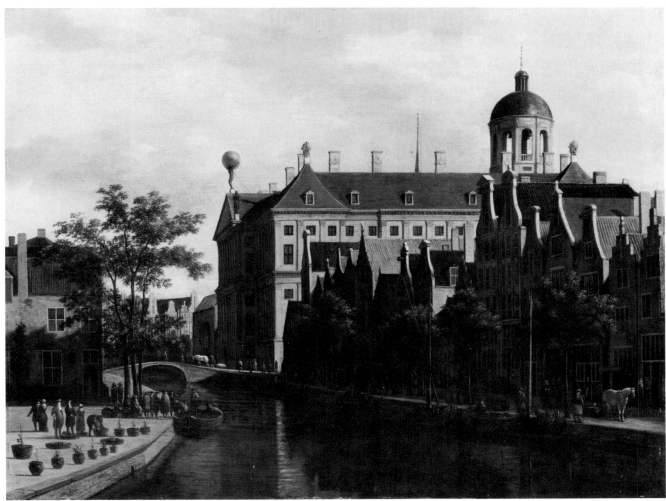

CATALOGUE NUMBER 2

the huge bronze figure of Atlas supporting the globe of the heavens over the west pediment. (The pediment sculptures, although they cannot be seen here, represent an allegory of Amsterdam and the tribute brought her by the four continents.)[1] Berckheyde also painted more familiar views from the Dam Square that show the facade of the Town Hall as well as the neighboring public monuments, the Nieuwe Kerk and the Waag (fig. 1).

The Carter painting is one of several variants of a composition best known in a picture now in the Amsterdams Historisch Museum (fig. 2).[2] The paintings all differ slightly in their vantage points and in the activities of the people, differences to be expected of an artist repeating himself. They also vary somewhat in the buildings shown. If the pictures were by Berckheyde's contemporary van der Heyden, we might expect these changes to be a matter of artistic license; but since Berckheyde was generally a much

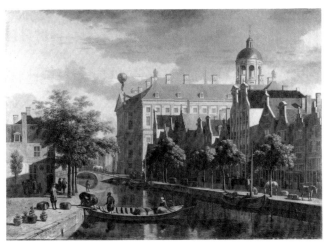

FIGURE 2. Gerrit Berckheyde, *The Nieuwezijds Voorburgwal with the Flower Market in Amsterdam*, about 1668–70. Oil on canvas, 17³/4 x 24 in. (45 x 61 cm.). Amsterdam, Amsterdams Historisch Museum.

9

FIGURE 3. Jan Abramsz. Beerstraten or Abraham Beerstraten, *The Nieuwezijds Voorburgwal*, about 1665.
Chalk and gray wash on paper, 10³/₈ x 15³/₄ in. (26.5 x 40 cm.). Amsterdam, Gemeentearchief.

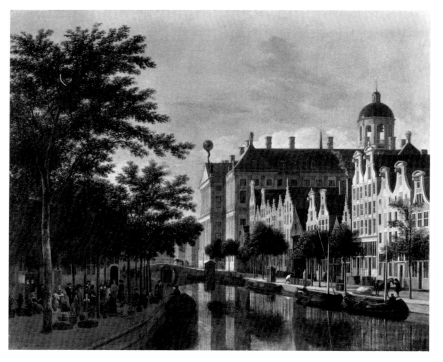

FIGURE 4. Gerrit Berckheyde, *The Nieuwe-zijds Voorburgwal with the Flower Market in Amsterdam*, 1686. Oil on canvas, 21 x 25 in. (53.5 x 63.5 cm.). Lugano, Thyssen-Bornemisza Collection.

10

more scrupulous recorder of appearances, a closer look at the changes may be helpful in suggesting the sequence in which the pictures were painted.

A drawing of about 1665 shows the site somewhat before Berckheyde began to paint his views of it (fig. 3).[3] Scaffolding still surrounded the cupola when construction of the Town Hall was nearing an end, and the Atlas was not yet in place. In Berckheyde's painting in Amsterdam (fig. 2) and in the variant in Leningrad[4] the trees are considerably taller, and a pair of modern house facades have replaced two older ones on the east bank (the tenth and eleventh from the left). In the Carter painting the trees are a little higher still, and a tiny house visible in the drawing and earlier painting (eighth from the right in the drawing) has been replaced by a tall, neck-gabled building that blocks the light that had streamed between the buildings in the earlier picture. Another version, now lost,[5] shows the site exactly as it is given in the Carter painting. Finally, the painting dated 1686 in Lugano (fig. 4) shows that there have been more changes, chiefly the pair of neck-gabled facades, second and third from the right in the Lugano picture,[6] that have replaced two others—one of which had evidently been built, as we have just noticed, shortly before the Carter painting. All this suggests that if the Amsterdam and Leningrad pictures are datable at the end of the 1660s or the beginning of the 1670s, the Carter version and the lost version of the same composition should be placed a few years later.[7]

Berckheyde's views of this site thus reflect twenty years of construction and facelifting, as the Nieuwezijds Voorburgwal was changing from a picturesque jumble of late medieval and modern buildings toward a stateliness like that of the nearby Herengracht and the other new semi-circular canals. He achieves quite different effects in the five versions, which differ in size and in the play of light. The Amsterdam picture has crisp patterns of light and dark, the shaded facades receive reflected light from the quay, and the more prominent action in the foreground is accentuated by the device of blocking with a tree the distant view up the canal. The Carter painting is less forcefully lighted, has a narrower range of values and smaller figures, and it exploits the view into the distance, where the Nieuwezijds Voorburgwal continues northward and turns to reveal more splendid houses on its west bank. In the Lugano composition Berckheyde includes the grove of trees in the Flower Market that he had omitted from the earlier versions (the principal liberty he had taken with the scene), shows many more figures and potted plants, and uses afternoon sun to light the facades brilliantly and accentuate their height by the reflections cast in the water.

The Carter painting, like the other versions, shows Berckheyde's characteristically soft, rather broad handling of paint. His tendency to generalize forms for pictorial effect can easily be verified by comparing the elaborate detail of the stone and metalwork in the facades recorded in the Beerstraten drawing (fig. 3) with the paintings, in which these details are suppressed and the buildings are given many more smooth surfaces and flat planes to reflect the light.

1. For the history of the building and its allegorical program, see Katherine Fremantle, *The Baroque Town-Hall of Amsterdam*, Utrecht, 1959.

2. A sensitive appreciation of this painting by Richard J. Wattenmaker is given in the exhibition catalogue *The Dutch Cityscape in the 17th Century and its Sources*, Amsterdam, Amsterdams Historisch Museum, and Toronto, Art Gallery of Ontario, 1977, pp. 28–29; see also Stechow, *Dutch Landscape Painting*, p. 127.

3. Reproduced and discussed in Boudewijn Bakker, *Amsterdam getekend*, The Hague, 1978, p. 57.

4. Leningrad, Hermitage (St. Petersburg, Hermitage, *Catalogue de la galerie des tableaux*, vol. 2, 1901, p. 17, no. 1214, pl. 114).

5. Exhibited Amsterdam, F. Muller and Co., *Oude Meesters*, 1918, no. 10, repr., mistakenly as *De Pijpenmarkt en het Stadhuis te Amsterdam*.

6. That these two neighboring pairs of houses actually stood in this location is demonstrated by later topographical engravings, for example one by Petrus Schenk (1661–1715), *100 Afbeeldinge der voornaamste Gebouwen van Amsterdam*, Amsterdam, [n.d.], pl. 9.

7. One detail might seem to argue against this sequence: it has been pointed out that the Amsterdam version contains one of the streetlights that were part of the scheme of lighting devised by Jan van der Heyden and installed in 1669, and thus cannot date earlier than that year (Amsterdam, Kunsthandel P. de Boer, *Zomertentoonstelling*, 1952, p. 3, no. 6; Utrecht, Centraal Museum, *Nederlandse architectuurschilders*, exh. cat., 1953, p. 5, no. 10). The streetlight may give an earliest possible date for the Amsterdam picture, but its absence in the other versions cannot provide a latest possible date for them, since the architectural evidence to the contrary is so strong; it is more satisfactory in this case to attribute their elimination to choice on Berckheyde's part.

Anthonie van Borssom
1629/30–1677

The few documents concerning van Borssom suggest that he resided in Amsterdam throughout his life. He was the son of Cornelis van Borssom, a mirror manufacturer originally from Emden. There is no record of his birth, but van Borssom was reportedly forty years old when he married in Amsterdam in 1670. The subjects of his landscapes indicate that he traveled to the regions of Utrecht and Cleves. Chiefly known for his fresh and sensitive landscape drawings in the style of Rembrandt's work of the late forties, the artist was a prolific draftsman whose summary style suggests that he worked quickly. His paintings, which are more rare, reveal by their influences an impressionable mind; they treat a wide range of subjects and styles, including plants and animals in the manner of Otto Marseus van Schrieck, river scenes that recall certain of Jacob van Ruisdael's works of the early fifties, church interiors in the style of van Vliet, landscapes with cattle that reflect the influence of Potter, nocturnes in the manner of van der Neer, and a few Koninck-like panoramas. Van Borssom also made etchings of animals and birds. Nothing is known of his training. His paintings reveal a familiarity with the landscapes of contemporary Haarlem artists, and his drawings suggest that he may have studied with Rembrandt in the late forties. During the eighteenth century, when his drawings were greatly admired, he was imitated by artists such as Jacob and Abraham van Strij, Jan Hulswit, and Hendrik Spilman.

3

Panoramic Landscape near Rhenen with the Huis ter Leede

Oil on canvas, 20¼ x 26 in. (51.2 x 66 cm.)

Collections: M. M. van Valkenburg, Laren, by 1938; Alois Meidl; [G. Cramer, The Hague].

Exhibitions: Rotterdam, Museum Boymans, *Meesterwerken uit vier eeuwen*, 1938, no. 152, repr. p. 104 (as Adriaen van de Velde).

References: Thieme-Becker, vol. 34, 1940, p. 198 (under Adriaen van de Velde).

Van Borssom's panorama of the flat country near Rhenen, viewed from the bank of the Rhine, shows the castle of the Leede (or Lynden) family prominently in the distance. A large fortified building of the twelfth century, it had been much altered from its medieval appearance (fig. 1)[1] in van Borssom's time; by 1745 it was already in ruins, as it is today.

The majority of van Borssom's paintings, which represent rural scenery with animals and rustics in more inti-

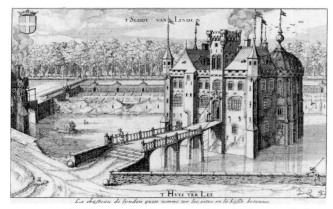

FIGURE I. *T' Huys ter Lee*. Engraving, from Christopher Butkens, *Les Annales Généalogiques de la Maison de Lynde*, Antwerp, 1626, p. 54.

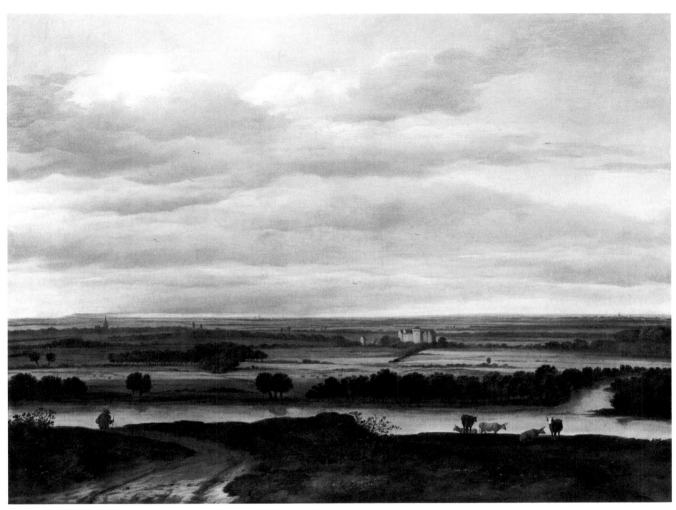

CATALOGUE NUMBER 3

mate compositions than the Carter picture, reflect the strong influence of the leading *animaliers* Paulus Potter and Adriaen van de Velde. Van Borssom also painted a small number of extensive landscapes whose main inspiration was evidently Philips Koninck (cat. no. 16). The Carter painting, long attributed mistakenly to Adriaen van de Velde, clearly belongs to this group of pictures by van Borssom. His paintings of this type, although similar to Koninck's panoramas in composition and in the use of certain motifs and devices, notably the pattern of horizontal striations to render the succeeding planes of the middleground and background, are nevertheless painted more thinly in a drier, crisper technique that recalls the Haarlem painters of an earlier generation, especially Cornelis Vroom and Salomon van Ruysdael. Van Borssom

does not attempt the drama or the brooding moods of Koninck's paintings; his panoramas have a simpler, clearer aspect that has its own appeal.

A canvas in Düsseldorf (fig. 2) is closest to the Carter painting in style and content. Its date, evidently to be read 1666, gives an indication of the date of our picture, which may be a few years later.[2] Cows are disposed in the foreground in a manner that recalls Potter, but the sweeping view of level river country and the massive hill at the right—which makes a fantasy out of what otherwise might plausibly be Dutch scenery—are clearly patterned on Koninck's pictures. In the Carter painting, by contrast, van Borssom does without the imported hills and thereby gives his view an extreme flatness and simplicity that is true to the locale.

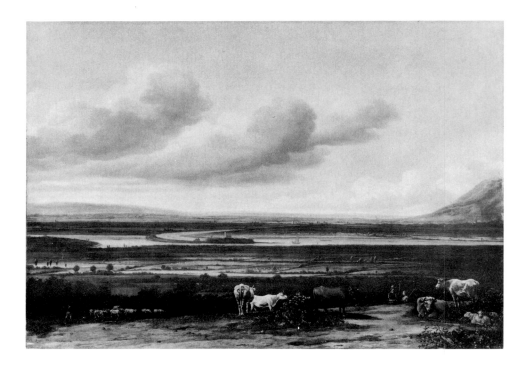

FIGURE 2. Anthonie van Borssom, *View of Schenckenschanz and Hochelten*. Oil on canvas, 35 3/8 x 49 5/8 in. (90 x 126 cm.). Düsseldorf, Kunstmuseum.

1. This engraving from Christopher Butkens's *Les Annales Généalogiques de la Maison de Lynde*, Antwerp, 1626, p. 54, shows the appearance of the castle to be identical to that in Rademaker's etching (*Nederlandsche Outheeden en Gezigten*, Amsterdam, 1725, no. 274) whose caption identifies it as a view of the building as it appeared in 1520 and says that it is "now very much altered by the changes made in it."

2. A *Distant View of a Town* dated 1671 in the Statens Museum for Konst, Copenhagen, has many points of similarity with the panoramas, but is somewhat softer in contours; its date strengthens the likelihood that the Düsseldorf picture, whose date reads 16 . . . 6, must in fact be of 1666. The technique of the Carter painting suggests that it was done at some time between these two dates. A signed but undated panorama (76 x 107 cm.) with peasants and cattle in the foreground, probably of the later 1660s, was sold in Lucerne, Galerie Fischer, June 25, 1976, no. 390, repr.

Ambrosius Bosschaert
1573–1621

Ambrosius Bosschaert was born in Antwerp in 1573 but soon left the city with his family for religious reasons and joined the growing Calvinist population of Middelburg in the United Provinces. By 1593 he belonged to the Guild of St. Luke in Middelburg, but no dated work by him is known until 1607. Bosschaert doubled as an art dealer, as did many seventeenth-century artists; this trade may have occupied him during these early years. In 1604 he married Maria van der Ast, sister of Balthasar van der Ast, a Middelburg still-life specialist slightly younger than Bosschaert and strongly influenced by him. The origins of Bosschaert's style are unclear. Before him Georg Flegel in Frankfurt and Georg Hoefnagel in Antwerp had executed detailed studies of flowers, and Lodewyck Jansz. van der Bosch reportedly produced compositions similar to those of Bosschaert, though none is known today. Bosschaert may also have been familiar with works by Jan Brueghel, but the Flemish master was not his teacher.

By January 1615 Bosschaert had moved to Bergen-op-Zoom, where he remained for slightly less than a year before settling in Utrecht, which was then the center for Dutch flower painting. While in Utrecht from 1616 to 1619 Bosschaert attempted ornate compositions with tall flowers, lightened his backgrounds, and painted his first arrangements in a niche. By late August 1619 he had moved to Breda, where he lived until his death in 1621. In these productive final years, when he executed more than one-fourth of his surviving works, Bosschaert introduced a new element, a distant riverscape, into his backgrounds. Together with Jacques de Gheyn, Roelandt Savery, and Balthasar van der Ast, Bosschaert was a pioneer of the first phase of Dutch still-life painting, characterized by a detailed, accurate representation of a wide variety of species. The symmetrical organization and precise description in Bosschaert's Middelburg works set the standard for still-life painting in that city until 1650–60.

4

Bouquet of Flowers on a Ledge

Signed on the sill, lower right: AB (joined)
Oil on copper, 11 x 9 in. (28 x 23 cm.)

Collections: U. Palm, Stockholm, before 1934; [G. Stenman, Stockholm]; Dr. E. Perman, Stockholm, by 1936; Mrs. John Goelet, Amblainville, France, to 1965; [Newhouse Galleries, New York, 1976].

Exhibitions: Amsterdam, Kunsthandel P. de Boer, *De Helsche en de Fluweelen Brueghel en hun invloed op de kunst in de Nederlanden,* 1934, p. 20, no. 251, repr.; Paris, Musée de l'Orangerie, *Rubens et son temps,* 1936, no. 3, pl. 1; Eindhoven, Stedelijk van Abbemuseum, *Het Hollandse stilleven,* 1957, no. 11; Philadelphia, Museum of Art, *A World of Flowers,* 1963 (cat. in *Philadelphia Museum Bulletin* 58, 1963, frontispiece); San Francisco, California Palace of the Legion of Honor; Toledo Museum of Art; Boston, Museum of Fine Arts, *The Age of Rembrandt,* 1966, no. 98, repr.

References: Ingvar Bergström, *Studier i holländskt stillebenmålerei under 1600-talet,* diss., Gothenburg, 1947, p. 72, fig. 51, pl. 1; Paris, Musée de l'Orangerie, *La nature morte de l'antiquité à nos jours,* exh. cat., 1952, p. 40; L. J. Bol, "Een Middelburgse Brueghel-groep II," *Oud-Holland* 70, 1955, pp. 96–109, fig. 7; M. L. Hairs, *Les peintres flamands de fleurs au XVIIe siècle,* Paris and Brussels, 1955, p. 90; Jean Leymarie, *La peinture hollandaise de Gérard de Saint Jean à Vermeer,* Lausanne, Paris, and New York, 1956, p. 75, repr. p. 76; Jean Leymarie, *Dutch Painting,* Geneva and New York, 1956, p. 75, repr. p. 76; Bergström, *Dutch Still-Life Painting,* p. 62, frontispiece; L. J. Bol, *The Bosschaert Dynasty,* Leigh-on-Sea, 1960, pp. 30–31, no. 46, pp. 20, 67, pl. 30; L. J. Bol, " 'Goede onbekenden'," *Tableau* 3, 1981, p. 526, fig. 4.

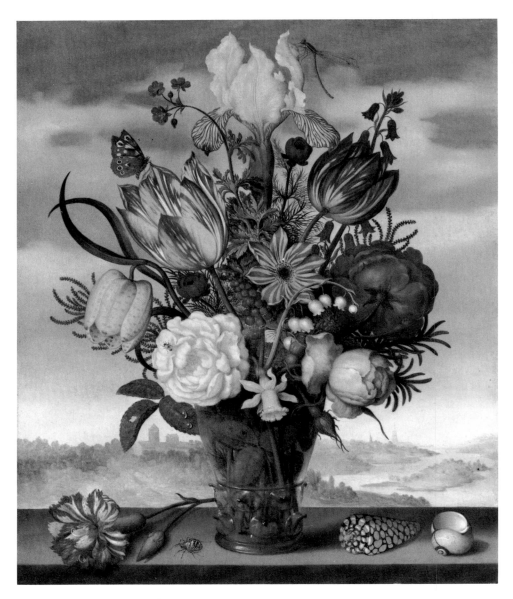

Bosschaert's bold and exquisite still life, which shows a bouquet of brilliantly colored flowers including tulips, irises, and roses set against a blue sky and distant landscape, is probably the most familiar work in the Carter collection. The strict axial symmetry of the composition is characteristic of Bosschaert and his contemporaries, but the use of a simple ledge with a landscape setting is unique, not only in this artist's work but also in Dutch still-life painting generally. The bright open background accentuates the saturated reds, yellows, and blues of the bouquet, giving the picture its special intensity.

Bosschaert's still lifes have been accurately compared to group portraits.[1] By using individual life studies the artist

brings together various types of flowers, often rare and exotic specimens, but does not represent bouquets that could actually have existed. Bosschaert was concerned with making each flower believable, not the bouquet; each blossom is therefore depicted accurately but the bunch of flowers is far too large for the glass roemer. He combines flowers that bloom in early spring, such as the daffodil and the liverwort (*Anemone hepatica*, the striped blossom in the center), with others that bloom in midsummer or later —for example, the pink damask rose and the carnation.[2] This practice, typical of Bosschaert, and his repetition of the same blossoms in a number of different paintings strongly suggests that he composed his paintings from col-

ored drawings of particular flowers, although none of these is known.[3]

In an age when certain flowers were highly prized—tulips were objects of heady speculation, some breeds costing thousands of guilders[4]—paintings such as this one might have recorded a private horticultural collection or might have provided a precious and durable substitute for a sophisticated garden. All of the flowers here were cultivated in Holland in the seventeenth century, but certain examples such as the hybrid striped tulip were more highly valued than others. Shells were also avidly collected in the Netherlands at this time. A conchologist would have been proud to own the exotic specimens in the picture, a *Polymita pictar* from Cuba on the right and a *Conus marmoreus* (?) from East India on the left.[5]

To Bosschaert's audience this still life would have signified more than opulent display or a collector's taste in flowers and shells. The blossoms would have been a reminder, as they were so often in the seventeenth century, of the brevity of human life and the vanities of earthly pleasures. The association of the *Vanitas* theme with floral still lifes derived from several biblical verses, notably Isaiah 40:6, "All flesh is grass, all the goodliness thereof is as the flowers of the field: the grass withereth, the flower fadeth; because the spirit of the Lord bloweth upon it."[6] Some of the religious associations of particular flowers in fifteenth- and sixteenth-century Netherlandish paintings evidently survived into the next century.[7] Both shells and flowers were used in emblem books, too, to exemplify the foolish way in which man spends his money (fig. 1). The message implied by Bosschaert's painting may be similar to that of a roughly contemporary painting ascribed to Jan Brueghel (fig. 2) in which a verse referring to the inevitable fading and wilting of the flowers is inscribed below a beautiful bouquet.[8] The inscription goes on to advise the reader to have faith in the word of God alone, contrasting the everlasting God to the short-lived flowers. The Carter painting may have a similar significance, for Bosschaert has combined allusions to death and decomposition with traditional symbols of renewal and resurrection. Unlike later artists such as Dirck de Bray (cat. no. 6) or Jan van Huysum (cat. no. 15), Bosschaert does not refer to the imminent decay of the flowers by depicting them as overripe and wilting. Instead he hints at their passing beauty by showing the insects preying on the flowers, such as the dragonfly on the iris,[9] by placing proverbially transient dew drops on one of the lower leaves,[10] and by representing the holes in another. The most expli-

cit reminder of death may be the beetle on the white rose, a *doodgraver*, or burying beetle, which digs holes under the dead bodies of mice and other small animals to provide

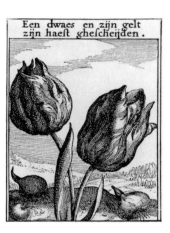

FIGURE 1. Roemer Visscher, "Een dwaes en zijn gelt zijn haest ghescheijden" ("A fool and his money are soon parted"), 1614. Engraving from *Sinne-Poppen*, Amsterdam, 1614.

FIGURE 2. Jan Brueghel the Elder, attributed to, *Still Life with Flowers in a Glass Vase*. Oil on copper, 11 3/4 x 7 7/8 in. (30 x 20 cm.). London, Richard Green Galleries.

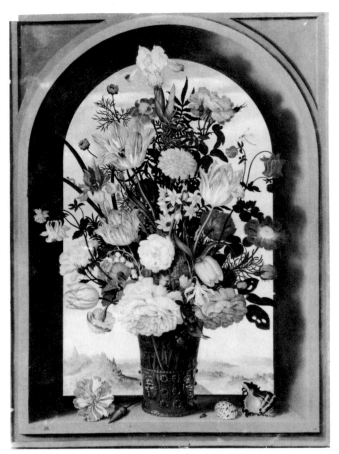

FIGURE 3. Ambrosius Bosschaert, *Bouquet in a Niche*, about 1619–20. Oil on panel, 25¼ x 18⅛ in. (64 x 46 cm.). The Hague, Mauritshuis.

FIGURE 4. Pieter Bruegel the Elder, *Two Apes*, 1562. Oil on wood, 7⅞ x 9 in. (20 x 23 cm.). Berlin, Staatliche Museen Preussischer Kulturbesitz, Gemäldegalerie.

nests for its larvae. Countering these morbid elements are flowers and insects with more hopeful associations, such as the butterfly and the carnation, both symbols of the resurrection of the soul.[11] Other flowers in the arrangement, such as the rose and anemone,[12] had particular associations that reinforce the general theme of the transience of human life and earthly pleasures as contrasted to the eternal world of God.

The Carter painting, one of four works from Bosschaert's late period with a background landscape (fig. 3),[13] is unique in the absence of the stone niche that frames the bouquet in the other works. The painting takes on a brilliance and clarity of color and light unrivaled by his contemporaries, but which recalls the miniature drawings in gouache or watercolor made in the previous century by such artists as Georg Hoefnagel. The brightly lighted open background reinforces the minute detail of Bosschaert's

brushwork, just as the deep shadows and pale sky of the contemporary *Flowers in a Niche before a Landscape* (Amsterdam, Mrs. Peters-Wetzlar) complement the softer technique of that picture. It is tempting to view the Carter painting as the final step in an evolution from Bosschaert's early works against a dark background,[14] to compositions enclosed in an illuminated stone niche,[15] to more open and brighter paintings with a distant landscape behind the bouquet. Bosschaert's development, however, was not so straightforward, for in his last dated painting of 1620 (Stockholm, Nationalmuseum) he returns to a darker background.

The little group of paintings by Bosschaert that juxtapose a niche or ledge with a vast landscape in the background have no immediate precedent, but evidently go back to a remarkable, enigmatic picture by Pieter Bruegel the Elder, the *Two Apes* of 1562 (fig. 4), in which monkeys are placed in a stone window through which a view of Antwerp can be seen.[16] The vantage point for the landscape is impossibly high, as it is in Bosschaert's pictures, foiling any illusion that the spectator could ever look at the monkeys and landscape from such a place. It is not clear whether the relationship of flowers to distant landscape had any significance for the seventeenth century other than as a pictorial device. Recently Bosschaert's *Bouquet in a Niche* in the Mauritshuis (fig. 3) was ana-

lyzed as an illustration of the totality of Nature, combining the description of individual parts with a view of nature as a whole, in a conception similar to that first set down by Petrarch and followed in subsequent literature.[17] While Bosschaert may have known this tradition, it does not entirely explain the relationship of flowers to the extensive landscape with buildings and proud towers, which may have a further moral: that as beauty and decay can be observed in flowers, they can be found as well in the world beyond.

1. Bol, *Bosschaert Dynasty*, p. 20.

2. For this information, and for assistance in identifying the flowers in this painting and other still lifes, we are grateful to Dr. Sam Segal. Bol (*Bosschaert Dynasty*, p. 21) describes the flower to the left of the iris as a wild flower, but according to Dr. Segal it is a *Geranium Tubnosum* (stork's bill), originally found from the Central Mediterranean region to Persia and in cultivation since 1581.

3. Bergström, *Dutch Still-Life Painting*, p. 50; Bol, *Bosschaert Dynasty*, p. 20. None of these studies by Bosschaert survives. The iris, daffodil, liverwort, the white rose, the tulip in the upper left, and the yellow fritillary in the center of the left side are repeated in other works by Bosschaert (see Bol, *Bosschaert Dynasty*, p. 30).

4. Bol, *Bosschaert Dynasty*, p. 19; Bergström, *Dutch Still-Life Painting*, p. 48. The peak of tulip speculation occurred in 1637, when the bubble burst, prices deflated, and many fortunes were lost.

5. The shells are identified by Bergström, *Dutch Still-Life Painting*, p. 65.

6. The verse from Isaiah 40 is inscribed below an etching by Claes Jansz. Visscher of 1635, probably after a painting of about 1600 (Münster, Baden-Baden, *Stilleben in Europa*, exh. cat., 1979–80, p. 320, fig. 175).

7. Ingvar Bergström, "Disguised Symbolism in 'Madonna' Pictures and Still Life I," *Burlington Magazine* 97, 1955, pp. 303–8; and "Disguised Symbolism II," pp. 342–49; Münster, *Stilleben*, p. 308.

8. Münster, *Stilleben*, p. 320, fig. 167.

9. Bergström, "Disguised Symbolism II," p. 346. The biblical passage describing destruction by insects is Psalm 105:31–34.

10. Ingvar Bergström, "Notes on the Boundaries of *Vanitas* Significance," *Ijdelheid der Ijdelheden*, exh. cat., Leyden, Stedelijk Museum 'de Lakenhal,' 1970.

11. On the butterfly, see Bergström, "Disguised Symbolism II," pp. 342, 346; and on the carnation, see Bergström, "Disguised Symbolism I," p. 307, "Disguised Symbolism II," p. 345, and *Den Symboliska Nejlikan*, Malmö, 1958.

12. The rose could have a number of different meanings; for example, the inevitable combination of the good (the blossom) with the bad (the thorns), the dangers of frivolous living, and the brevity of physical beauty (Arthur Henkel and Albrecht Schöne, *Emblemata: Handbuch zur Sinnbildkunst des XVI. und XVII. Jahrhunderts*, Stuttgart, 1967, cols. 303–6). The anemone is used by Camerarius to illustrate the motto "Brevis est Usus," which refers to the transience of earthly life. (Joachim Camerarius, *Symbolorum et Emblematum ex Re Herbaria*, 1590, no. 69, quoted from Henkel and Schöne, *Emblemata*, col. 308).

13. The other paintings are the *Little Bouquet in an Arched Window*, formerly in the collections of J. William Middendorf, New York, and Edward W. Carter, now in the London art market, and *Flowers in a Niche before a Landscape*, Amsterdam, Mrs. Peters-Wetzlar (Bol, *Bosschaert Dynasty*, nos. 38, 44).

14. *Bouquet in a Roemer*, Milan, Cicogna collection; *Bouquet in a Gilt-Mounted Wan-Li Vase*, Oxford, Ashmolean Museum (Bol, *Bosschaert Dynasty*, nos. 3, 41).

15. *Bouquet in a Glass Beaker Standing in a Niche*, Copenhagen, Statens Museum for Konst (Bol, *Bosschaert Dynasty*, no. 33).

16. For a discussion of the meaning of the painting see Margaret A. Sullivan, "Pieter Bruegel the Elder's *Two Monkeys*: A New Interpretation," *The Art Bulletin* 63, 1981, pp. 115–26.

17. Münster, *Stilleben*, pp. 17–22.

Jan Both

about 1615/18–1652

Jan Both's birthdate is unknown, but he was probably born in Utrecht between 1615 and 1618. His father, a glass painter or engraver, may have been his first teacher. According to Sandrart, Jan and his older brother Andries studied with Abraham Bloemaert about 1625–27 and later traveled to Italy. Jan was first recorded in Rome in 1638, but he may have arrived three years earlier; he remained there until 1641. Among his colleagues were Claude Lorrain, Joachim van Sandrart, the older Dutch expatriate Pieter van Laer, and possibly Carel de Hooch. After his return to Holland, Both seems to have remained in Utrecht, where he was named an officer in the painter's guild in 1649. He was buried in Utrecht in 1652.

Both was the leading artist of the second generation of Italianate landscape painters; the idyllic mood, spacious vistas, and strong structural accents in Both's landscapes herald what has been called a classical phase. His work consists primarily of wooded landscapes flooded with warm, golden sunlight, but it also includes a handful of urban genre scenes in the style of Pieter van Laer and several religious and mythological subjects. Nearly fifty drawings and seventeen etchings by Both are preserved.

The impressive list of artists influenced by Both includes Aelbert Cuyp (cat. no. 10), Nicolaes Berchem, and Adam Pynacker (cat. no. 20). The works of his closest follower, Willem de Heusch, have been mistakenly attributed to Both. Extremely popular throughout the seventeenth and eighteenth centuries, Both was widely imitated and copied. The attribution of paintings to Both is complicated by the artist's occasional practice of painting more than one version of a composition. Other artists such as Cornelis van Poelenburgh, Nicolaes Knupfer, Jan Baptist Weenix, and his brother Andries sometimes added the staffage to Both's landscapes.

5

Landscape with a Draftsman

Signed, lower left: J Both
Oil on canvas, 41 ⅛ x 46 ½ in. (107 x 120 cm.)

Collections: [Shickman Gallery, New York, 1968]; Mr. and Mrs. Malcolm Farmer, Jr., Providence, Rhode Island; [Shickman Gallery, New York, 1977]; [Nystad, The Hague, 1979].

References: James D. Burke, *Jan Both: Paintings, Drawings and Prints*, diss., Harvard, 1972, pp. 238–39, no. 96; published New York, 1976.

Filled with the warm sunlight of the Italian Campagna, the landscape before the artist is actually Both's invention and not a view he might have seen in Italy. The picture represents a well-known Roman monument in a setting generally reminiscent of the southern countryside, but the

FIGURE 1. Israel Silvestre, *Ponte Lucano*. Etching, 2¾ x 6 ⅛ in. (7.1 x 15.5 cm.). Rome, Gabinetto Nazionale delle Stampe (F.C. 67071), on deposit from the Accademia Nazionale dei Lincei. Photograph courtesy of the Fototeca Unione, Rome.

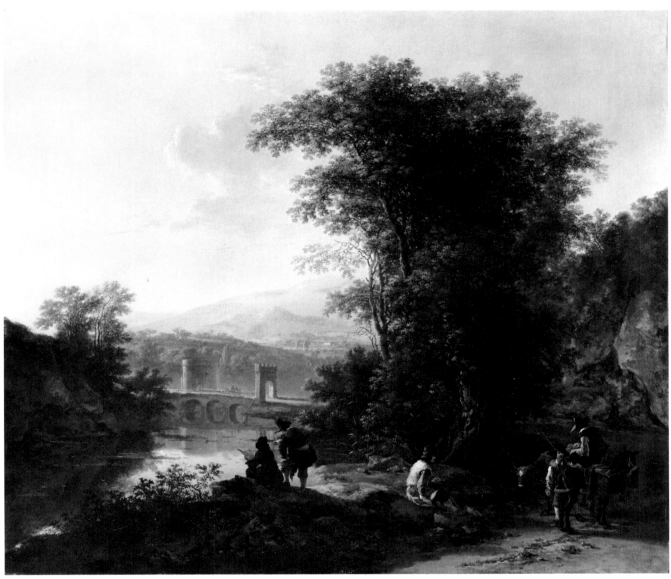

CATALOGUE NUMBER 5

trees are more massive and the mountains higher than those found in the vicinity.

The Ponte Lucano and the Tomb of the Plautii, here visible in the distance, are actually located in far gentler surroundings several miles from Tivoli. An etching by Israel Silvestre (1621–91) shows approximately what Jan Both would have seen during his sojourn in Italy (fig. 1): a triple-arched bridge flanked on one side by a portal, which was evidently more decrepit than Both indicates, and on the other by the great cylindrical tomb constructed for the Plautii family in 2 A.D. and given an upper story during the Middle Ages.[1] Such imaginary relocations of actual Roman

monuments were common enough among Dutch painters but rare in the works of Both, who generally preferred landscapes without recognizable buildings. Even in this painting he has altered the appearance of the arch, making it more complete, and he has incorrectly placed the tomb on the side of the bridge closer to the mountains.[2]

The artist who sits sketching on the river bank is a familiar figure in Both's paintings.[3] He furnishes further evidence of Both's close study of pictures by Claude Lorrain, which not only suggested to Both the possibilities of sunny landscape fantasies based on the Roman Campagna but also sometimes depicted artists at work.[4] Joachim von

21

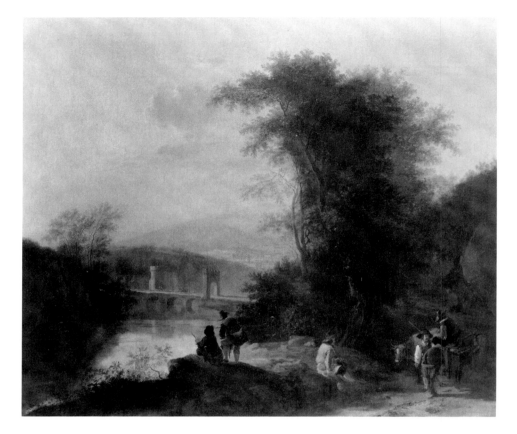

FIGURE 2. Jan Both, *Landscape with River*, about 1645–50. Oil on canvas, 41 x 46½ in. (104.2 x 118.2 cm.). Connecticut, private collection. Photograph courtesy of the Schaeffer Gallery, New York.

FIGURE 3. Jan Both, *Landscape with Bridge and River*, 1645–50. Oil on copper, 17⅞ x 23 in. (45.5 x 58.5 cm.). Amsterdam, Rijksmuseum.

draftsman in his painting is doing, and used the drawings in the studio as raw material for his painted inventions, not only in Rome but later in Holland after his return. Few of his drawings, unfortunately, have survived.

Both was evidently fond of this composition for at least three versions with minor changes are known, including a close variant (fig. 2) that has been dated later than the Carter painting; another, thought by Hofstede de Groot to be the prime version, has recently been recognized as a copy.[6] In other variants the draftsman is omitted (fig. 3),[7] or the bridge as well,[8] but the landscape remains much the same. Other paintings and drawings by or attributed to Both represent the Ponte Lucano and the river in different landscapes;[9] these, in turn, inspired works by Thomas Wijk and Willem de Heusch.[10] A drawing attributed to Both but apparently by de Heusch is clearly based on our composition.

As only two dated works by Both are known,[11] his chronology can only be reconstructed very approximately. The treatment of light and atmosphere in this picture is fully as sensitive as that of Both's most mature works, generally dated about 1650, such as the large *Landscape with a Draftsman* in the Rijksmuseum. The

Sandrart, who lived in Rome from 1629 to 1635, described going out into the countryside with Claude Lorrain and Nicholas Poussin (and Pieter van Laer?) "to paint or to draw landscapes directly from nature."[5] Jan Both surely made similar expeditions a decade later, just as the

massive forms on one side of the composition, the compact shape of the central tree, and the tight brushwork, however, are characteristics of works that have been dated to the first half of the 1640s—for instance, the *Landscape with a Distant Harbor* in the Rijksmuseum[12] or *A Rocky Landscape with an Ox Cart* in the National Gallery, London.[13] By about 1650 Both's style had undergone changes not yet evident in our painting. His brushwork had become looser, and he preferred more promi-

nent, detailed foreground vegetation, as well as more open trees with extended branches. In place of the dramatic juxtaposition of near and far and the compositional imbalance of the Carter picture, he preferred more unified compositions marked by a gradual recession into space. The Carter painting combines characteristics of Both's mature style with those of the early forties and was therefore probably painted in the mid-1640s.[14]

1. On the Ponte Lucano and the Tomb of the Plautii, see T. Ashby, "The Classical Topography of the Roman Campagna II," *Papers of the British School at Rome* 3, 1906, pp. 126–28, fig. 12; P. Gazzola, *Ponti Romani*, vol. 2, 1963, no. 51; G. Tomassetti, *La Campagna Romana*, vol. 3, 1977, p. 604; E. Martinori, *Via Nomentana, Via Patinaria, e Via Tiburtina*, Rome, 1932, p. 109; G. M. De Rossi, *Torri e castelli medievali della Campagna Romana*, Rome, 1969, p. 134; and the exhibition catalogue *I ponti de Roma*, Rome, Gabinetto Nazionale delle Stampe, nos. 64 (our fig. 1), 185, and 206. Piranesi's etching of 1763, plate 115 of the *Views of Rome*, is a more dramatic view of the bridge and tomb.

2. An etching by Israel Silvestre (published by De Rossi, *Torri e castelli*, fig. 388) shows the tomb and arch as they appear in Both's painting. Karen Einaudi has suggested (in a letter) that Silvestre's print might date from after 1659, when he settled in Paris. We are grateful to her, and to An Zwollo, Cornelius Vermeule, and John Herrmann for their assistance in providing information on the bridge and tomb.

3. Among others, HdG 87–95.

4. For example, two paintings of the 1630s, the *Landscape with a River* (Boston, Museum of Fine Arts) and *Caprice with Ruins of the Roman Forum* (Springfield, Massachusetts, Museum of Fine Arts); Marcel Röthlisberger, *Claude Lorrain: The Paintings*, New Haven, 1961, pp. 140–42; and Stechow, *Dutch Landscape Painting*, pp. 154–55.

5. Joachim von Sandrart, "Landschaften nach dem Leben zu mahlen oder zu zeichnen," *Teutsche Academie der Bau-, Bild-, und Mahlerey-Künste*, vol. 1, Nuremberg, 1675, p. 311; ed. A. R. Peltzer, Munich, 1925, p. 184.

6. The versions are (1) the Carter painting, which was unknown to Hofstede de Groot (Burke lists it as "HdG 94a?" but its dimensions and the location of its signature differ significantly; *Jan Both*, no. 96); (2) a copy formerly in the Lansdowne Collection, London, and later with the dealer Bruno Meissner, Zurich (HdG 89; Burke, *Jan Both*, under no. 76 as a copy); (3) the painting in the David G. Carter collection, New Haven (fig. 2; HdG 94; Burke, *Jan Both*, no. 76, as *Landscape with River [and Ponte Molle?]*); (4) a painting in the H. Kaven sale, Berlin, Lepke, March 22, 1917, no. 58 (HdG 94a).

7. This painting on copper in the Rijksmuseum, Amsterdam (HdG 36; Burke, *Jan Both*, no. 6, where two other versions are listed), is smaller than the other versions. It is incorrectly entitled *Landscape with the Ponte Molle* in *All the Paintings of the Rijksmuseum in Amsterdam*, 1976, no. A51.

8. Rijksmuseum, Amsterdam (HdG 52; Burke, *Jan Both*, no. 3, where an etched and a painted version are listed).

9. An example by Both is the *Italian Landscape*, oil on copper, 51 x 70 cm., The Hague, Mauritshuis. Others whose attributions are less secure are the paintings sold as Both in Amsterdam, Mak van Waay, October 31, 1967, no. 38; in Berlin, Galerie Stumpf, May 7, 1918, no. 85 (HdG 39); *Tivoli with the Ponte Lucano* in a private collection in Scotland, by a follower of Both; and *Italian Landscape with a Bridge and a Round Tower*, Basel, Oeffentliche Kunstsammlung, attributed to Both, but by a weak imitator or follower.

10. By Wijk, a drawing in the Graphische Sammlung in Munich, inv. no. 1896 (W. Wegner, *Katalog der Staatliche Graphischen Sammlung München*, 1973, no. 1087, where drawings of this subject by other artists are listed). A drawing with Paul Brandt, Amsterdam, attributed to Both but apparently by de Heusch, is clearly based on our composition. Also by de Heusch, paintings in the Rijksmuseum (no. A149) and in the Museum of Fine Arts in Budapest (no. 578); a painting sold in Amsterdam (P. Brandt, November 5, 1968, no. 73) and another from the collection of Viscount Barrington (with D. A. Hoogendijk, Amsterdam, in 1937, oil on canvas, 45 x 66 cm.). By Gaspar Dughet, a painting at the Galleria Doria Pamphili in Rome representing the bridge in its true setting but with the tower too well preserved. The Ponte Lucano and the Tomb of the Plautii seem also to have inspired ruins in the drawings connected with Claude Lorrain's *Pastoral Landscape* of 1677 in the Kimbell Art Museum, Fort Worth, Texas. See Marcel Röthlisberger, *Claude Lorrain: The Drawings*, Los Angeles, 1968, vol. 1, pp. 405–6, nos. 1102–5, vol. 2, figs. 1102–5, and Röthlisberger, *Claude: Paintings*, pp. 445–47, vol. 2, fig. 311. Another representation of the site is included in the *Liber Veritatis*, vol. 2, no. 74, "certainly not by Claude" (Röthlisberger, *Claude: Drawings*, pp. 428–29).

11. One is a drawing in the Museum of Fine Arts in Budapest dated 1643 (Burke, *Jan Both*, D–10); the other the *Landscape with Mercury and Argus*, Munich, Bayerischen Staatsgemäldesammlungen (Burke, *Jan Both*, no. 79), which is dated 1650 according to Burke and 1651 according to Blankert, who notes that the last digit is difficult to read (*Italianiserende landschapschilders*, p. 128).

12. Amsterdam, Rijksmuseum, no. A49; Burke, *Jan Both*, no. 2.

13. London, National Gallery, no. 1917; Burke, *Jan Both*, no. 55.

14. Paintings of about the same date are *Rocky Italian Landscape with Herdsmen and Muleteers*, London, National Gallery (Burke, *Jan Both*, no. 50); and *Landscape with Travelers*, Paris, Louvre (Burke, *Jan Both*, no. 87).

Dirck de Bray
active about 1651–80

Although he belonged to a famous family of artists in Haarlem, little is known about Dirck de Bray, son of Salomon (1597–1664) and brother of Jan (about 1627–97) and Joseph (d. 1664). Dirck de Bray was a Catholic, like the rest of his family, and eventually joined a monastery in Brabant. In 1651 he entered the workshop of Passchier van Wesbuch as a student of bookbinding and printing. He began his prolific production of etchings, engravings, and woodcuts soon thereafter with various book illustrations and title pages for a political journal. Renowned as the greatest woodcut artist of his day, de Bray executed hundreds of labels and tradesmen's cards, as well as series of the months of the year, portraits, and religious subjects. He was employed by Enschede, the Haarlem bookmaking firm, where many of his blocks are still preserved today. Prints by de Bray are known from 1656 to 1676. His career as a painter was apparently confined mostly to the 1670s. His paintings, numbering fewer than a dozen, include flower and game subjects as well as still lifes with religious symbols.

6

Flowers in a Glass Vase

Signed and dated, lower left: 1671 D D Bray f
Oil on wood, 19 x 14³/₈ in. (49.1 x 36.6 cm.)

Collections: Sale, London, Sotheby, February 25, 1948, no. 92 (as dated 1673); [Duits, London]; Sidney van den Bergh; Wassenaar; [G. Cramer, The Hague].

Exhibitions: Laren, Singer Museum, *Twee Nederlandse collecties schilderijen . . .* , 1954, no. 31, repr.; Leyden, Stedelijk Museum 'de Lakenhal,' *17de eeuwse meesters uit Nederlandse particulier bezit*, 1965, no. 6 (as dated 1673); San Francisco, California Palace of the Legion of Honor; Toledo Museum of Art; Boston, Museum of Fine Arts, *The Age of Rembrandt*, 1966–67, no. 102, repr. (as dated 1673).

References: W. Bernt, *Die niederländischen Maler des 17. Jahrhunderts*, 1, Munich, 1962, no. 38, repr.; A. B. de Vries, "Old Masters in the Collection of Mr. and Mrs. Sidney van den Bergh," *Apollo* 80, 1964, pp. 354–55, pl. II (as dated 1673); A. B. de Vries, *Verzameling Sidney J. van den Bergh*, Wassenaar, 1968, p. 30, repr. (as dated 1673); L. J. Bol, *Landschaften und Stilleben holländischen Maler. Nahe den Grossen Meistern*, Braunschweig, 1968, p. 334, fig. 302; W. Bernt, *The Netherlandish Painters of the Seventeenth Century*, 1, London, 1970, no. 178, repr.; W. Bernt, *Die niederländischen Maler und Zeichner des XVII. Jahrhunderts*, 1, Munich, 1979, no. 192, repr.

A shaft of light plays over de Bray's blossoms, illuminating some while others are consumed by the shadow. De Bray barely describes the background; rather, he evokes the setting of the vase entirely through the fluctuation of

FIGURE 1. Dirck de Bray, *Portrait of Salomon de Bray*, 1664. Woodcut, 2nd state of 3. Amsterdam, Rijksprentenkabinet.

Salomon de Bray, Schilder en Bouwmeester, tot Haerlem.

light and dark in a manner closer to Goya's sensitive treatment of light in the next century than to that of any of his contemporaries.

Our panel is one of the earliest paintings by de Bray, who until the decade beginning in 1671 had worked as a printmaker specializing in woodcuts.[1] Many of de Bray's prints show an interest in painterly effects (fig. 1)[2] and in the manipulation of light and dark, which was carried

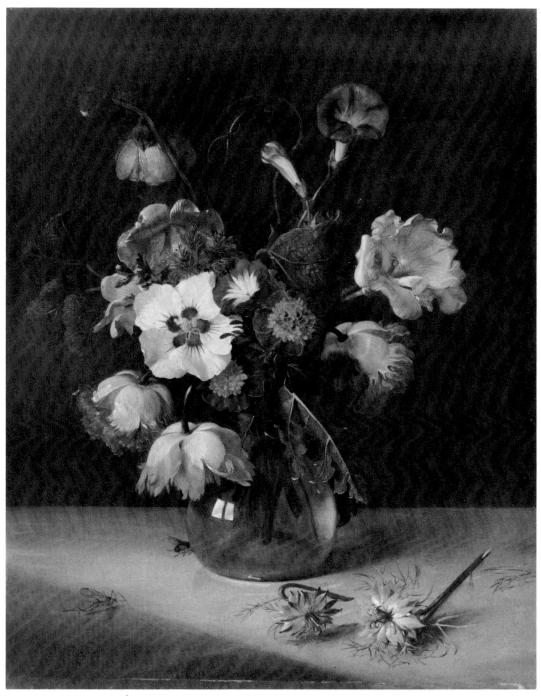

CATALOGUE NUMBER 6

25

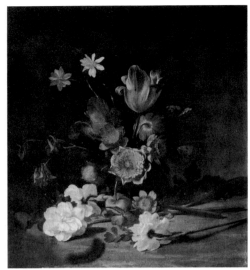

FIGURE 2. Dirck de Bray, *Still Life of Tulips, Narcissi, and Other Flowers*, 1671. Oil on wood, 16 x 13 1/2 in. (40.6 x 34.3 cm.). Sale, London, Christie's, June 21, 1968, no. 91. Photograph courtesy of Christie's, London.

over into his paintings. Nowhere is the treatment of illumination more striking than in this panel. The nearly empty foreground becomes a field for the shaft of light flooding the velvety shadows. In a painting of 1671 (fig. 2) in which the foreground is filled with books, the light is more direct. Later, in a *Still Life with Flowers in a Porcelain Vase* of 1674 (fig. 3) and in another work from that year,[3] de Bray again devotes the foreground entirely to the play of light and shadow. The later painting (fig. 3) also shares with the Carter panel the motif of an insect crawling out of the shadow and a similar repertoire of flowers, though more compactly grouped.

It is difficult to trace a development in de Bray's brief career as a painter; if anything, he seems to adopt a harder, firmer touch in his later works. The soft, fluid technique of the Carter panel disappears. The contrast of light and dark remains a primary interest of the artist but never again plays such a significant role in the composition.

Seventeenth-century Dutch flower paintings frequently contain symbols of *Vanitas*. Flowers themselves, especially overripe or drooping flowers such as the poppies in the lower left and right of the Carter painting, could recall the passage of time and the inevitable decay of natural beauty.[4] There may be a particular significance attached to the limp opium poppies in this painting, for these flowers were long associated with night and sleep.[5] All of the species in this painting flower at the same time of the year, but some open and close at different times of day. The

FIGURE 4. Dirck de Bray, *Still Life with Crucifix*, 1678. Oil on wood, 19 1/4 x 14 5/8 in. (49 x 37 cm.). Zwolle, Provinciaal Overijssels Museum.

morning glory, the uppermost blossom to the left of center and in the center of the arrangement, shuts its flowers during the afternoon. If de Bray intended to refer to the passage of time in this painting, he did so through the allusion to night and day as represented by the flowers and echoed in the interplay of light and dark.

This subtle symbolic content contrasts with de Bray's religious still lifes, in which he includes scepters, cruci-

fixes, and other signs of the Catholic church (fig. 4);[6] it differs also from the more obvious symbolic language of Bosschaert (see cat. no. 4). The Carter painting contains none of the flowers with familiar religious connotations, such as the iris symbolizing the Immaculate Conception[7] or the narcissus signifying resurrection.[8] De Bray also omits such precious or exotic species as tulips or hyacinths. The familiar symbol of sin, the fly,[9] is present, but perhaps simply as a naturalistic detail. The insect does not devour the flowers but merely crawls behind the vase.

De Bray emerges as a mature and original master in the Carter still life, which is one of his earliest paintings, if not the first. The sources of his style are not at all obvious. Hans Bollongier (1600–1670), the only other flower specialist in de Bray's native Haarlem, and also Jan Davidsz. de Heem have been suggested as influences,[10] but their connection to de Bray is difficult to see. It seems just as likely that de Bray was influenced by the Flemish artist Daniel Seghers (1590–1661) both in his choice of flowers in a glass vase as a subject for nearly half his paintings and to a limited degree in his style as a flower painter. Like de Bray, Seghers was a devout Catholic who joined a monastery. His still lifes of flowers in a glass vase (fig. 5)[11] are frontal compositions without de Bray's luminous atmo-

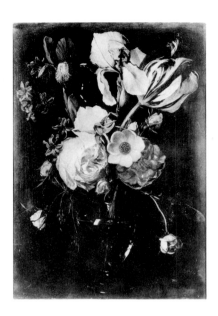

FIGURE 5. Daniel Seghers, *Vase of Flowers*. Oil on copper, 11 x 8¼ in. (28 x 21 cm.). Antwerp, Museum Mayer van den Bergh. Copyright A.C.L. —Brussels.

sphere, but their loose arrangements, curling petals, and downward-hanging blossoms anticipate the Carter painting. The Jesuit Seghers, the most famous flower painter of his day, might well have provided a sympathetic model for the aspiring young de Bray.

1. In the literature 1678 is given as the date of de Bray's last painting (Moes in Thieme-Becker, p. 554; Bernt, *Netherlandish Painters*, 1, p. 18; Bol, *Landschaften und Stilleben*, p. 289). A canvas, signed and dated 1680 known to us only from a photograph, appeared recently in a sale in Brussels (Palais des Beaux-Arts, November 19–20, 1968, no. 66).

2. F. W. Hollstein, *Dutch and Flemish Engravings, Etchings and Woodcuts, 1450–1700*, vol. 3, Amsterdam, 1949–, no. 122. The woodcut is after a drawing by Jan de Bray in the Kupferstichkabinett in Berlin (E. Bock and J. Rosenberg, *Die Niederländischen Meister im Kupferstichkabinett*, Berlin, vol. 2, 1930, pl. 73).

3. *Bouquet in a Glass Vase*, 1674, oil on wood, 40.6 x 34.3 cm., formerly Nystad, The Hague.

4. This connection is made explicit in a painting attributed to Jan Brueghel the Elder, *Still Life with Flowers in a Glass Vase* (see Bosschaert, cat. no. 4, fig. 2). On *Vanitas* in flower paintings, see Münster,

Stilleben in Europa, pp. 304–12, 318–22; and Ingvar Bergström, "Disguised Symbolism in 'Madonna' Pictures and Still Life," *Burlington Magazine* 97, 1955, pp. 303–8, 340–49.

5. Dr. Sam Segal kindly identified the flowers. His forthcoming book on Cornelis van Spaendonck will contain a discussion of the poppy in literature and art.

6. Examples are *Still Life with Symbols of the Virgin Mary*, 1672, Amsterdam, Amstelkring Museum, and the *Still Life with Crucifix* in Zwolle (fig. 4).

7. Münster, *Stilleben in Europa*, p. 308.

8. Ibid., p. 316.

9. Bergström, "Disguised Symbolism," p. 346.

10. Bol, *Landschaften und Stilleben*, p. 334.

11. M. L. Hairs, *Les peintres flamands de fleurs au XVIIe siècle*, Brussels, 1955, pp. 233–40, for other examples.

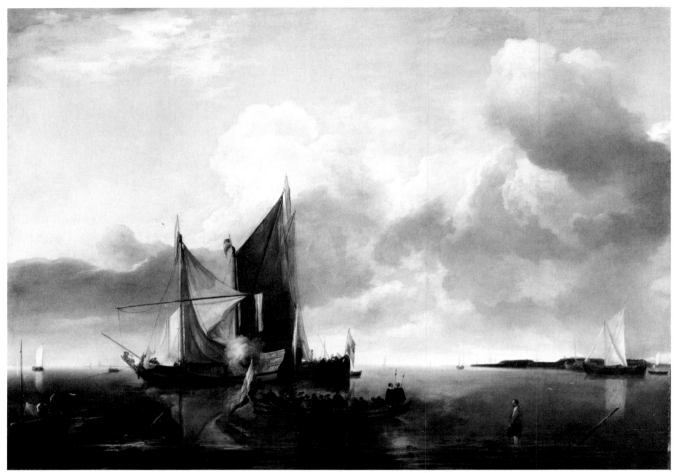

CATALOGUE NUMBER 7

Jan van de Cappelle
1624/26–1679

Jan van de Cappelle's birthdate is unknown, but he was reported to be about forty-two years old in November 1666. He was born in Amsterdam, obtained citizenship upon his marriage in 1653, and apparently lived his entire life there. His share in his father's successful dyeworks and his substantial properties gave him a financial and social position enjoyed by few artists. He amassed a vast art collection that included nine paintings and more than a thousand drawings by de Vlieger, hundreds of drawings by Avercamp, Rembrandt, and van Goyen, and paintings by Dürer, Elsheimer, Jordaens, Rubens, Porcellis, Seghers, and Hals, among others. Van de Cappelle had his portrait painted by Rembrandt, Hals, and Eeckhout.

Views of rivers and estuaries with calm waters and stately ships form the bulk of van de Cappelle's production, but he also painted a few marines and beach scenes with choppy seas and about fifty winter landscapes. According to Eeckhout, van de Cappelle was self-taught. De Vlieger no doubt influenced his early style, but it is difficult to distinguish the innovations of these two artists in the late forties when both were producing silvery-gray marines with still waters and shimmering light. After about 1650 van de Cappelle's sunlight is conveyed with a variety of colors that lend an overall warm, golden tonality to many of his pictures. His later development is not easy to trace since there are only a few dates for paintings after 1653. A few drawings and one etching by van de Cappelle are known. The artist was widely admired in Holland and England in the eighteenth and nineteenth centuries and had many later followers and imitators.

7

Ships in a Calm

Oil on canvas, 30 1/8 x 42 7/8 in. (79 x 109 cm.)

Collections: Mssrs. Murrieta (their sale, London, Christie's, May 14, 1892, no. 126); [P. & D. Colnaghi, London (?)]; R. D. Walker, London (his sale, London, Christie's, July 1, 1907, no. 147, as "Dutch School"); [H. Buttery, London]; J. Wythes, Copped Hall, Essex; Major Elwes, Oxfordshire; Colonel F. G. R. Elwes (his sale, London, Sotheby, March 26, 1969, no. 26); [David Koetser, Zurich].

References: HdG 123; Margarita Russell, *Jan van de Cappelle*, Leigh-on-Sea, 1975, p. 78, no. 123, fig. 86.

The painting represents a barge, which was used to row important personages to and from ships, and several single-masted sailing vessels in the background. One of them is a yacht which fires a salute, doubtless to honor the party aboard the barge. In the foreground at left and right fishermen pause to regard the passing barge in attitudes of respect.

The Carter painting is an especially successful and well-preserved example of a type of seascape that van de Cappelle apparently began to paint in 1645,[1] in which ships are becalmed on a broad expanse of water dominated by a lofty sky and massive clouds. His first pictures are populated by a profusion of ships, big and small, and he continued to paint these so-called "parade" compositions from time to time throughout his career; by 1650 he had made prominent use of the motif of the barge and its important passengers saluted by ships of the fleet (fig. 1),[2] as Simon de Vlieger had also done a year earlier.[3] In the 1650s he also painted a number of calms with many fewer ships, mostly ordinary small transport vessels and the occasional yacht and barge, which lack the pomp and intricacy of his great showpieces. To this category of simpler compositions the Carter picture belongs; but the touch of cere-

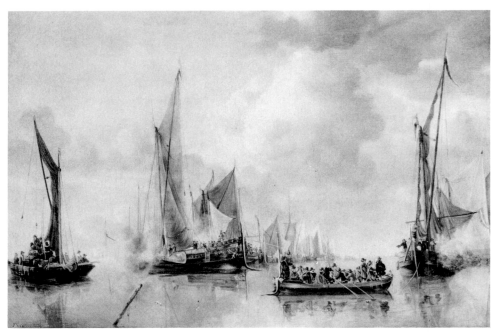

FIGURE 1. Jan van de Cappelle, *The Home Fleet Saluting the State Barge*, 1650. Oil on wood, 25 1/4 x 36 3/8 in. (64 x 92.5 cm.). Amsterdam, Rijksmuseum.

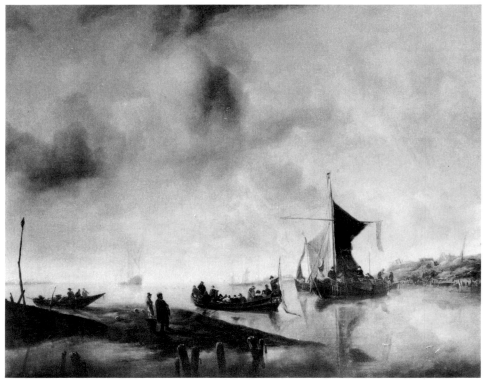

FIGURE 2. Jan van de Cappelle, *View off the Dutch Coast*. Oil on canvas, 30 x 35 in. (76.2 x 88.9 cm.). Rochester, Memorial Art Gallery of the University of Rochester, George Eastman Collection of the University of Rochester.

30

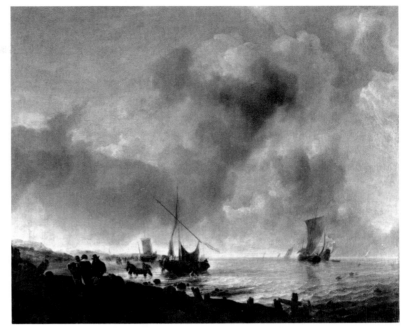

FIGURE 3. Jan van de Cappelle, *Ships off the Coast*, 1651. Oil on canvas, 28½ x 34¼ in. (72.5 x 87 cm.). The Hague, Mauritshuis.

moniousness lent by the salute of the barge, and reinforced by the fishermen spectators, distinguishes it from the paintings most nearly related to it, such as the well-known work in Toledo which is similarly composed[4] and the canvas in Rochester (fig. 2) in which bystanders are used in the same fashion.[5]

The sky in the Carter painting is one of van de Cappelle's most impressive creations. Taking his example from Porcellis (cat. no. 18) and de Vlieger, Cappelle developed a repertory of effects unsurpassed by any Dutch artist; like other painters he often echoed the general arrangement of the ships and land in the cloud formations, but his skies have an unprecedented power and boldness of design. In the great beach view of 1651 in the Mauritshuis (fig. 3)[6] he had already employed a pattern of massive, upswept clouds like those on the right side of the Carter picture, but in the latter the low-lying horizontal bank of clouds at the left, dramatically back-lighted, introduces a new note. The splendid complexity of the sky, its luminosity echoed in

the water, is a major achievement. Stechow devoted a passage to another picture by van de Cappelle that could apply to this one:

Van de Cappelle's picture is based on "luminous tonality".... The picture is essentially restricted to a gamut extending from grey to brown . . . but at the same time, this tonality, far from being of the more graphic and somewhat schematized type favoured by the artists of the thirties and forties, exhibits a silky, all-pervading luminous sheen which results in the impression that the entire scene is steeped in moisture. . . . Once more, Jan van de Cappelle emerges as one of the great representatives of a true *ars nova*; again his new achievement is based on new optical discoveries; again, it is not the discoveries that automatically result in a new style; again, it is not sight alone but sight coupled with insight that counts, and accounts for this miracle.[7]

Although it is often difficult to date paintings by van de Cappelle with much confidence, this one would seem to belong to the first half of the 1650s, a period from which there are a number of dated pictures of comparable tonality and handling.[8]

1. The painting in the Robarts collection, London, is indeed dated 1645 according to Russell (*Cappelle*, pp. 21–22, 36, fig. 1); HdG 50; see also Stechow (*Dutch Landscape Painting*, p. 117), who was cautious about accepting the date.

2. HdG 17; Russell, *Cappelle*, pp. 22–23; and L. J. Bol, *Die holländische Marinemalerei*, Braunschweig, 1973, pp. 224–25.

3. In the painting in the Kunsthistorisches Museum, Vienna (inv. no. 478; Bol, *Marinemalerei*, pp. 186–87, fig. 190; and Russell, *Cappelle*, p. 21, figs. 2, 2a).

4. HdG 24; Stechow, *Dutch Landscape Painting*, p. 118, fig. 232.

5. Russell, *Cappelle*, p. 89, no. 7, fig. 91 (not in HdG).

6. HdG 133; Stechow, *Dutch Landscape Painting*, pp. 106–7, fig. 212; Russell, *Cappelle*, p. 28, fig. 19; and most recently the Mauritshuis catalogue *Hollandse schilderkunst. Landschappen 17de eeuw*, The Hague, 1980, pp. 19–20, where the reappearance during cleaning of a signature and the date 1651 is reported.

7. Stechow, *Dutch Landscape Painting*, p. 107, on the Mauritshuis painting (see note 6).

8. For example, the paintings of 1653 (HdG 51; formerly Lady Wantage; Russell, *Cappelle*, fig. 13) and of 1652 (not in HdG; formerly Spencer-Churchill collection; Russell, *Cappelle*, p. 89, no. 3, fig. 11).

Pieter Claesz.
1597/98–1661

Pieter Claesz. was born in Burgsteinfurt in Westphalia in 1597 or 1598. Few facts about his life are known. His birthdate has been surmised from a document of 1640 that gives his age as forty-three. By the time of his marriage in 1617 he was living in Haarlem, where he seems to have settled, where his son Nicolaes Claesz. Berchem was born in 1620, and where Pieter died in 1661. Dated paintings by Claesz. span nearly forty years, from 1621 to 1660. Houbraken reports that Claesz. began by painting fish studies and small still lifes. His teacher is unknown, but his earliest paintings follow in the tradition of the previous generation of "breakfast" still-life painters such as Floris van Dyck and Clara Peeters. Throughout his career Claesz. alternated between a loose painterly style that may have been influenced by his townsman Frans Hals and a more finely detailed technique. In the 1620s Claesz. together with W. C. Heda (cat. no. 12) introduced a new and original type of still life, remarkable for its modest subject matter of simple foods and vessels, its attention to light and atmosphere, and its reduced range of color. Following the revived demand for elaborate, richly colored still lifes in the 1640s, Claesz. introduced into his compositions expensive objects, touches of local color, and such decorative elements as a leafy vine. He continued, however, to paint modest compositions for about ten more years. Pieter Claesz.'s pupils include his son Nicolaes Claesz. Berchem, who painted landscapes, portraits, and historical subjects but never a still life, and Roeland Koets, a specialist in fruit still lifes who occasionally collaborated with his master.

8

Still Life with Herring, Wine, and Bread

Signed and dated, right: PC (joined)/1647
Oil on wood, 17 1/2 x 23 1/4 in. (44.5 x 59 cm.)
Collections: Private collection, The Netherlands; [J. Hoogsteder, The Hague, 1980].
References: N. R. A. Vroom, *A Modest Message as Intimated by the Painters of the "Monochrome Banketje,"* Schiedam, 1980, vol. 1, p. 47, fig. 55, vol. 2, p. 34, no. 141.

The subject is a breakfast of herring, bread, and wine, which the artist displays with a vine branch, currants, a lemon, and some nuts. These are the typically simple ingredients of a class of still-life painting that grew to great popularity during the 1620s and 1630s, spurred by the example of Claesz. and W. C. Heda (cat. no. 12), and was practiced by a whole generation of artists.[1] Earlier table still lifes had generally been colorful and abundant in the display of vessels and varieties of food; they were sym-

metrical and seen from a relatively high vantage point to allow a better view. Claesz. and the painters of his generation reduced color and concentrated on tonal relationships; they eliminated all but a simple repertory of objects, gave the table a well calculated disorder, and brought down the viewpoint to foreshorten objects and complicate the play of form. Their still lifes have much in common with the tonal dune landscapes and river views of van Goyen and Salomon van Ruysdael (cat. nos. 11 and 22), the genre scenes of Dirck Hals, and the church interiors of Saenredam (cat. no. 23), all of which reflect the sober, reductive aesthetic that dominated much of Dutch art, especially in Haarlem, for a quarter-century.

This picture by Claesz. comes at the end of the period when sobriety of content and style were the rule in still

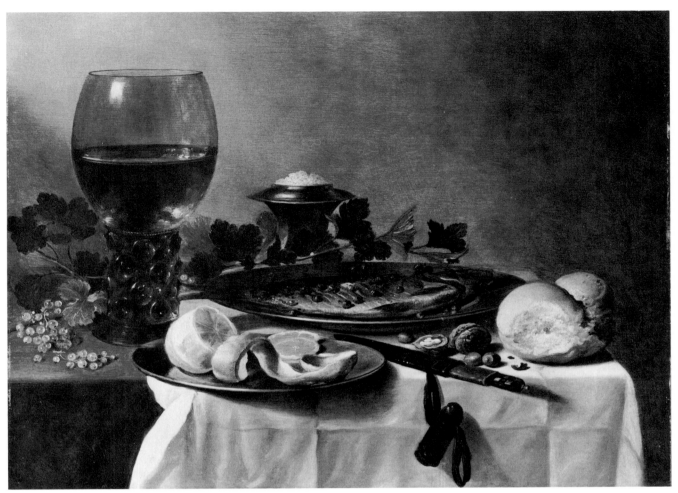

CATALOGUE NUMBER 8

33

FIGURE 1. Pieter Claesz., *Still Life*, 1642. Oil on wood, 23⅝ x 32⅞ in. (60 x 83.5 cm.). Moscow, Pushkin Museum of Fine Arts.

FIGURE 2. Pieter Claesz., *Still Life*, 1647. Oil on wood, 25¼ x 32¼ in. (64 x 82 cm.). Amsterdam, Rijksmuseum.

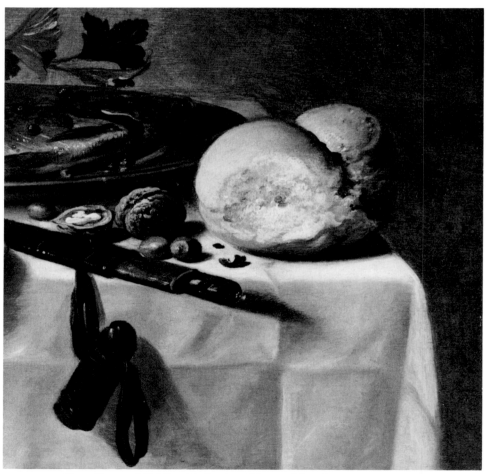

FIGURE 3. Pieter Claesz., *Still Life with Herring, Wine, and Bread* (detail).

34

life and, in fact, was painted at a time when sumptuous display was again in fashion. It belongs to a group of paintings by Claesz. that might be considered the last great expression of his genius. Claesz. had used all these ingredients—among others the same *roemer*, pewter plates, knife, and knife case—in paintings more than two decades earlier, and in 1642 he had reassembled them into an impressive composition now in the Pushkin Museum, Moscow (fig. 1).[2] Five years later, in 1647, he painted at least four variations on the theme, substituting certain objects at will and rearranging them somewhat, while retaining the basic layout. The best-known is in the Rijksmuseum, Amsterdam (fig. 2); in it the dangling lemon peel and rumpled tablecloth cause the design to spill over the edge, and the dish of peppercorns perched on the salt lends a note of instability. The pictures in Bremen and Budapest[3] introduce a ham and a pie and have a greater air of movement and disorder. The Carter painting, in contrast, is the most serene of the group: the objects lie flat, none disturbs its neighbor, and the forms may be read clearly. Claesz. created an intricate pattern of ovals by foreshortening all the circular shapes; at the same time he insisted on the illusions of volume and space by such familiar devices as the peeled lemon and the knife that juts over the table edge. His rich, lustrous paint, applied fluidly and rather broadly, not only evokes the textures of the simple foods but also has a direct sensual appeal of its own (fig. 3). Manipulated with the greatest subtlety, the diffuse, raking light defines the objects and at the same time softens their shadows.

1. The term *monochrome banketje* has been in general use for most painted still lifes of food, drink, and related objects from about 1620 onward, ever since the appearance of N. R. A. Vroom, *De schilders van het monochrome banketje*, Amsterdam, 1945 (expanded and republished as *A Modest Message as Intimated by the Painters of the "Monochrome Banketje,"* 2 vols., Schiedam, 1980). A recent attempt to coin more accurate terminology would classify most pictures of this type by Heda and Claesz. as "presentations of riches" (Münster, *Stilleben in Europa*, exh. cat., 1979–80, pp. 408, 420–28).

2. Inv. no. 580; N. I. Romanov, "Dutch Still-life Painting in the Moscow Museum of Fine Arts," *Art in America* 20, 1932, p. 172.

3. Oil on wood, both signed and dated 1647; the Bremen painting is 50.5 x 71 cm., the Budapest painting 63.5 x 88 cm. (Vroom, *A Modest Message*, vol. 1, figs. 31, 56). An undated but similar composition, probably of this period, is in the Hermitage, Leningrad (oil on wood, 40 x 61 cm., Vroom, *A Modest Message*, vol. 2, p. 33, no. 137, repr.).

Adriaen Coorte
active 1683–1707

Practically nothing is known about Adriaen Coorte's life. His name appears on one document, the annual records of 1695–96 for the Guild of St. Luke in Middelburg, in which Coorte, who was not enrolled as a free master, was fined for selling his paintings. On the evidence of this document and the fact that so many of his paintings were sold in Middelburg in the eighteenth century, it is assumed that Coorte lived in or near this city. Dated paintings are known from 1683 to 1707. His work consists entirely of still lifes of various types, including fruits, vegetables, flowers, shells, game, and *Vanitas* subjects. His simple, austere style is unique, but his smooth surfaces and soft translucent colors accord with late seventeenth-century taste.

9

Wild Strawberries in a Wan Li Bowl

Signed and dated on table ledge, lower left: A Coorte/1704
Oil on paper, mounted on wood, 11⅝ x 8⅞ in. (29.5 x 22.5 cm.)
Collections: [J. Goudstikker, Amsterdam, 1933]; Sale, London, Christie's, June 28, 1974, no. 76, repr.
Exhibition: Amsterdam, J. Goudstikker, *Het stilleven*, 1933, no. 68.
References: L. J. Bol, "Adriaen Coorte, stillevenschilder," *Nederlands Kunsthistorisch Jaarboek* 4, 1952/53, p. 220, no. 38, repr.; L. J. Bol, *Adriaen Coorte*, Assen and Amsterdam, 1977, no. A57, repr.

Apparently little appreciated in the eighteenth and nineteenth centuries and ignored by critics from Houbraken to Fromentin, Coorte has only been recognized as a gifted and original master within the last thirty years.[1] When it was shown in a dealer's exhibition in 1933, *Wild Strawberries in a Wan Li Bowl* was one of the first paintings to bring this all-but-forgotten artist to light.[2] Coorte was truly an artist for whom less meant more. In his most typical paintings he reduces subject matter to a bare minimum; the beauty of his light, atmosphere, and texture saves his simple subjects from becoming boring or pedantic.

The sparse composition and the melting light and shadow in the Carter painting are hallmarks of Coorte's mature style. In his early painting of 1685 (fig. 1), a bowl of strawberries[3] forms part of a more elaborate composition with a curtain and branch hanging over the ledge, invading the space between the viewer and the objects represented.[4] By 1696 Coorte could focus solely on a bowl of strawberries (fig. 2), although he still included the device of the overhanging sprig. The light falls directly on the fruit,

illuminating the entire bowl and setting it off sharply against the background. In the Carter painting, by contrast, and in a variant of the same year that has recently reappeared,[5] the light filters through the dark shadow, revealing only part of the design and leaving the rest obscure. This shifting light is used most eloquently in Coorte's

FIGURE 1. Adriaen Coorte, *Bowl with Strawberries, Gooseberries, and Asparagus on a Stone Ledge with Draped Velvet Cloth*, signed and dated 1685. Oil on canvas, 16½ x 17⅜ in. (42 x 44 cm.). Sale, London, Christie's, April 10, 1970, no. 67. Photograph courtesy of Christie's, London.

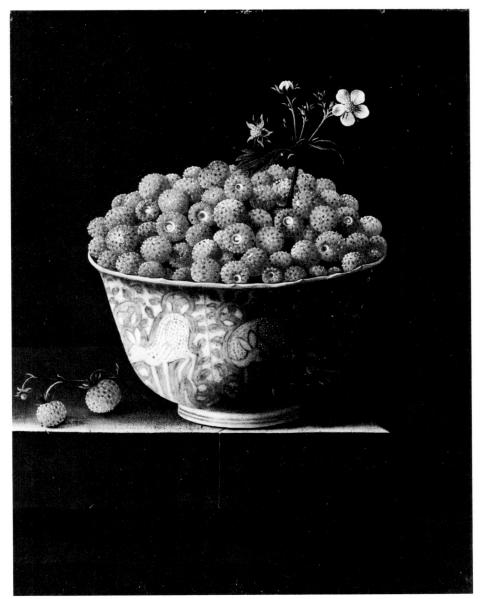

CATALOGUE NUMBER 9

FIGURE 2. Adriaen Coorte, *Bowl with Strawberries*, signed and dated 1696. Oil on paper mounted on wood, 10⅛ x 8¾ in. (25.7 x 22.2 cm.). Cothen, heirs of W. F. van Beeck Calkoen.

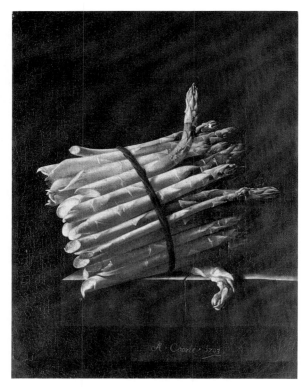

FIGURE 3. Adriaen Coorte, *Asparagus*, signed and dated 1703. Oil on canvas, 11¾ x 9 in. (29.8 x 22.8 cm.). Cambridge, Fitzwilliam Museum.

FIGURE 4. Jakob van Hulsdonck, *Bowl of Strawberries*. Oil on copper, 11 x 13½ in. (28 x 34.3 cm.). Formerly Marjorie W. Prescott (Sale, New York, Christie's, January 9, 1981, no. 13). Photograph courtesy of Christie's, New York.

last works, which represent no more than pieces of fruit on a ledge.[6]

Like Chardin a generation later, Coorte concealed a great deal of careful calculation behind an appearance of simplicity and accident. In the Carter painting the playful flower sticking up from the bed of berries and the two berries on the ledge animate the composition and also lend it balance. Similar accents appear in other works by Coorte; two examples are the curved asparagus at the top and bottom of the bunch in the still life of 1703 in the Fitzwilliam Museum (fig. 3) and the two berries in a painting from 1705 of strawberries on a ledge.[7]

In content and composition, Coorte seems to have been inspired by the much earlier still lifes with Chinese bowls, strawberries, and blooming sprigs by the Antwerp painter Jakob van Hulsdonck (1582–1647), which are, however, symmetrical and viewed from a higher vantage point (fig. 4).

Coorte painted strawberries in a bowl throughout his career, but he used this decorated porcelain bowl only once, in the Carter painting. A plain reddish-brown earthenware vessel of the type used to carry fruits to the market usually holds the berries (fig. 2). The Wan Li bowl in our painting belongs to a common type of porcelain made by the thousands during the Ming dynasty (1573–1619). The scalloped rim signifies a product made for export.[8] The artist may have included the bowl to please a particular client, but since nothing is known about Coorte's patrons, such ideas remain only speculation. Coorte may also have chosen the bowl to act as a foil for the fruit; its pale blue-green tones stand out in the light and accentuate the bright red berries, and the shadowed side fades and blends with the brown background.[9] The detailed rendition of the design of the bowl matches that of the fruit and flowers, and the dots of the deer's fur are echoed in the seeds catching the light on the strawberries.

1. L. J. Bol is responsible for the rediscovery of Coorte. See the publications listed under "References" and his catalogue for the exhibition *Adriaen Coorte stillevenschilder*, Dordrecht, 1958.

2. Amsterdam, *Het stilleven*, exh. cat., 1933, no. 68. At that time the only painting by Coorte that had been publicly exhibited was the *Bundle of Asparagus* (Amsterdam, Rijksmuseum; Bol, *Coorte*, no. A25), which had been shown in *La nature morte hollandaise*, Brussels, Palais des Beaux-Arts, 1929, no. 124, pl. 49.

3. Dr. Sam Segal has kindly informed us that the fruit in our painting, identical to that in the 1685 still life, is technically a wild strawberry, *Fragaria vesca*. According to Bol the name is deceptive because this type of berry was cultivated in Coorte's time (*Coorte*, p. 18).

4. Another painting from 1685 represents a bowl of strawberries in an elaborate composition set in a niche (Bol, *Coorte*, no. A3).

5. *Strawberries in an Earthenware Bowl*, signed and dated 1704, paper on wood, 28.5 x 22.2 cm., D. Koetser, Zurich (L. J. Bol, "Goede onbekenden," *Tableau* 3, 1980, p. 135, repr.).

6. Examples are Bol, *Coorte*, nos. 64–70.

7. Ibid., no. 67.

8. The authors are indebted to John Pope and Tom Wu for information about the bowl.

9. The support, paper on wood, accentuates the density of the background color. On the shadowed side of the bowl the blue-gray paint stands out in relief, possibly the result of a build-up of medium to make the colors more translucent.

Aelbert Cuyp
1620–1691

Born in Dordrecht in 1620, Cuyp lived there until his death in 1691. His drawings and paintings indicate that he visited other parts of the country, but apparently he never left Holland. Cuyp's development is not entirely understood, since dated works are known only from 1639, 1641, and 1646, and he was probably active until 1670. First trained in the studio of his father, the portraitist Jacob Gerritsz. Cuyp, Aelbert Cuyp treated a broad range of subjects in his early works, including still lifes, landscapes and interiors with figures, as well as landscapes. Cuyp's first landscapes are somewhat awkward assemblages of parts, with detailed vegetation and prominent dark foregrounds. Soon afterwards he adopted the yellow-brown tonality and vigorous brushwork of van Goyen's paintings of the later thirties. During the 1640s Cuyp seems to have spent time in Utrecht, where Cornelis van Poelenburgh, Gysbert d'Hondecoeter, and most importantly Jan Both influenced the development of his Italianate landscape style. Inspired by Both's compositions and his golden sunshine, Cuyp introduced the moist atmosphere and clear, tinted light that distinguished his works from those of other painters of Italianate scenes and that were to earn him enormous fame in the eighteenth and early nineteenth centuries. Cuyp's landscape style gradually became more refined in the 1650s and 1660s and his portraits more formal and elegant. In 1658 Cuyp married the wealthy widow Cornelia Boschman, a union that elevated his social status and assured him financial comfort for life. By about 1670 Cuyp's output seems to have slackened. He apparently spent his last twenty years as a respected citizen of Dordrecht, serving in a number of important civic positions.

10

The Flight into Egypt

Signed, lower left: A. Cuyp
Oil on wood, 26¾ x 35¾ in. (67.5 x 91 cm.)

Collections: Allegedly Royal Collection, Poland (Stanislaus I, died 1766; Stanislaus II, reigned 1764–95); Servad, Amsterdam (his sale, June 25, 1778, no. 48, bought by Yver for 560 florins¹); [Yver, Amsterdam]; Prince Talleyrand, Paris (his sale, July 7, 1817, entire contents bought beforehand by Buchanan); John Webb, London, valued at £1,050; Alexander Baring, later Lord Ashburton, London, by 1819; by descent to the 5th Lord Ashburton, The Grange, Hampshire; Alfred de Rothschild, Halton Manor (1907–18); Rothschild heirs, to 1924; [M. Knoedler, New York]; Charles T. Fisher, Detroit (by 1925); Thomas K. Fisher, Detroit (Sale, Christie's, London, June 28, 1974, no. 79, bought in); [Richard L. Feigen, New York, 1977].

Exhibitions: British Institution, 1819, no. 105 (lent by Alexander Baring); New York, Knoedler Galleries, *Dutch Masters of the XVII Century*, 1925, no. 2, repr.; Detroit Institute of Arts, *The Third Loan Exhibition of Old Masters*, 1926, no. 24, repr.; Detroit Institute of Arts, *Catalogue of a Loan Exhibition of Old and Modern Masters*, 1927, no. 31; Detroit Institute of Arts, *Loan Exhibition of Dutch Genre and Landscape Paint-*

ing, 1929, no. 16; New York World's Fair, *Masterpieces of Art*, 1939, p. 32, no. 66, pl. 77. (*Guide and Picture Book*, fig. 105).

References: W. Buchanan, *Memoirs of Painting*, London, 1824, vol. 2, pp. 321–22, no. 10; Smith, *Catalogue Raisonné*, 1834, vol. 5, pp. 320–21, no. 132; G. Waagen, *Treasures of Art in Great Britain*, London, 1854, vol. 2, p. 110, no. 2; HdG 409; Jerrold Holmes, "The Cuyps in America," *Art in America* 18, 1930, pp. 167, 185, no. 27, fig. 4; W. R. Valentiner, "Dutch Loan Exhibition in Detroit Museum," *Art News*, October 19, 1929, pp. 3ff., repr. p. 8; John Walsh, Jr., "New Dutch Paintings at the Metropolitan Museum," *Apollo* 99, 1974, p. 349, n. 23.

Cuyp's setting evokes the sunny, rugged countryside of Italy, which he never saw. Although Cuyp did not leave Holland, he must have been greatly impressed by paintings of Italy by traveling Dutchmen, in particular Jan Both (see cat. no. 5), and he adopted their compositions, motifs, and particularly their delicately colored light and warm,

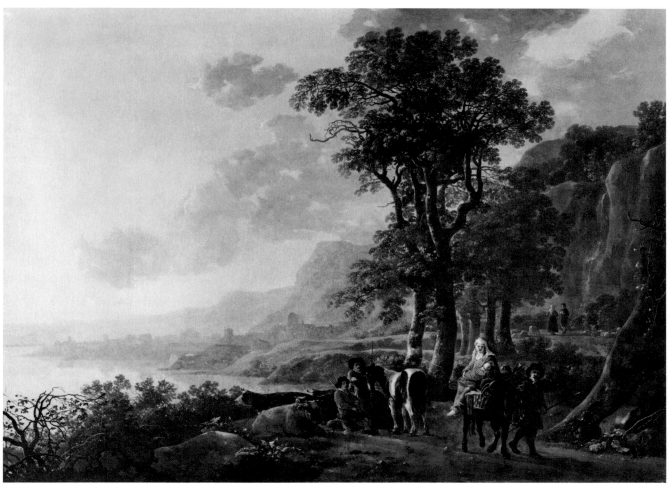

CATALOGUE NUMBER 10

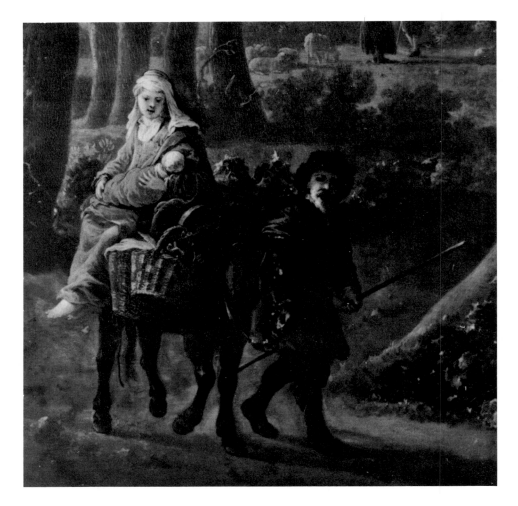

FIGURE 1. Aelbert Cuyp, *The Flight into Egypt* (detail).

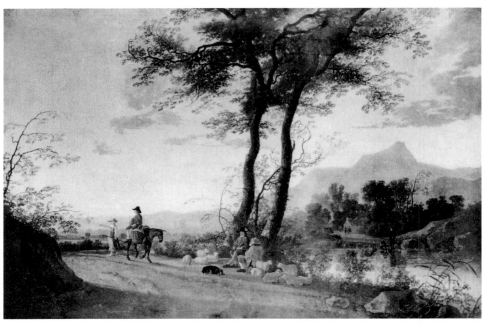

FIGURE 2. Aelbert Cuyp, *A Road near a River*. Oil on canvas, 43³/₄ x 65 in. (111 x 165 cm.). Dulwich, by permission of the Governors of Dulwich College Picture Gallery.

FIGURE 3. Aelbert Cuyp, *The Flight into Egypt*. Oil on wood, 40½ x 60¼ in. (105 x 153 cm.). Sale, Berlin, Goudstikker, March 12, 1941, no. 28. RKD neg. no. 4622.

benign atmosphere.[2] Other Utrecht artists such as Cornelis van Poelenburgh and Gysbert d'Hondecoeter seem to have influenced Cuyp's brilliant sunshine and sharp highlights against dark foliage.[3] Here the golden sunlight invades the whole composition, changing color in the sky, casting long shadows in the foreground, and sparkling on the foliage. Gustav Waagen, after seeing this picture in Lord Ashburton's collection, wrote in 1854 that "the composition itself has something more noble and poetical than is usual with [Cuyp]; to this is added a rare power and energy of foreground with the most delicate gradation of the clear tones to the warm evening sky, so that the picture is one of the most beautiful that ever came from the hand of this master."[4]

The "something more noble and poetical" sensed by Dr. Waagen may derive from the religious subject, which went unnoticed until fifty years ago. The "old Man [leading] an ass on which sits a young woman with a child in her arms"[5] is the Holy Family, whom Cuyp took pains to identify by putting Joseph's saw in the pack on the donkey's back (fig. 1). The shepherds pointing toward them in wonder reinforce the significance of the little family, although the men surely do not know their real identity. It is no surprise that Waagen failed to grasp Cuyp's intention, since the picture is composed like others with ordinary staffage (fig. 2) and since he, like his contemporaries, was unused to such elevated subjects in a painter whom he

regarded as one of the supreme landscapists. Ruskin probably spoke for many when he observed in 1873, "Nothing happens in his pictures except some indifferent person asking the way of somebody else. . . . For further entertainment, perhaps, a red cow and a white one; or puppies at play, not playfully; the man's heart not going even with the puppies. Essentially he sees nothing but the shine on the flaps of their ears."[6]

Cuyp's religious and history paintings were few but significant; they include representations of Bathsheba Bathing, the Conversion of Saul, the Annunciation to the Shepherds, Christ Entering Jerusalem, the Baptism of the Eunuch, Orpheus Charming the Beasts, and perhaps others.[7] He painted no fewer than three versions of the Flight into Egypt, a large panel of the later 1640s (fig. 3), the Carter painting, and a smaller panel of the same period (fig. 4). In both of the other versions an Italianate river valley is the setting through which the Holy Family wends its way unnoticed by the shepherds. Cuyp was adopting an old Netherlandish tradition of representing the Flight into Egypt in a contemporary landscape. Such pictures had been painted by various Flemish and Dutch masters of the fifteenth century, and later by Patinir, Elsheimer, Jan Brueghel, Rubens, Poelenburgh, Bloemaert, and Rembrandt.[8] In 1644 Paulus Potter had put the Holy Family into a fanciful landscape with animals and herdsmen (fig. 5). While certain artists such as Elsheimer, Rubens, and

43

FIGURE 4. Aelbert Cuyp, *The Flight into Egypt*. Oil on wood, 18 x 22⁷/₈ in. (45.7 x 58.1 cm.). New York, Metropolitan Museum of Art.

FIGURE 5. Paulus Potter, *The Flight into Egypt*, 1644. Oil on wood, 18¹/₂ x 25¹/₄ in. (47 x 64 cm.). Formerly New York, Newhouse Galleries.

44

Rembrandt followed the biblical text (Matthew 2:13–15) and set the scene at night, creating landscapes full of subtle threats, others like Potter and Cuyp chose daylight and more kindly surroundings. Cuyp's landscape, flooded with warm sun, refreshed by springs that cascade down the cliffs, and populated by simple herdsmen, seems to embody the favor bestowed by God on the fleeing family.

The Carter painting is close in treatment of detail and color to several others that have been dated on grounds of style to the early or middle 1650s,[9] and although we have too few dated paintings by Cuyp to be very certain, it is likely that it, too, was painted at that time.

1. HdG 409, gives Buchanan as the buyer from Talleyrand; the next owner as Webb; and Buchanan again as seller to Baring.

2. On the influence of Both, see Stechow, *Dutch Landscape Painting*, pp. 62–63; J. G. van Gelder and I. Jost, "Vroeg contact van Aelbert Cuyp met Utrecht," *Miscellanea I. Q. van Regteren Altena*, Amsterdam, 1969, pp. 100–103; Stephen Reiss, *Aelbert Cuyp*, London, 1975, p. 8; and Blankert, *Italianiserende landschapschilders*, pp. 171–72.

3. On the influence of Poelenburgh, see Stechow, *Dutch Landscape Painting*, p. 161; Blankert, *Italianiserende landschapschilders*, p. 172. On Gysbert d'Hondecoeter, see Blankert, *Italianiserende landschapschilders*, p. 172; Reiss, *Cuyp*, p. 32. Compare the *Landscape with Herdsman* by Gysbert d'Hondecoeter in the Rijksmuseum (no. A751) for a treatment of foreground vegetation and its reflection of light which resembles Cuyp very closely. Stechow ("Significant Dates on Some Seventeenth Century Dutch Landscape Paintings," *Oud-Holland* 75,

1960, p. 87) mentions also the influence of Gillis d'Hondecoeter on Cuyp's early Italianate landscapes.

4. Waagen, *Treasures*, vol. 2, p. 110, no. 2.

5. HdG 409. The first publication to give the correct subject was the 1929 Detroit exhibition catalogue (q.v.).

6. John Ruskin, *Modern Painters*, vol. 5, London, 1873, p. 259.

7. HdG 1–19.

8. For a discussion of various approaches to the subject, see Knipping, *Iconography of the Counter Reformation in the Netherlands*, Nieuwkoop and Leyden, 1974, vol. 2, pp. 383–87.

9. Especially the *View of the Rhine*, Rotterdam, Museum Boymans-van Beuningen (Reiss, *Cuyp*, no. 108); *River Landscape with Riders* (Reiss, *Cuyp*, no. 139); *Peasants by a River*, Dulwich, Dulwich College Picture Gallery (Reiss, *Cuyp*, no. 138); and *Baptism of the Eunuch*, National Trust, Anglesby Abbey (Reiss, *Cuyp*, no. 118).

Jan van Goyen
1596–1656

Jan van Goyen was born in Leyden in 1596 and began his training there at the age of ten. After studying with a succession of minor artists, including Isaac van Swanenburgh in Leyden and Willem Gerritsz. in Hoorn, van Goyen traveled to France in about 1615. One year later he studied in Haarlem under the pioneering landscapist Esaias van de Velde, the only one of his masters who strongly influenced his style. In 1618 van Goyen married in Leyden, and he is mentioned there again in 1627–28. From 1634 until his death in 1656 he resided in The Hague, although he traveled throughout Holland and to Belgium and Cleves.

Van Goyen was constantly beset with financial difficulties, including losses incurred by speculating in tulip bulbs, and despite his astounding rate of production and his additional occupations as dealer and appraiser, he died insolvent. His career spanned more than thirty-five years; dated works by him are known from 1620 to 1656. His paintings of the late twenties and early thirties, together with the works of Pieter de Molijn and Salomon van Ruysdael, established a new phase of Dutch landscape painting, distinguished by modest, domestic subject matter, a low vantage point, and a palette limited in color but richly varied in tone. A compulsive draftsman, van Goyen made more than a thousand sketches, most of them studies from nature. The rapid and summary technique of his drawings is reflected in the energetic brushwork of his paintings.

11

View of Dordrecht

Signed and dated on the rowboat, center: v Goyen 1645
Oil on wood, 25 1/2 x 37 1/2 in. (64 x 95 cm.)

Collections: Lord St. Leonards; S. E. Kennedy (Sale, London, Christie's, July 6, 1917, no. 13); [Thos. Agnew & Sons, London]; [F. Muller & Co., Amsterdam, 1919]; H. E. Smidt van Gelder, Aerdenhout, 1919–1979; [G. Cramer, The Hague, 1979].

References: Hans-Ulrich Beck, *Jan van Goyen 1596–1656*, vol. 2, Amsterdam, 1973, no. 300, repr.

This view of Dordrecht shows the city from a point to the southwest, near the junction of two major rivers, the Oude Maas and the Dordtse Kil. It is a view van Goyen painted with many variations in more than twenty works from 1641 through 1655.[1]

In the seventeenth century Dordrecht was regarded as Holland's oldest city. For centuries its position on a Rhine tributary and on other connecting waterways had made it preeminent as a center of trade, although it had yielded to competition from Amsterdam and Rotterdam in van

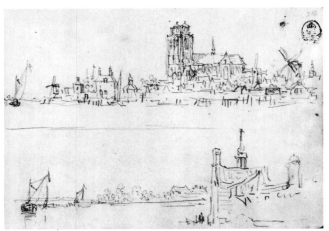

FIGURE 1. Jan van Goyen, *View of Dordrecht*, about 1648. Black chalk, 5 1/8 x 7 1/2 in. (13 x 19 cm.). Dresden, Staatliche Kunstsammlungen.

46

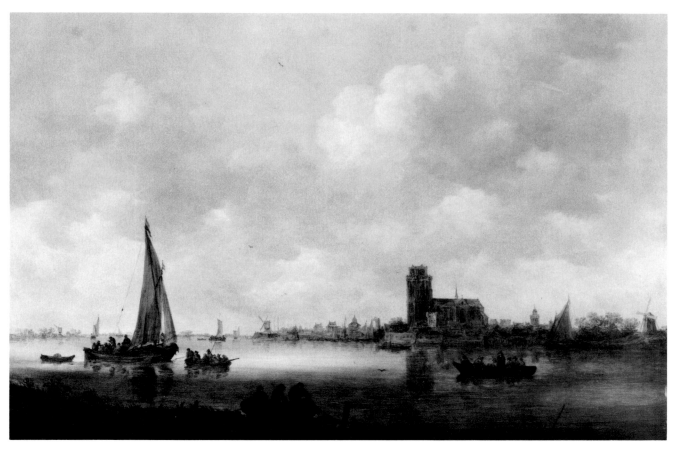

CATALOGUE NUMBER 11

Goyen's time. The Grote Kerk, dating from the late four-teenth and early fifteenth centuries, the most impressive church in Holland, stood as testimony to Dordrecht's greatness. For van Goyen and other artists, the city had the added attraction of a picturesque situation on an is-land created by a medieval moat, its buildings and forti-fications dominating the broad, busy waterways from which they could be seen for miles in several directions.

Van Goyen exploited the site for his particular interests, indifferent to exact topography but constantly varying his compositions and evoking the ever-changing effects of light, weather, and atmosphere.[2] It is surprising that so few drawings of Dordrecht survive; only one has come down to us, contained in a sketchbook of about 1648 (fig. 1),[3] although on earlier trips van Goyen must have made other drawings that he kept in his studio to consult for his paintings. A study of his twenty-odd paintings of Dor-drecht seen from this direction demonstrates that almost nothing is fixed, almost nothing repeated; the church re-mains the trademark of the site, but even its proportions

vary somewhat from painting to painting, and most of the other buildings appear, disappear, and move about ac-cording to van Goyen's wishes.

Here the Dordrecht skyline corresponds very roughly to actuality (fig. 2): the windmill at the far left (standaard-molen) stands in its usual place; farther to the right, two buildings with end-chimneys may be a warehouse of the West Indies Company and the Klokkelaarstoren; next to these is the Rondeel Engelenburg, a high, symmetrical building with cupola; on the waterfront between it and the Grote Kerk stands a high crane used for hoisting freight ashore, the Kraan Rodermond; then the Grote Kerk itself, its stumpy tower considerably heightened; in front of the Grote Kerk is a turreted medieval gate, the Oude Vuil-poort; and to the right of the Grote Kerk is a high tower that can only be the Town Hall, although van Goyen has considerably altered its features and proportions.[4] In this painting he gives a relatively accurate impression of the width of the river, but in others he chose to portray a vast expanse of choppy water (fig. 3). Van Goyen's free inter-

47

pretation of an actual location, even such a famous one as Dordrecht, is characteristic of his approach to painting[5] and evidently very much in tune with prevailing seventeenth-century attitudes toward reality.

The Carter painting shows the river in its most benign aspect. The water is nearly mirror-smooth, rowboats move across its surface, and a sailing vessel laden with passengers ghosts toward the city. The still water mirrors the vast sky, whose clouds cast shadows on the foreground and permit a bright patch of sunlight to fall in the center background. Painted at the height of van Goyen's so-called "tonal" period, the picture is extremely restrained in color. Hues are limited to browns, grays, pale blues, and pale greens, and the entire color scheme is pervaded by the effect of the warm brown tint of the panel, which van Goyen used as a unifying element by applying thin, partly translucent paint for much of the lower part of the picture. Boats, figures, and the distant city are rendered in van Goyen's characteristically rapid draftsmanlike technique. In the next decade van Goyen adopted a different color scheme for his views of Dordrecht and his other landscapes, dominated by silvery tones of gray and blue.[6]

FIGURE 2. Abraham Rademaker, *Dordrecht on the Merwede, 1650*, from *Kabinet van Nederlandsche outheeden en gezigten*, 1725. Etching. Amsterdam, Rijksprentenkabinet.

Painters of the next generation such as Aelbert Cuyp were attracted to more spectacular effects of light and to the picturesque aspects of commercial traffic on the river at Dordrecht (fig. 4), attractions felt long afterward by Turner.[7]

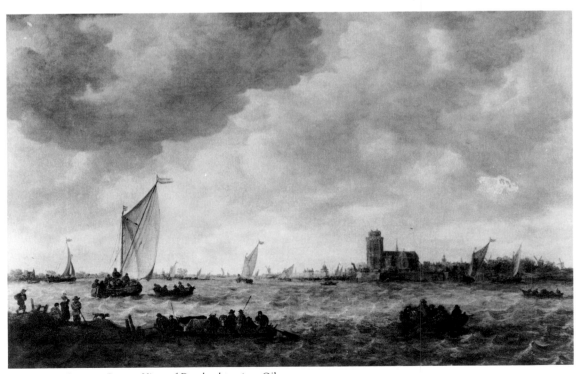

FIGURE 3. Jan van Goyen, *View of Dordrecht*, 1644. Oil on canvas, 37³⁄₈ x 57¹⁄₂ in. (95 x 146 cm.). Brussels, Musée Royal des Beaux-Arts.

48

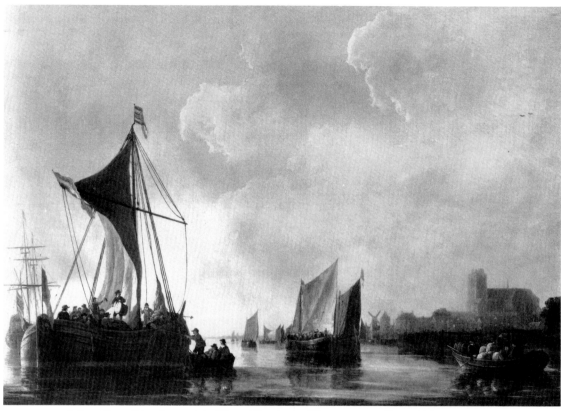

FIGURE 4. Aelbert Cuyp, *River Scene with a View of Dordrecht*. Oil on canvas, 39 ¼ x 53 ¼ in. (99.6 x 135.3 cm.). London, Wallace Collection.

1. Beck, *van Goyen*, vol. 2, nos. 292–305, 307–10, 312–17. The first dated view of Dordrecht, of 1633 (ibid., no. 290), is from the north.

2. For example, ibid., nos. 291, 293–95, 297, 299 (fig. 1).

3. Beck, *van Goyen*, vol. 1, Amsterdam, 1973, no. 846/72, and p. 271 for a discussion of the dating.

4. We are grateful for the help of the staff of the Gemeentearchief Dordrecht in the identification of some of the buildings.

5. See especially E. Haverkamp Begemann's discussion of van Goy-en's views of Rhenen and Dordrecht, "Jan van Goyen in the Corcoran: Exemplars of Dutch Naturalism," *The William A. Clark Collection*, exh. cat., Washington, 1978, pp. 51–59; and H. van de Waal, *Jan van Goyen*, Amsterdam (Palet-Serie), n.d., pp. 25–27.

6. For other views of 1651–55, see Beck, *van Goyen*, vol. 2, nos. 311–14, 317.

7. Turner's *Dort or Dordrecht: The Dort Packet-Boat from Rotterdam Becalmed* (R.A. 1818), Yale Center for British Art, New Haven.

Willem Claesz. Heda
1593/94–1680/82

Heda was born in 1593 or 1594; the location of his birth is unknown. To our knowledge he spent his life in Haarlem, where he is first mentioned as a member of the Guild of St. Luke in 1631. He later served in various official positions for the guild, and he died sometime between 1680 and 1682. With the exception of a few portraits and figure paintings, his production consists entirely of still lifes. Dated pictures by him are known from 1628 to 1665. Heda's works of the thirties already reveal the qualities that distinguish his paintings and those of his townsman Pieter Claesz. (cat. no. 8) from the still lifes of their predecessors: a lowered viewpoint, a reduced number of objects, a palette restricted to yellows, browns, and greens, and an emphasis on the reflections of light on various textures and surfaces. His still lifes differ from those of Claesz. in their smoother surfaces, generally more elaborate objects, and, after the mid-thirties, their predominantly upright formats. The most austere compositions by Heda belong to the second half of the thirties, but he continued to paint modest still lifes as well as more elaborate arrangements into the fifties. After mid-century, in an attempt to assimilate the innovations of the painters of ostentatious still lifes, Heda introduced more color and more contrived decorative effects into his pictures. Heda's son Gerrit studied with his father and imitated his style.

12

Still Life with Tobacco, Wine, and a Pocket Watch

Signed and dated on edge of table, left center: HEDA/1637
Oil on wood, 16½ x 21½ in. (42 x 54.5 cm.)

Collections: [Lenthal, Paris]; [P. de Boer, Amsterdam, 1949]; J. M. Redelé, Dordrecht, by 1952; [G. Cramer, The Hague].

Exhibitions: Rotterdam, Kunstkring, *Tentoonstelling van oude schilderijen collectie C. V. Kunsthandel P. de Boer*, 1951, no. 20; Paris, Orangerie, *La nature morte de l'antiquité à nos jours*, 1952, no. 37, repr., cat. by Charles Sterling; Rome, Palazzo delle Esposizione, *Mostra di pittura olandese del seicento*, 1954, no. 51; Dordrecht, *Nederlandse stilleven uit vier eeuwen*, 1954, no. 52; Rotterdam, Museum Boymans, *Tentoonstelling*, 1954, no. 73; Rotterdam, Museum Boymans, *Tentoonstelling kunstschatten uit Nederlandse verzamelingen*, 1955, no. 73, pl. 50; Eindhoven, Stedelijk van Abbemuseum, *Het Hollandse stilleven 1550–1950*, 1957, no. 28; Luxembourg, Musée de l'Etat, and Liège, Musée des Beaux-Arts, *Nature mortes hollandaises 1550–1950*, 1957, no. 29, pl. 17; Paris, Galerie André Weil, *La nature morte et son inspiration*, 1960, no. 24; San Francisco, Palace of the Legion of Honor; Toledo Museum of Art; Boston, Museum of Fine Arts, *The Age of Rembrandt*, 1966–67, no. 101, repr.

References: Charles Sterling, *La nature morte de l'antiquité à nos jours*, Paris, 1952, p. 47, repr.; rev. and trans. ed. *Still Life Painting from Antiquity to the Present Time*, Paris and New York, 1959, p. 52; Jean Leymarie, *La peinture hollandaise de Gérard de Saint-Jean à Vermeer*, Lausanne, Paris, and New York, 1956, fig. 173; Jean Leymarie, *Dutch Painting*, Geneva and New York, 1956, repr. p. 173; Charles Boucaud, *Les pichets d'étain*, Paris, 1958, p. 229.

Heda's contemporaries would have classified this picture as a *toebackje*, a type of still life with tobacco and other requisites for smoking that sometimes also contains pitchers and glasses for drinking. His first securely dated picture, of 1628, a more explicit representation of such a subject (fig. 1), already reveals the radical simplification of composition and color scheme pioneered by Heda and his Haarlem compatriot Pieter Claesz. (cat. no. 8). This development is analogous to the changes in content and style of the landscapes painted in the late twenties and thirties by Heda's Haarlem contemporaries Jan van Goyen and Salomon van Ruysdael (see cat. nos. 11 and 22). Limiting

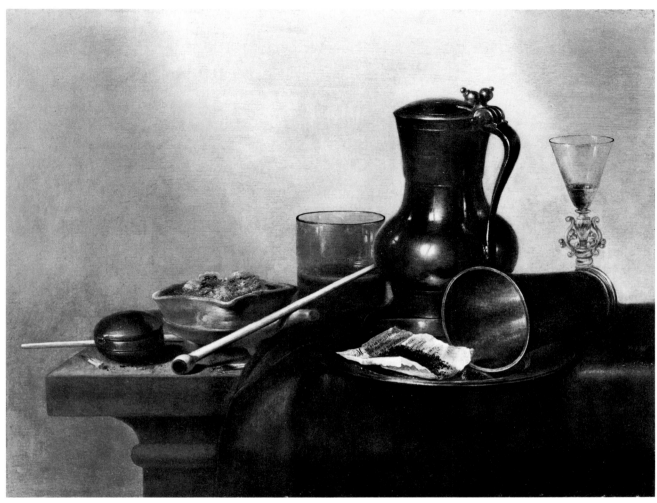

CATALOGUE NUMBER 12

FIGURE 1. Willem Claesz. Heda, *Vanitas*, 1628. Oil on wood, 17⅞ x 27⅜ in. (45.5 x 69.5 cm.). The Hague, Museum Bredius.

his range of color (hence, the misleading term "monochrome"), but not his range of tones, Heda keenly observes the effects of light on various textures, juxtaposing, for example, the smooth surfaces of the tumbler and plate with the crumbly tobacco and crinkled paper.

Most of Heda's paintings preceding the Carter picture are of another type, the so-called *banketje*, in which food and serving vessels are disposed on a table. The arrangements are sometimes elaborately disordered and the objects often rare and expensive, but a certain sobriety is lent by the artist's modest colors and his careful arrangement of shapes.[1] In the mid-1630s Heda painted several pictures in which vessels are massed into a sturdy triangle and placed on a dark green cloth that does not distract but provides a rich foil for the objects (fig. 2). He revived this scheme in 1637 for the Carter painting, which is one of the simplest and most firmly constructed of all his pictures. It may be no coincidence that in the preceding year Pieter Claesz. had painted two *toebackjes* of somewhat similar content and of comparable simplicity.[2]

The seventeenth-century spectator was not only expected to savor the artist's skillful illusions and to enjoy his ingenious arrangement of forms, he was also invited to ponder the meaning of the objects. In Heda's *toebackje* of 1628 a skull, broken pipe, and overturned glass make the brevity of human life the unmistakable lesson (fig. 1).[3] In the Carter painting nearly a decade later, this idea is still present but is more subtly integrated into the whole. The overturned cup and the watch are part of the pattern of ovals and circles that dominate the composition, yet they still suggest, in the words of the verse inscribed under a contemporary still life, that "The glass is empty. Time is up." (*Het glas is leeg. Dit tijd is om*).[4] The message is reinforced by the tobacco and pipes, for the relatively new habit of smoking, like the older vices of drinking, gambling, and whoring, was constantly attacked by preachers and lay moralists in Heda's time (Petrus Scriverius's *Saturnalia . . . The Use and Misuse of Tobacco*, published in Haarlem seven years earlier, has a frontispiece showing a skull resting on two pipes).[5] The watch in Heda's picture

FIGURE 2. Willem Claesz. Heda, *Still Life with Roemer, Silver Cup, and Oysters*, 1634. Oil on wood, 16⅞ x 22½ in. (43 x 57 cm.). Rotterdam, Museum Boymans-van Beuningen.

52

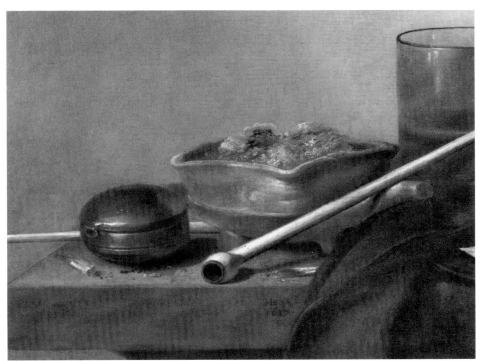

FIGURE 3. Willem Claesz. Heda, *Still Life with Tobacco, Wine, and a Pocket Watch* (detail).

(fig. 3) might also suggest temperance, the careful regulation of life and its appetites, as it does in other Dutch paintings.[6] Its cover is closed, a rarity in still life; the closed watch serves as a kind of metaphor for the artist's method of concealing the eternal and inevitable truth behind the appearances of the everyday world.

1. For the term *monochrome banketje* see Pieter Claesz., cat. no. 8, note 1.

2. The pictures of 1636 in the Hermitage, Leningrad, and formerly in the collection of J. William Middendorf, Washington (Vroom, *A Modest Message*, vol. 2, p. 23, nos. 79, 80, repr.).

3. See Ingvar Bergström, "Notes on the Boundaries of *Vanitas* Significance," in *Ijdelheid der Ijdelheden*, exh. cat., Leyden, 1970.

4. Ibid.

5. For tobacco, its uses, its intoxicating effects, and its associations with *Vanitas*, see Bergström, *Dutch Still-Life Painting*, pp. 156–57; Amsterdam, Rijksmuseum, *Tot lering en vermaak*, exh. cat., 1976, pp. 55–57, no. 7; Braunschweig, Herzog Anton Ulrich-Museum, *Die Sprache der Bilder*, exh. cat., 1978, pp. 154–57, no. 36.

6. Bergström, *Dutch Still-Life Painting*, pp. 189–90; E. de Jongh, *Zinne- en minnebeelden in de schilderkunst van de zeventiende eeuw*, [Amsterdam], 1967, pp. 56–60.

Jan van der Heyden
1637–1712

Born in Gorinchem in 1637, van der Heyden reportedly first studied with a glass engraver. After 1650 he lived in Amsterdam; his paintings indicate that he traveled extensively in his own country and also visited Belgium and Germany, stopping in Cologne, Düsseldorf, Emmerich, and Cleves. More famous in his own lifetime as an inventor and engineer than as an artist, van der Heyden devoted himself primarily to practical projects for the last forty years of his life. In 1672 he and his brother Nicolaes invented and manufactured a new type of fire hose, documented in Jan van der Heyden's book of 1690, *Beschrijving der Nieuwlijks uitgevonden en geoctrojeerde Slang-Brand-Spuiten*, illustrated with prints by the artist. Jan also developed a street-lighting system for Amsterdam; he served as director of street lighting in 1670 and as fire chief in 1677.

The first artist to create imaginary views from existing city streets and buildings, van der Heyden freely rearranged familiar sites and buildings to suit his compositions, as earlier artists had done with still life, landscape, and architectural subjects. His production as a painter was confined largely to the years 1664–78. Before his first cityscape, dated 1666, van der Heyden painted landscapes on glass and still lifes composed of scholarly articles in a room, the latter a subject he resumed in the final two years of his life. He also painted actual known buildings in landscapes, usually invented, and Italianate landscapes. In the seventies van der Heyden's style became increasingly refined and his colors cooler and paler, a development found also in the art of Gerrit Berckheyde (cat. no. 2). The smooth surfaces and minute details in van der Heyden's finest paintings, in which each brick and its mortar are clearly legible, earned him great popularity in the eighteenth century. His imaginary city views based on reality set an important example for the Italian *vedute* pioneers of the next century.

13

A View of the Herengracht, Amsterdam

Signed on the bridge abutment, lower right: VH (joined)
Oil on wood, 13 1/4 x 15 5/8 in. (33.5 x 39.7 cm.)

Collections: Probably Jacob Crammer Simonsz. (his sale, Amsterdam, November 25, 1778, no. 10); probably Duc de la Vallière, Paris (his sale, Paris, February 21–23, 1781, no. 67, to A. J. Paillet); [A. J. Paillet, Paris]; probably M. B. de Boynes, Paris (his sale, Paris, March 15–19, 1785, no. 42); P. Meazza, Milan (his sale, Milan, April 15–23, 1884, no. 186); Antoine Baer, 1885;[1] Albert Lehmann, Paris (his sale, Paris, June 12–13, 1925, no. 255); Alfred de Rothschild; Baron de Beurnonville;[2] Esmond, Paris; [Otto Wertheimer, Paris, 1945]; [Duits, London, 1950]; Sidney J. van den Bergh, Wassenaar, by 1953; [G. Cramer, The Hague, 1971].

Exhibitions: Amsterdam, F. Muller & Co., *Maîtres hollandais du XVIIe siècle*, 1906, no. 62; Birmingham, England, Museum and Art Gallery,

Some Dutch Cabinet Pictures of the Seventeenth Century, 1950, no. 25; Paris, Orangerie, *Le paysage hollandais au XVIIe siècle*, 1950–51, no. 36, pl. 26; Zurich, Kunsthaus, *Holländer des 17. Jahrhunderts*, 1953, no. 53; Rome, Palazzo delle Esposizioni, *Mostra di pittura olandese del seicento*, 1954, no. 54, and Milan, Palazzo Reale, 1954, no. 62; New York, Metropolitan Museum of Art, Toledo Museum of Art, Art Gallery of Toronto, *Dutch Painting, The Golden Age*, 1954–55, no. 38; Rotterdam, Museum Boymans, *Kunstschatten uit Nederlandse verzamelingen*, 1955, no. 75, pl. 145; Tel Aviv Museum, *Holland's Golden Age*, 1959, no. 51; Laren, Singer Museum, *Kunstschatten. Twee Nederlandse collecties schilderijen*, 1959, no. 53; Leyden, Stedelijk Museum 'de Lakenhal,' *17de eeuwse meesters uit Nederlandse particulier bezit*, 1965, no. 24.

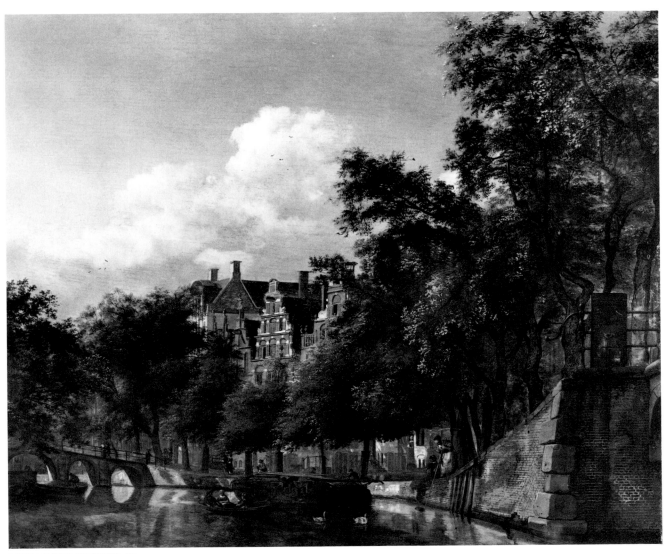

CATALOGUE NUMBER 13

References: HdG 22; J. Bruyn, "Le paysage hollandais au XVIIe siècle," *Art et Style* 17, 1950; A. B. de Vries, "Old Masters in the Collection of Mr. and Mrs. Sidney van den Bergh," *Apollo* 80, 1964, p. 357, repr.; Jakob Rosenberg, Seymour Slive, and E. H. ter Kuile, *Dutch Art and Architecture, 1600–1800*, Harmondsworth, 1966, p. 193, pl. 164B, 1972 ed., p. 332, fig. 263; A. B. de Vries, *Verzameling Sidney J. van den Bergh*, Wassenaar, 1968, p. 68 repr.; Helga Wagner, *Jan van der Heyden*, Amsterdam and Haarlem, 1971, p. 69, no. 11; E. Haverkamp Begemann, "Jan van der Heyden by Helga Wagner" (review), *Burlington Magazine* 115, 1972, p. 401.

The view is from the Leliegracht southward along the Herengracht toward the bridge that marks the Warmoesgracht, now called the Radhuisstraat. This quiet section of the Herengracht, one of three broad semicircular canals constructed in the seventeenth century to ring the city center, lies only a few hundred yards from the Town Hall and Flower Market painted by Berckheyde (see cat. no. 2). In contrast to Berckheyde, van der Heyden interprets his site freely, altering the spatial relationships and architectural details.

Van der Heyden painted many views of Amsterdam, where he lived and worked (fig. 1), including several others showing houses once located at the curve in the Herengracht shown in the Carter painting (fig. 2).[3] In these other views van der Heyden has lifted the buildings from their original site and invented new settings for them. In one the Town Hall of Haarlem appears further down the canal, and another represents a section of the Martelaarsgracht.[4] These paintings emphasize the stately character of the canal and are dominated by the lofty and varied facades of the great patrician houses.

An intimate, lyrical spirit distinguishes the Carter painting from all the other views of the Herengracht, in which the three majestic Herengracht houses (numbers 168–74) are comparable to the "portraits" of famous monuments such as the town halls of Amsterdam and Haarlem and various churches all over the country. In the Carter painting, by contrast, the linden trees obscure most of the buildings and permit only a glimpse of the houses; the swans, rowboat, and promenading figures give the place as much the air of a pleasure ground as of a commercial metropolis.

The location, not the buildings, seems to have interested the artist in our painting. Van der Heyden has chosen to omit numbers 170–72, the famous "Huis Bartolotti" designed by a follower of Hendrick de Keyser,[5] and number 168, one of the first houses built by Philip Vingboons in Amsterdam,[6] both of which still stand today. The step-gabled house visible through the trees resembles the house

FIGURE 1. Map of Amsterdam. *Blue Guide to Holland*, London, 1961.

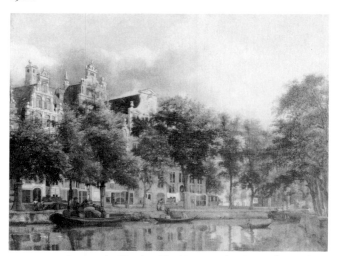

FIGURE 2. Jan van der Heyden, *The Herengracht, Amsterdam*. Oil on wood, 13 x 17³/4 in. (33 x 45 cm.). Paris, Musée du Louvre.

to the far left of the Louvre painting (fig. 2), number 174, which today has been replaced by a building in the Empire style.

The artist has also taken liberties with the site itself. Most notably he has condensed the distance between the Leliegracht and the Warmoesgracht, as demonstrated by a photograph of the site (fig. 3). He has eliminated much of the distance between the bridge and the curve, thus emphasizing the bend, and has exaggerated the upward sweep of the wall. These changes give van der Heyden his main organizing device, the continuous undulating curve of the bridge and the canal wall that lends such grace to the composition. In composing the scene the artist may have used some form of optical device, perhaps a concave lens[7] that would condense distances. Whether van der

FIGURE 3. The Herengracht, Amsterdam, from the Leliegracht toward the Radhuisstraat (photograph: Thomas J. Schneider).

Heyden really used optical instruments is still uncertain, but he may well have visited Delft during the 1650s, where Fabritius, de Hooch, Vermeer, and other painters of city views were experimenting in the field of optics.[8]

The picture was probably executed during the years 1668–74, a period of great productivity in which van der Heyden painted his finest cityscapes. Lacking any dated works after 1668 and before 1673, we cannot assign it a more exact date.[9] Its clarity, precision, and warm colors are the mark of the entire group of views between these years; after the mid-1670s van der Heyden favored more pastel colors, less minute detail, and more unified light.

An old tradition credits Adriaen van de Velde with having painted the figures in van der Heyden's pictures until Adriaen's death in 1672; thereafter van der Heyden is supposed to have painted his own. But no one has yet made a convincing case that the figures really differ.[10] We are inclined to think that their consistently fine and lively quality, like that of the illustrations in van der Heyden's own book about fire fighting, indicates that van der Heyden painted them all, taking his cue in the beginning from Adriaen van de Velde's style.

The Carter painting is probably the one mentioned under number 11 in the will made by the painter's widow in 1712, "De bogt van de Heerengracht met de War-Moessluys in Verschiet," valued at 50 guilders,[11] a relatively modest sum when compared to the 320 guilders set on an especially fine picture of a more important place, the Town Hall and Dam Square (now Paris, Musée du Louvre) or 200 guilders on an elaborate still life.

A painting that has been claimed as a pendant to the Carter picture, *Street by a Canal* (formerly in the collection of H. A. Wetzlar, Amsterdam), though it is close in size,[12] is nevertheless so different in scale and composition that it could hardly have served as a suitable companion piece.

1. Notation in the Meazza sale catalogue in the Frick Art Reference Library, New York. Hofstede de Groot's citation of an Amsterdam sale in 1765 is an error (HdG 22).

2. Notation on photograph mount, Witt Library, London.

3. Paris, Musée du Louvre; Waddeson Manor; and private collection, England (Wagner, *van der Heyden*, nos. 12–14).

4. Private collection, England (Wagner, *van der Heyden*, no. 14).

5. Built as a single house for the banker Willem de Heuvel, who changed his name to Guillielmo Bartolotti after inheriting a fortune from an Italian uncle, the house has been dated to about 1615–20. Restored in 1975, the house is owned by the Vereeniging Hendrick de Keyser and is generally attributed to the school of Hendrick de Keyser. See H. R. Hitchcock, *Netherlandish Scrolled Gables of the Sixteenth and Early Seventeenth Centuries*, New York, 1978, pp. 91–92; H. F. Wijman, *D'Ailly's historische gids van Amsterdam*, 1963, pp. 312–313.

6. Built in 1638 for Michiel Pauw, a director of the West Indies Company and knight of the Order of St. Mark, whose coat of arms is carved on the gable. See Wijman, *Historische gids*, p. 312.

7. See Arthur K. Wheelock, Jr., "A Re-Appraisal of Gerard Dou's Reputation," *The William A. Clark Collection*, exh. cat., Washington, Corcoran Gallery of Art, 1978, pp. 64–65, for a discussion of different lenses and glasses known in the seventeenth century.

8. Heinrich Schwarz, "Vermeer and the Camera Obscura," *Pantheon* 24, 1966, pp. 177–78; Arthur K. Wheelock, Jr., *Perspective and Optics in Delft*, diss. Harvard, published New York, 1977, p. 278. A red chalk

drawing by van der Heyden in the Fodor Collection, Amsterdam, *A Row of Houses on the Herengracht*, leaves a hint that van der Heyden might have experimented with optical instruments. The sheet is covered by a pencil grid, the horizontal lines of which slant slightly towards the center from left to right. Grids were used as aids in transcribing images seen through a lens, or in transferring a composition: in this case, the purpose of the horizontal lines converging at the center would probably have been to facilitate the drawing of distant objects, possibly to exaggerate the distance.

9. Among others dated 1668: *Amsterdam Town Hall*, Paris, Musée du Louvre, and *Huis ten Bosch Pavilion*, formerly Buchenau collection (Wagner, *van der Heyden*, nos. 2, 137); dated 1673: *Old Palace, Brussels*, Luton Hoo, Sir Harold Wernher (Wagner, *Van der Heyden*, no. 27).

10. Stechow, *Dutch Landscape Painting*, pp. 209–10, note 15. Wagner thinks that until 1672 van de Velde painted figures in some of the pictures, van der Heyden in others (*van der Heyden*, pp. 34–35).

11. The inventory is given in Abraham Bredius, "De natlatenschap van Jan van Heyden's weduwe," *Oud-Holland* 30, 1912, pp. 132–38. Our painting is no. 11, p. 135.

12. It measures 34.7 x 40 cm. Wagner, *van der Heyden*, p. 87, no. 88. She is correct, however, in pointing out Hofstede de Groot's error in assuming the Carter picture (his no. 22) to be identical with his no. 213, the Wetzlar painting.

Meyndert Hobbema
1638–1709

Baptized Meyndert Lubbertsz. in Amsterdam in 1638, for unknown reasons the artist adopted the surname Hobbema as a young man. In the late 1650s Hobbema studied with Jacob van Ruisdael in Amsterdam, as attested by Ruisdael's statement in 1660 that Hobbema had "served" him and had been his pupil for several years. The influence of Ruisdael's work, however, is not apparent until 1662. Hobbema's works before then, primarily riverscapes, suggest the influence of Cornelis Vroom and Anthonie van Borssom (cat. no. 3). After a brief period in the early 1660s of strong dependence on Ruisdael, Hobbema developed his own less somber and more animated version of the wooded landscape. With the exception of a few town views, Hobbema painted exclusively landscapes with trees. About thirty drawings are attributed to him, some of them studies from nature that he later incorporated into paintings. Dated works are known from 1658 to 1689; his production slackened considerably, however, after his marriage in 1668 and his appointment in that year as a wine-gauger of the Amsterdam octroi. Hobbema lived in Amsterdam all his life, although he traveled to South Holland and Overijssel. He had few followers and was ignored by contemporary critics, but his agreeable vision of the Dutch countryside became popular in the eighteenth century and had considerable influence on painting in England and France during the nineteenth century.

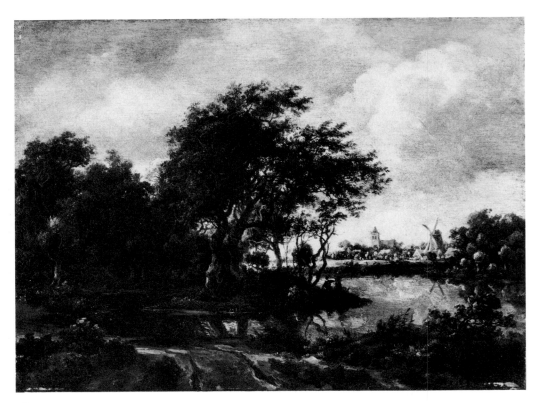

CATALOGUE
NUMBER 14A

58

14

A. *Landscape with Anglers and a Distant Town*

Signed, bottom left: m hobbema
Oil on wood, 9⁷/₈ x 12⁵/₈ in. (25.3 x 31.2 cm.)

B. *Landscape with a Footbridge*

Signed on bridge, right: m hobbema
Oil on wood, 9³/₄ x 12⁵/₈ in. (25 x 31.2 cm.)

Collections (for the pair): Paul Iwan Hogguer (his sale, Amsterdam, P. van der Schley, August 18, 1817, nos. 23, 22); J. Hulswit;[1] Sir Charles Bagot (his sale, London, Christie's, June 18, 1836, nos. 51, 52); Marquess of Lansdowne, Bowood, 1844–76, at least; [Thos. Agnew and Sons, London]; [Charles Sedelmeyer, Paris; *Catalogue of Three Hundred Paintings . . .* , 1898, nos. 61, 62]; Rodolphe Kann, Paris, by 1883; [Duveen Brothers, Paris]; Walter von Pannwitz, Hartekamp, to 1962. (for *Landscape with Anglers and a Distant Town*): Sidney J. van den Bergh, Wassenaar, to 1973; [G. Cramer, The Hague, 1973]. (for *Landscape with a Footbridge*): [Rosenberg and Stiebel, New York, 1962].

Exhibitions (for *Landscape with Anglers and a Distant Town*): London, Royal Academy, *Works by Old Masters . . . Winter Exhibition*, 1876, no. 204; Dordrecht, Dordrechts Museum, *Nederlandse landschappen uit de zeventiende eeuw*, 1963, no. 45, fig. 112; Leyden, Stedelijk Museum 'de Lakenhal,' *17de eeuwse meesters uit Nederlandse particulier bezit*, 1965, no. 25. (for *Landscape with a Footbridge*): Rotterdam, Museum Boymans, *Tentoonstelling van schilderijen . . . uit particuliere verzamelingen in Nederland*, 1939–40, no. 31, pl. 26.

References (to the pair): Smith, *Catalogue Raisonné*, 1835, p. 127, nos. 45, 46, *Supplement*, IX, 1842, p. 723, nos. 13, 14; Mrs. Anna Brownell Jameson, *Companion to the Most Celebrated Private Galleries of Art*, London, 1844, pp. 315–16, nos. 71, 72; Gustav Waagen, *Treasures of Art in Great Britain*, vol. 3, 1854, p. 161, nos. 3, 2; Wilhelm Bode, *Rembrandt und seine Zeitgenossen*, Leipzig, 1906, 2nd ed., Leipzig, 1907, p. 150, trans. as *Great Masters of Dutch and Flemish Painting*, London, 1909, pp. 173–74; *Catalogue of the Rodolphe Kann Collection*, vol. 1, Paris, 1907, nos. 47, 48; HdG, 176, 245; M. J. Friedländer and O. van Falke, *Die Sammlung von Pannwitz*, vol. 1, Munich, 1926, nos. 62, 63; G. Broulhiet, *Meindert Hobbema*, Paris, 1938, nos. 200, 87, repr. pp. 202, 145. (to *Landscape with Anglers and a Distant Town*): A. B. de Vries, *Verzameling Sidney J. van den Bergh*, Wassenaar, 1968, p. 70, repr.

These two panels, although they are among the smallest of Hobbema's paintings, are complex and ambitious in composition. They are typical of the artist's most accomplished works of the 1660s in their strength, variety of terrain, and lively alternation of sunlit open spaces and dark woods. The two pictures are a pair, having had the same owners from their earliest appearance at auction in the last century until twenty years ago; after a decade of separation they were reunited by the Carters.

There is no doubt that Hobbema painted the panels to hang side by side, for the two compositions balance and enhance one another. The path winding through the trees

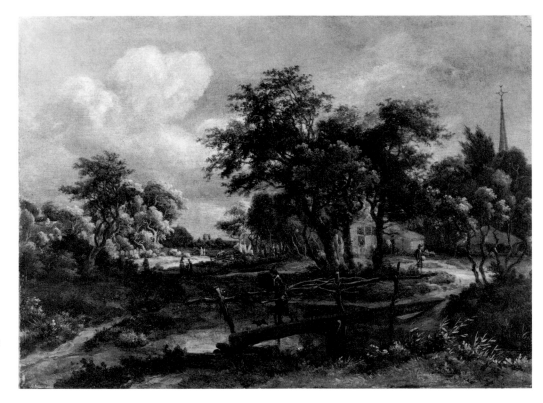

CATALOGUE
NUMBER 14B

59

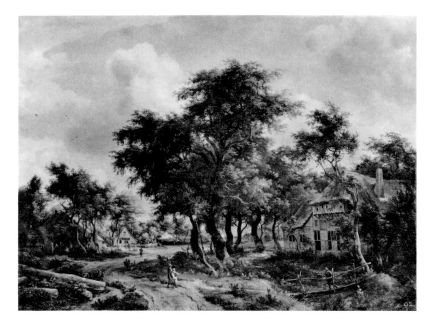

is the counterpart of the river bending around the woods, the distant town corresponds to the sunny clearing, and the roads to the river and the bridge both lead into their respective compositions. The *Landscape with a Footbridge* probably should be hung on the right, so that the road echoes the river, the open spaces are adjacent, and the trees on the outer edge enclose the compositions. Hobbema's sensitivity to the formal demands of companion pieces is equally evident in his larger pendants, such as the well-known pair of 1663, now separated.[2]

Compositions with a curved road or river winding around a central group of trees that opens onto a sunlit area in the distance became a specialty of Hobbema in the mid-sixties (figs. 1, 2).[3] The Carter panels probably date from about 1663–65, for they compare closely with such works as *A Woody Landscape with an Angler at a Stream* of 1664 (fig. 2). They bear the separated signature *m hobbema* used by the artist from 1661 to 1667;[4] their compositions suggest that they were probably executed before the second half of the decade, when Hobbema re-

FIGURE 3. Meyndert Hobbema, *A Woody Landscape*, 1667. Oil on wood, 24 x 33½ in. (61 x 85.1 cm.). Formerly Swaythling collection (sale, London, Christie's, July 12, 1946, no. 25). Photograph courtesy of the Witt Library, London.

laxed the tight curve of the road or river and opened up the middle and far distances of his landscapes (fig. 3). The Carter landscapes are unusual among this group for their low viewpoint and their energetic brushwork. In his contemporary paintings of larger size the scene is represented from a higher, more distant vantage point (fig. 1). In the Carter pendants the small size of the pictures is complemented by their more intimate viewpoint and their looser, sketchier technique, which led Wilhelm Bode to praise their fresh treatment and rich color and to remark that they "give the impression of having been painted directly from nature."[5]

The formal correspondence that links these two panels is only one of the types of relationships between paired paintings in seventeenth-century Dutch painting. Landscape pendants often represented different seasons or times of the day, and pairs of genre paintings were used to express a moral message. In these cases in which the relationship was primarily one of contrast—winter opposed to summer, virtuous conduct opposed to immoral behavior—the meaning was lost if the pair was separated. Hobbema's little landscapes make up a looser unit, one that is comparable to that of many pairs of portraits: each picture, although strong enough to stand alone, is fully successful only when hung with its companion.

1. Hofstede de Groot notes the buyer as J. Hulswit, who paid 621 guilders for each (Frick Art Reference Library, New York); Jameson (*Companion*, pp. 315–16) says that M. Saporta was the buyer.

2. *Road into a Forest*, 1663, oil on canvas, 95 x 130 cm. (Washington, National Gallery of Art); *Landscape with Trees and a Causeway*, 1663, oil on canvas, 94 x 130 cm. (Blessington, Ireland, Sir Alfred Beit).

3. Other examples are *Wooded Landscape with Figures and a Beggar*, 1668, London, Buckingham Palace (Broulhiet, *Hobbema*, no. 274); and the *Woody River Scene*, formerly Sulley collection, sale, London, Christie's, June 1, 1934, no. 33.

4. Wolfgang Stechow, "The Early Years of Hobbema," *Art Quarterly* 22, 1959, p. 13. The Frankfurt landscape of 1659 is an exception to this rule (ibid., p. 13, fig. 9).

5. Bode, *Rembrandt und seine Zeitgenossen*, p. 150 (our translation), who also mentions a small painting in the Thieme collection, Leipzig; the broken strokes and rich impasto in these landscapes are also found in a small panel dated 1659 with Newhouse Galleries, New York, in 1977 (repr. *Art Journal* 36, 1977, p. 176).

Jan van Huysum
1682–1749

Jan van Huysum was born in 1682 in Amsterdam, where he seems to have spent his entire life. He was trained in the studio of his father Justus van Huysum (1659–1716), a flower painter specializing in decorative compositions. Other painters who may have influenced van Huysum's early still lifes are Jan Davidsz. de Heem (1606–1683/84), Abraham Mignon (1640–1679), and Willem van Aelst (1625/26–after 1683). Several hundred paintings by van Huysum are known, mostly fruit and flower pieces, but also a small number of arcadian landscapes; there are dated paintings from 1706 through 1744. His paintings evolved from compact compositions against a dark background to looser, overflowing arrangements set against a yellow-green background of distant trees. Van Huysum used live flowers as models for his paintings. His drawings consist primarily of free compositional studies, which seem to have been experiments in design rather than preparatory works. According to his earliest biographers van Huysum was notoriously secretive, refusing to allow anyone into his studio for fear that his colors might be imitated. The artist had only one pupil, Margaretha Havermann, who left his studio in the middle of the century, but his style was followed into the nineteenth century by artists such as Jan van Os, his son Johannes van Os, and the brothers Gerard and Cornelis van Spaendonck. Highly acclaimed from the beginning of his career, van Huysum received enormous prices for his paintings throughout his lifetime.

15

Bouquet of Flowers in an Urn

Signed and dated, lower right: Jan van Huysum 1724
Oil on wood, 31 1/2 x 23 3/8 in. (80 x 59.6 cm.)

Collections: Johan Diedrich Pompe van Meerdervoort, Dordrecht, or Jan van Huysum, Amsterdam (their sale, October 14, 1749, no. 8);[1] Gerrit Braamcamp, Amsterdam (his sale, Amsterdam, van der Schley, July 31, 1771, no. 90, for fl. 3800);[2] Jan Gildemeester, Amsterdam (his sale, June 11–12, 1800, no. 89, for fl. 3000); [Spaan]; Pieter Smeth van Alphen (his sale, Amsterdam, August 1–2, 1810, no. 47, for fl. 4500); [de Vries]; Jhr. Jan Six van Hillegom, Amsterdam, by 1835; by descent to Jan Six, Amsterdam (his sale, Amsterdam, October 16, 1928, no. 15a); [A. Staal, Amsterdam, 1929]; Arthur Hartog, The Hague; [Newhouse Galleries, New York, 1974].

Exhibitions: Amsterdam, Rijksmuseum, *Verzameling schilderijen en familieportretten van de heeren Jhr. P. H. Six van Vromade, Jhr. P. H. Six en Jhr. W. Six*, 1900, no. 48; Amsterdam, Rijksmuseum, *Tentoonstelling van oude kunst door de Vereeniging van Handelaren in Oude Kunst in Nederland*, 1929, no. 76, repr.; The Hague, Gemeentemuseum, *Oude kunst uit Haagse bezit*, 1936–37, no. 104; The Hague, Maurits-huis, *Herwonnen kunstbezit*, 1946, no. 28; Utrecht, Centraal Museum, *Herwonnen kunstbezit*, 1946, no. 67; Los Angeles County Museum of Art, *A Decade of Collecting, 1965–1975*, 1975, no. 72, repr.

References: G. Hoet, *Catalogus of Naamlyst van Schilderyen mit Derzelver Pryzen*, vol. 2, The Hague, 1752, p. 503; J. F. de Bastide, *Le Temple des Arts ou Le Cabinet de Monsieur Braamcamp*, Amsterdam, 1766; Smith, *Catalogue Raisonné*, vol. 6, 1835, p. 476, no. 55; HdG 43; M. H. Grant, *Jan van Huysum 1682–1749*, Leigh-on-Sea, 1954, p. 17, no. 4; C. Bille, *De Temple der Kunst of het Kabinet den Heer Braamcamp*, Amsterdam, 1961, vol. 1, pp. 81, 226, fig. 90; vol. 2, p. 21, no. 90.

Van Huysum's bouquet, described by Hofstede de Groot as one of the best works by the master,[3] overflows the vase in a profusion of ripe, heavy blossoms. Every detail is rendered with the artist's legendary precision, a faithfulness to botanical truth no less scrupulous than Bosschaert's a century earlier. Like other flower painters of the later seventeenth century, however, van Huysum was an inventive composer who favored loose arrangements and an

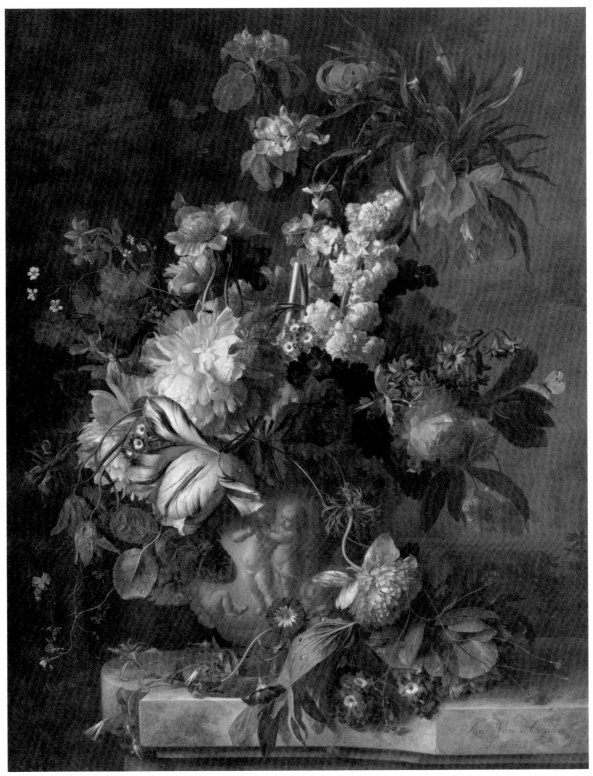

CATALOGUE NUMBER 15

63

FIGURE 1. Jan van Huysum, *Bouquet of Flowers in an Urn* (detail).

air of disorder; this one is typical in its exuberant asymmetrical design held together by bold sweeping curves.

Van Huysum, like Bosschaert and other earlier artists, paints an impossible bouquet that mixes spring flowers (the blue auricula on the ledge) with late bloomers such as the morning glory (fig. 1) and that includes exotic and precious blossoms. These later flower pieces, however, reflect both advances in horticulture and changes in taste by the early eighteenth century. By that time the hyacinth —the tall white flower in the center—and the blue blossoms on the right side had replaced the tulip as the most highly valued specimen, although striped hybrid tulips were still much appreciated. All the poppy anemones are of the double form; the yellow-pink blossom with its multiple layers of petals is a particularly complex example. The yellow rose on the right, called a "rosa huysumiana," is a hybrid named after the painter and today known only through eighteenth-century paintings, mainly by its namesake.

The vivid flowers in the Carter arrangement were undoubtedly painted from life. We know this was van Huysum's practice from a letter to a patron in which he explained that he could not complete a picture until a certain yellow rose bloomed the following spring.[4] Unlike Bosschaert, who seems to have solved the problem of combining flowers of different seasons in a single painting by

working from studies, van Huysum insisted on painting directly from live flowers, with the result that some of his paintings required two growing seasons to finish and bear two dates.[5] Van Huysum did make drawings, but they are primarily compositional studies that are only loosely connected to his finished works, as is the case with a sheet in Berlin (fig. 2) that evidently served him as an aid in composing the Carter painting.

Van Huysum's painting continues the moralizing tradition of Bosschaert and his contemporaries[6] and contains some of the same symbols, such as the butterfly symbolizing the human soul, the insects (in this case yellow ants and a wasp), and the conspicuous dew drops on the petals (fig. 3).[7] In van Huysum's pictures, however, the message of the transience of beauty and earthly pleasures is expressed in a language entirely different from that of the early flower painters. Van Huysum, like his predecessors Jan Davidsz. de Heem, Cornelis de Heem, and Abraham Mignon, chooses blossoms that have mostly passed their prime and are beginning to droop and wilt, hinting at their imminent expiration. The broken tulip prominent in the center of the composition (fig. 3), a favorite motif in van Huysum's later works, is the most direct reminder of the vulnerability of the flowers. The significance of certain flowers in the emblematic literature such as the anemone, a specific symbol of passing beauty, and the crown impe-

FIGURE 2. Jan van Huysum, *Flowers in an Urn*. Pen and brown ink with wash, 7³/₄ x 6¹/₈ in. (19.7 x 15.5 cm.). Berlin, Staatliche Museen Preussischer Kulturbesitz, Kupferstichkabinett, KdZ 2816.

FIGURE 3. Jan van Huysum, *Bouquet of Flowers in an Urn* (detail).

rial, which stood for moderation in youth,[8] may have enriched the general message of the composition. Even the vase may relate to the *Vanitas* theme. The putti adorning it—apparently inspired by the relief sculptures of François du Quesnoy but designed by van Huysum himself, and similar to those found on vases in many other paintings by van Huysum—engage in frivolous activities such as drinking and dancing, against which *Vanitas* emblems and literature warn. Since this type of pottery was fashionable in the early eighteenth century, however, we cannot be sure that its presence here was actually intended to carry a moral.

The compositional type of our painting, an abundant, overflowing bouquet on a stone ledge with a light yellow-green background of distant trees, first appears in van Huysum's works of 1720–22.[9] In the Carter panel, as in many of van Huysum's works of the 1720s, the flowers seem to have fallen accidentally out of the vase. Later in the 1730s van Huysum puts flowers, fruit, and often a bird's nest on the ledge, sometimes overhanging precariously as *trompe l'oeil* devices. Many of the flowers here, such as the crown imperial, the yellow rose, the yellow

flax, and the broken tulip, appear in other works by the artist.[10]

The pale yellow-green landscape background, whose open lawn and feathery trees suggest a park, occurs in many of van Huysum's works after 1720. Such parks are common in the work of de Heem, Weenix, and others; but the pale tonality and amorphous tree forms in our painting are van Huysum's invention. This fanciful decorative setting, painted loosely and suggestively, resembles the landscape backgrounds in the late works of Adriaen van der Werff[11] and anticipates the practice of English portrait painters later in the eighteenth century, especially Gainsborough and Reynolds.

The Braamcamp collection in which this painting figured was among the most renowned in Europe during the eighteenth century; his van Huysums were praised and coveted by the collector's contemporaries.[12] We know from J. F. de Bastide's lengthy description in verse of the collection that the van Huysums hung in the Grand Salon which overlooked the elaborate garden behind Braamcamp's house on the Herengracht.[13]

1. The sale catalogue does not clearly distinguish the two collections, but the Carter painting probably belonged to Meerdervoort since it appears at the beginning of the catalogue. The painting, described as "Een extra fraye Bloempot, kragtig en uitvoerig geschilderd door Jan van Huysum, in zyn beste tyd, h. 2v. 8d., br. 2v. 1d." fetched the highest price at the auction, 1,245 guilders (Hoet, *Catalogus*, vol. 2, p. 269, no. 8).

2. HdG 43 and Grant (*van Huysum*, no. 4) mistakenly identify the Carter painting as no. 91 in the Braamcamp sale.

3. HdG 43.

4. F. Schlie, "Sieben Briefe und eine Quittung von Jan van Huysum," *Oud-Holland* 18, 1900, p. 141.

5. Paintings by van Huysum with two dates are *Vase of Flowers*, 1723/24, and *Fruits and Flowers*, 1732/33 (Grant, *van Huysum*, nos. 19, 162).

6. His *Still Life with Flowers* in the Amsterdams Historisch Museum, which bears an inscription from Matthew 7:28–29, demonstrates most clearly that van Huysum's paintings could bear explicit moralizing messages. As early as 1604 elaborate bouquets closer to Huysum in spirit than to Bosschaert were used as *Vanitas* emblems in a series of etchings by Theodor de Bry after compositions by Jacob Kempener (Münster and Baden-Baden, *Stilleben in Europa*, exh. cat., 1979–80, fig. 176).

7. For these symbols, see Ambrosius Bosschaert, cat. no. 4, notes 9–11.

8. Joachim Camerarius, *Symbolorum et Emblematum ex Re Herbaria*,

Nuremberg, 1590, nos. 69, 71, cited by Albert Henkel and Albrecht Schöne, *Emblemata Handbuch zur Sinnbildkunst des XVI. und XVII. Jahrhunderts*, Stuttgart, 1967, cols. 308–9.

9. A canvas dated 1720, last recorded in a sale in Genoa (Pallavicino Grimaldi, November 29, 1899, no. 14), is the first dated work with this type of background.

10. The crown imperial and the yellow rose are found, for example, in paintings in the Rijksmuseum, the Glasgow Art Gallery and Museum, and in several English private collections (Grant, *van Huysum*, nos. 1, 10, 11, 20). The yellow flax—the long, thin-stemmed flower in the lower right corner of our panel, one of the materials used to make artists' canvases—appears in a painting dated 1722 in the collection of Edmond de Rothschild (Grant, *van Huysum*, no. 22).

11. See, for example, the *Holy Family* of 1714 (Amsterdam, Rijksmuseum).

12. Dirck Smits mentions Braamcamp's van Huysums in his eulogy of the man and his collection in Johan van Gool's *Die Nieuwe Schouburg der Nederlantsche Kunstschilders en Schilderessen*, vol. 2, The Hague, 1751; and J. F. de Bastide (*Le Temple des Arts*) wrote eloquently of the flower still lifes in the collection. M. d'Argenson (probably Marc-René Marquis d'Argenson) offered in a letter of 1762 to pay Braamcamp any price for his van Huysums; Braamcamp refused the offer (Bille, *De Temple der Kunst*, pp. 39, 64).

13. Bille, *De Temple der Kunst*, pp. 81, 226.

Philips Koninck
1619–1688

The son of a wealthy goldsmith, Philips Koninck was born in Amsterdam in 1619. He was trained by his older brother Jacob in Rotterdam, where in 1640 he married the sister of Abraham Furnerius, a Rembrandt follower whose drawing style is close to Koninck's. By 1641 he had returned to Amsterdam, where he lived thereafter. Cornelia Furnerius died in 1642 and Koninck remarried in 1657. Like so many Dutch artists, Koninck supplemented his income by another occupation: he owned and operated an inland shipping company. A prosperous member of the middle class, Koninck was acquainted with many of Amsterdam's prominent citizens. He painted several portraits of his friend the poet Vondel, and also several subjects from Vondel's writings. Koninck died in Amsterdam in 1688.

Although he is known today primarily for his panoramic landscapes, Koninck was esteemed by his contemporaries for the portraits, genre scenes, and literary subjects he painted throughout his career. Houbraken's statement that Koninck studied with Rembrandt has no documentary support, but we know that in Amsterdam the two were acquainted. Koninck's early landscape style undoubtedly was influenced by Rembrandt and by Hercules Seghers as well. By the mid-fifties Koninck had developed his own distinctive painted landscape: a long, open view across the flat Dutch countryside in which the evocative power of space, light, and shadow is paramount. His compositions are mostly imaginary; he rarely depicted a recognizable site or building. After the mid-sixties an idyllic strain pervades Koninck's landscapes, which are populated with pastoral types or more elegant folk; his later portraits adopt the classicizing style popular in Holland after the middle of the century. Nearly three hundred drawings by Koninck are known, and about eight landscape etchings, with washes added to most impressions to emulate the tonal effects of prints by Seghers and Rembrandt.

16

Panoramic Landscape with a Village

Oil on wood, 11½ x 14¼ in. (29 x 36 cm.)

Collections: Thomas Sivright, Meggetland and Southouse (his sale, Edinburgh, Tait, February 18, 1836, no. 2921, as Rembrandt); S. B. Hog, Row, Doune, Perthshire (Sale, London, Sotheby, May 16, 1928, no. 10); [Asscher and Welker, London, 1928]; [P. de Boer, Amsterdam, 1936]; Dr. Lübbert, Schwante and South Africa; Lübbert family, South Africa to 1978; [Newhouse Galleries, New York].

References: Pantheon 1, 1928, p. 268; Horst Gerson, *Philips Koninck*, Berlin, 1936, p. 103, no. 9.

This small early landscape combines an extensive panorama with a close-up view of cottages by the side of the road. The improbable succession of different types of ter-rain and the sharp right angle of the river suggest that the composition is an invention of the artist. The brooding sky and emphatic pattern of light and shade that give many of Koninck's works their power are evident in the Carter painting.

It is not surprising that the picture was attributed to Rembrandt in the last century.[1] Although Rembrandt's painted landscapes of about 1638–40 surely influenced the Carter panel, there can be no doubt about its attribution to Koninck, whose compositions differ notably from those of the older master. Rembrandt never painted a pure panorama. Koninck, on the other hand, preferred broad

CATALOGUE NUMBER 16

views of flat land rendered in superimposed bands of alternating color and value. In this respect his works are more closely modeled after those of Hercules Seghers, whose moody panoramas set a powerful example for both Rembrandt and Koninck.[2]

Koninck introduces a characteristic element in this landscape, the sharply winding road that leads back into the distance. While other artists had frequently used more or less straight roads as a device to organize their views, to stress perspective, and to provide a route, as it were, for the vicarious traveler, none had thought to give the road such a serpentine course. After Koninck's first dated painting, of 1647, which has a straight road,[3] his paths turn dramatically, with the result that the foreground is compressed and the viewer has a slower, more complex imagi

nary passage through the landscape. The tight bend in the road in this picture makes the space beyond appear more accessible and less vast, thereby adding an unusual note of intimacy to a panoramic landscape.

The Carter composition is most closely related to several other small early paintings, the *Flat Landscape* in the Assheton-Bennett collection at the City Art Gallery, Manchester, dated 1648 (fig. 1),[4] and the *Wide River Landscape* in the Metropolitan Museum in New York, (fig. 2).[5] The latter is especially close in structure and spirit to the Carter painting, having some of the same anomalies of scale. Both are similarly persuasive in overall effect, which owes more to the powerful play of light and shade and the impression of vast distance than to any methodical attention to perspective. These small early paintings have a

68

FIGURE 1. Philips Koninck, *Flat Landscape*, 1648. Oil on wood, 11¾ x 16 1/16 in. (29.8 x 40.8 cm.). Manchester, City Art Gallery, Assheton-Bennett Bequest.

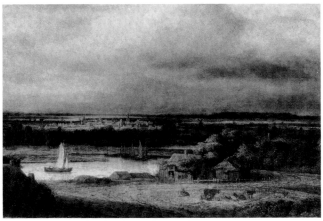

FIGURE 2. Philips Koninck, *Wide River Landscape*, about 1648–50. Oil on canvas, 12⅞ x 23½ in. (32.6 x 59.8 cm.). New York, Metropolitan Museum of Art.

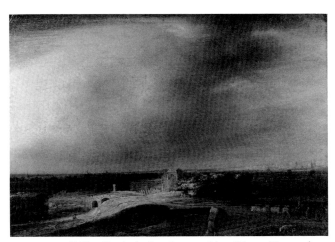

FIGURE 3. Philips Koninck, *Landscape with a Distant Town*, about 1645. Oil on wood, 8⅝ x 11⅝ in. (22 x 29.5 cm.). Lugano, Thyssen-Bornemisza Collection.

cohesiveness that is lacking in Koninck's large, ambitious works of the same years—for example those in the Metropolitan Museum (1649) and in the Sammlung Oskar Reinhart, Winterthur (1651).[6] Koninck's progress in these small paintings may be measured by comparing them with a panel in Lugano that has been persuasively attributed to Koninck and dated to the mid-1640s (fig. 3).[7] It is painted with a heavy impasto built up with many fine strokes whose vigor recalls Rembrandt's technique of the late thirties; but the horizontal bands on the horizon and the broad divisions of light and dark stamp it as an early work by Koninck. Only a few years later, in the Carter panel, Koninck had considerably refined his technique. His uneven impastos and uncertain outlines have given way to a more homogeneous surface, characterized by granular paint textures and softer, more suggestive modulations of tone to define form.[8]

1. The attribution was evidently strengthened by a false monogram, which has since been removed; an unidentified owner noted on a label on the back of the panel: "This Picture of Rembrandt was purchased by me at the sale of pictures belonging to the late Mr. Sievewright of Migget-land. Mr. David Loring shewed me Rembrandt's mark *R* in the right hand corner below." The owner noted the date, July 26, 1858, and signed with the initials JMH.

2. Gerson believed that Koninck absorbed the influence of Seghers through the art of Rembrandt (Gerson, *Koninck*, p. 21). Koninck could easily have seen works by Seghers in Amsterdam, however; by 1656 Rembrandt owned eight of his paintings, some of which Koninck must have known. Gerson describes Koninck's bands of changing tone as his own, but Seghers had employed a similar device, although less distinctly, in such paintings as the *Houses Overlooking a Valley* (Rotterdam, Museum Boymans-van Beuningen), *Village on a River* and *View of Rhenen* (both Berlin-Dahlem, Gemäldegalerie), and *View of Brussels* (Cologne, Wallraf-Richartz Museum).

3. *Landscape with Wanderers*, 1647, London, Victoria and Albert Museum (Gerson, *Koninck*, no. 34).

4. Ibid., no. 13.

5. Gerson did not know this painting, the lost original of which he listed in four copies (*Koninck*, no. XII); John Walsh, Jr., "New Dutch Paintings at the Metropolitan Museum," *Apollo* 99, 1974, p. 348, pl. v.

6. Gerson, *Koninck*, nos. 46, 60.

7. H. Gerson, "Dutch Landscape," *Burlington Magazine* 95, 1953, p. 48; and H. Gerson, "Bredius 447," *Festschrift Dr. h.c. Eduard Traut-scholdt*, Hamburg, 1965, pp. 109–11. There is a vigorous defense of the Rembrandt attribution, however, by J. C. Ebbinge-Wubben in *The Thyssen-Bornemisza Collection*, Lugano, 1968, pp. 282–83.

8. The value contrasts here have evidently been somewhat exaggerated in the course of time, as in many other paintings by Koninck, by the darkening of dark parts of the picture and by some thinning of the glazes that tone the light passages.

Aert van der Neer
1603/4–1677

Aert van der Neer was born in 1603 or 1604, probably in Amsterdam. According to Houbraken he began painting as an amateur while working as a steward for a wealthy family in Gorinchem. He became a professional artist when he moved to Amsterdam in the early 1630s but proved unable to support himself solely by painting; after keeping an inn in Amsterdam from 1659 to 1662, he declared bankruptcy; fifteen years later he died in Amsterdam in dire poverty.

Van der Neer is the most celebrated Dutch specialist in nocturnal and sunset landscapes. His subjects include winter scenes, landscapes with rivers or canals, views of towns with burning buildings, and marines. More than three hundred paintings by the artist are known. There is no record of van der Neer's formal training, but he apparently began as a figure painter; a genre painting of 1632 and a handful of biblical and historical subjects have been preserved. His early landscape style suggests the influence of Raphael Govertsz. and Joachim Govertsz. Camphuysen, whom van der Neer knew in Gorinchem and Amsterdam, and of Gillis d'Hondecoeter and Alexander Keirincx. With a few exceptions van der Neer's best works date from before his stint as an innkeeper. Large, repetitious compositions that lack the freshness and animation of his earlier works dominate van der Neer's production after the late fifties. His pupils were his sons Johannes and Eglon Hendrik; the latter became a well-known genre painter. It was not until artists of the Romantic period made the representation of sunlight or moonlight a subject in itself that van der Neer earned the fame that eluded him in his own lifetime.

17

Frozen River with a Footbridge

Signed, lower right: AVDN (joined)
Oil on wood, 15 x 19¼ in. (38 x 49 cm.)
Collections: Sir Montague John Cholmeley, 2nd Bt., Easton, (d. 1874); probably sale, London, Christie's, December 17, 1915, no. 117; Lindlar; probably sale, London, Christie's, November 30, 1917, no. 42; [Van der Kar]; Sale, London, Christie's, March 29, 1974, no. 67, repr.; [David Koetser, Zurich, 1974].

The painting represents a river winding into the distance, past farm buildings and towns on both banks. Skaters dot the ice, men play *kolf*, a sleigh laden with passengers moves along the bank, and a pair of travelers trudges in the direction of the viewer. Van der Neer's thin, translucent paint, applied to the brown ground of the panel, conveys the rich variation of tones in the almost colorless earth, trees, and buildings. His real virtuosity is evident in the sky, in which low, puffy clouds are surmounted by a thinner layer, all tinted to a play of blues, salmon-pinks, yellows, and rose by the declining sun.[1] Van der Neer's distinctive contribution to Dutch landscape is this combination of delicate observation and spectacle.

His winter scenes have an important place in the development of the genre in which Avercamp (cat. no. 1) was the pioneer. Van der Neer adopted the new emphasis on atmosphere, skies, and subtle illumination that had been progressively introduced by Esaias van de Velde, Jan van Goyen, and Isack van Ostade in their winter landscapes.[2] From the mid-1640s onward he combined the traditional busy variety of activities on the ice with breathtaking effects of light in the skies and reflected in the ice and snow, effects that came to dominate his pictures.[3] The gnarled

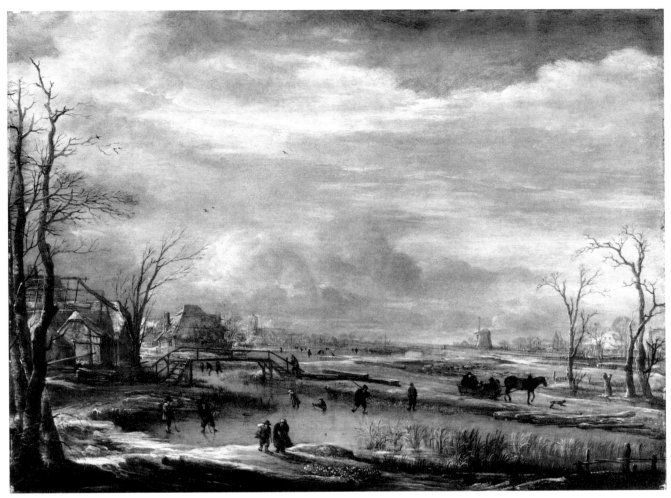

CATALOGUE NUMBER 17

FIGURE 1. Aert van der Neer, *Frozen River with a Footbridge* (detail; infrared photograph).

trees and picturesque buildings that had framed his compositions gave way to simpler foregrounds but did not entirely disappear from his work.[4] The Carter painting belongs to a group of small paintings van der Neer evidently executed from about 1650 to the early 1660s, in which he reduced the figures in number and size, the better to emphasize the sweep of his views, the binding atmosphere, and the tinted light.[5] The intimacy and informality of these pictures disappear from van der Neer's work after his latest dated winter landscape of 1662 or 1665, the only painting in the group that seems to bear a reliable date.[6]

An infrared photograph (fig. 1) brings out van der Neer's underdrawing and reveals his struggle to arrange the figures most effectively. A large figure in the center foreground was removed, and others were eliminated and replaced by smaller ones. The effect was to place the scene at a greater distance from the spectator and to produce a measured recession in the scale of the figures in order to make the illusion of the picture space more credible. A deceptively simple composition was thus the result of considerable experiment and calculation.

1. There has been some abrasion and restoration in the upper right corner of the sky.

2. For this development, see Stechow, *Dutch Landscape Painting*, pp. 84–95; Fredo Bachmann, *Die Landschaften des Aert van der Neer*, Neustadt an der Aisch, 1966, pp. 50–51.

3. Compare the paintings dated 1642 and 1645 (Hamburg, private collection, and Washington, Corcoran Gallery of Art; Stechow, *Dutch Landscape Painting*, figs. 181, 182).

4. Compare the *Winter Landscape* signed and dated 1643 (HdG 510, formerly Earl of Crawford and Balcarres) with the paintings listed in the next footnote, but note that the Carter painting and also the large *Frozen River* (Amsterdam, Rijksmuseum) of about 1655 retain the trees.

5. Similar paintings from the same period are *Ice Sports* (The Hague, Mauritshuis, bearing an unreliable date of 16[5]5), *Winter Landscape* (Munich, Alte Pinakothek), and *Winter* (Rotterdam, Museum Boymans-van Beuningen, no. 2309).

6. *Winter Sports on a Frozen River* (HdG 575, formerly Alfred Brod, London, repr. in *Apollo* 69, 1959, p. 113, not seen by us). Hofstede de Groot read the date as 1662, Stechow (*Dutch Landscape Painting*, p. 93) as 1662 or 1665.

Jan Porcellis
1580/84–1632

Jan Porcellis—or Joannes, as he seems to have been known in later life—was born in Ghent of parents who emigrated to the United Provinces in 1584; he was married in Rotterdam in 1605. Nothing is known of his training, but Houbraken says he was a pupil of the Haarlem sea painter Hendrik Vroom. Porcellis's earliest works do indeed suggest that he must at least have made a close study of Vroom's pictures. By 1615 he was a widower with three children, had gone bankrupt in Rotterdam, and had moved to Antwerp. He returned north in 1622 and settled for a few years in Haarlem, where he remarried and began to enjoy some success. In 1628 Ampzing could claim him as a Haarlem painter and assert that he was considered the greatest marine artist. In 1624 he was living in Amsterdam; by 1626 he had moved to Voorburg near The Hague; and by 1629 he had settled at Zoeterwoude outside Leyden, where the properties he amassed before his death in 1632 were testimony to his great prosperity. His son Julius, about whom little is known, evidently inherited Jan's practice. Until his death in 1654 Julius painted seascapes that resemble his father's in style and form of signature, creating confusion over attributions that has persisted until our own day.

Porcellis began painting marine subjects in the lively, anecdotal manner of Vroom, but by 1620 he was less interested in the glories of the Dutch fleet than in the sea and beach in their most ordinary aspects. During the 1620s he painted compositions of remarkable simplicity whose low horizons, towering skies, near-monochrome color schemes, and palpable atmosphere represented a reform in seascape that is comparable to the changes in contemporary landscape and still life. His influence is seen not only in the marines of Simon de Vlieger and many others, but also in the shifting skies and atmosphere of landscapes by Jan van Goyen and Haarlem painters of the late 1620s and 1630s. About thirty drawings have been preserved, a set of etchings, and a suite of engravings by Claes Jansz. Visscher after his designs. Porcellis's paintings, of which fewer than sixty are known today, were praised by seventeenth-century writers and evidently much appreciated by painters: Rubens owned one, Rembrandt six, Allart van Everdingen thirteen, and Jan van de Cappelle sixteen. Porcellis's reputation was eclipsed in the eighteenth century and not revived until his merits were recognized by the generation of critics whose values were shaped by Realism and Impressionism.

18

Vessels in a Moderate Breeze

Signed on plank, lower right: IP
Oil on wood, 16¼ x 24¼ in. (41.5 x 61.7 cm.)
Collections: [Nystad, The Hague]; Mrs. N. Crommelin-Waller, Laren and The Hague; [Nystad, The Hague, 1977].

References: John Walsh, Jr., *Jan and Julius Porcellis, Dutch Marine Painters*, diss., Columbia University, 1971, pp. 111–12, 236–37, no. A45; L. J. Bol, *Die holländische Marinemalerei des 17. Jahrhunderts*, Braunschweig, 1973, pp. 98, 102, fig. 98; John Walsh, Jr., "The Dutch Marine Painters Jan and Julius Porcellis—II: Jan's Maturity and 'de jonge Porcellis,'" *Burlington Magazine* 116, 1974, pp. 738, 741, fig. 30.

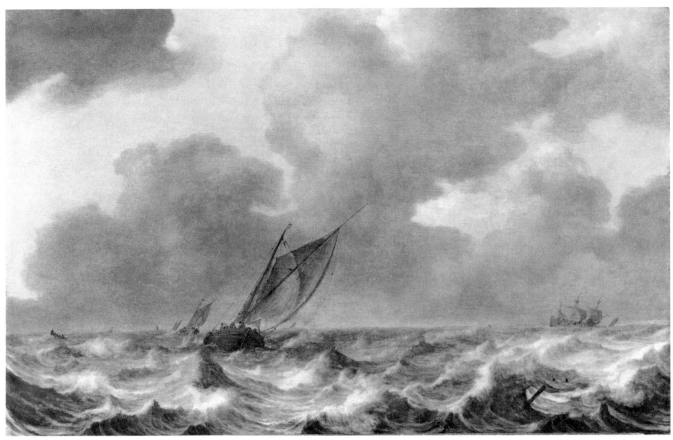

CATALOGUE NUMBER 18

Porcellis's picture represents three single-masted transport vessels sailing close-hauled toward the distant land, which is indicated only by a tower at left center and a suggestion of dunes at the right. A three-masted ship sails downwind at the far right.

The Carter painting is one of Porcellis's most extreme attempts to reduce the seascape to essentials: an expanse of open water, a few vessels, and a towering sky. Porcellis was an accurate recorder of forms, even those that are notoriously difficult to render such as moving water, cloud formations, and ships in motion. Yet the most impressive truth in such pictures is the atmosphere; it nearly eliminates local colors, mutes the value-scale, and thickens progressively to obscure the distant view. The result is a painting that is almost entirely gray, relieved only by the brown of the nearest vessel and the pale blue of the sky.[1]

The painting is related to a large drawing by Porcellis in the Louvre (fig. 1) in which a very similar transport vessel is seen stern-on, but which is differently composed and

likely to have been an independent work.[2] Porcellis's device for stressing the distance, a line of similar vessels that diminish dramatically in size, was used in a drawing of three *damloopers* he made for one of Claes Jansz. Visscher's engravings (fig. 2).[3] There the parade is toward the spectator; in the Carter painting the ships sail away, encouraging the spectator to assume that his viewpoint may be from a fourth vessel sailing in the wake of the others.

The Carter picture can be dated to the end of the 1620s, as the handling of waves and sky resembles that of a painting of 1629.[4] The broad expanse of empty sea and the subtle play with equilibrium in the placement of ships are found in several other works, among others the well-known little panel of 1629 in Munich[5] and a picture in Stockholm that appears to date from a few years earlier (fig. 3).[6] In all of these Porcellis reveals himself to be a great sky painter and the first artist who consistently exploited the expressive possibilities of skies. From the early 1620s onward he had not only lowered the horizon and

74

FIGURE 1. Jan Porcellis, *A Single-Master in a Moderate Breeze*. Ink and wash with white heightening on paper prepared with brown, 9³/₈ x 13³/₄ in. (23.8 x 35 cm.). Paris, Musée du Louvre.

FIGURE 3. Jan Porcellis, *A Single-Master with Reduced Sail in a Choppy Sea*. Oil on wood, 12¹/₄ x 21⁵/₈ in. (31 x 55 cm.). Stockholm, Nationalmuseum.

FIGURE 2. Claes Jansz. Visscher, *Damloopers groot omtrent 16 last*, 1627. Engraving. Greenwich, England, National Maritime Museum.

increased the proportion of sky to water, but he had also painted cloud formations of constantly varying form and illumination, which reinforced his compositions and set the mood of his pictures.[7] The new range of possibilities for skies must have been one of Porcellis's principal contributions to the art of his younger contemporaries.

1. The red-brown ground is now more visible than it would have been when the picture was painted, before the thin layers of gray became more translucent with age, and gives much of the painting a rosy tinge that is sometimes found in other works by Porcellis.

2. Inv. no. 23240, signed in monogram on a plank, lower left; it is much the largest of the thirty-odd Porcellis drawings that have been preserved (Walsh, *Porcellis*, p. 393, no. F25).

3. The drawing is in the Institut Néerlandais, Paris (inv. no. J.3441; M. J. Henkel, *Le dessin hollandais des origines au XVIIᵉ siècle*, Paris, 1931, pl. XLVII; Walsh, "Porcellis II," p. 737, fig. 27; Walsh, *Porcellis*, p. 385, no. F16). The print, which follows the drawing without significant alteration, is no. 3 in the suite of twelve engravings entitled *Icones Variarum Navium Hollandicarium*, issued by C. J. Visscher in 1627 (Walsh, *Porcellis*, pp. 430–33, nos. J11–12).

4. *Single-Masters in a Light Breeze*, signed and dated 1629, in the Stedelijk Museum 'de Lakenhal,' Leyden (Stechow, *Dutch Landscape Painting*, p. 113, fig. 221; Walsh, "Porcellis II," p. 738, fig. 29; Walsh, *Porcellis*, pp. 105, 224–25, no. A36; Bol, *Die holländische Marinemalerei*, p. 98, fig. 97).

5. *Single-Masters in a Rough Sea*, signed and dated 1629, Alte Pinakothek, Munich (Stechow, *Dutch Landscape Painting*, p. 113, fig. 219; Walsh, "Porcellis II," p. 738, fig. 28; Walsh, *Porcellis*, pp. 103–5, 221–23, no. A35).

6. Inv. no. 564; Walsh, "Porcellis II," p. 737, fig. 25; Walsh, *Porcellis*, pp. 102–3, 217–18, no. A32.

7. For a discussion of Porcellis's skies, see Walsh, "Porcellis II," p. 737.

Frans Post
1612–1680

Frans Post, son of a glass painter, was born in 1612 in Haarlem. He was probably taught by his brother, the painter and architect Pieter Post, and was evidently familiar with the work of such other Haarlem artists as Cornelis Vroom, Pieter de Molijn, and Pieter Saenredam. Post spent eight years, from 1636 to 1644, working for Prince Johan Maurits of Nassau in Brazil. Upon his return he settled permanently in Haarlem, and in 1646 he joined the guild.

Post's entire production seems to have consisted of Brazilian landscapes, nearly all executed in the Netherlands. Only six paintings, later presented to Louis XIV of France, and one drawing by Post are known to have been made in South America, and there are no secure works from before his trip. Immediately after his return the artist established his reputation with drawings for the etched illustrations in Caspar van Baerle's account of the Nassau administration's role in Brazil, *Historia de Rerum per Ostenium in Brasilia*. Although he was popular in his own time, Post's reputation had faded until about fifty years ago, when a resurgence in his popularity began.

Post's exact and somewhat naive style is unique in seventeenth-century Dutch landscape painting, although it reflects earlier Dutch and Flemish landscape and is influenced by contemporary developments. Post's freshest and most vivid landscapes date from the first decade after his return from the New World. His later, more contrived compositions are full of such decorative effects as jungle animals in the foreground and are sometimes dry and repetitious.

19

Brazilian Landscape with a Worker's House

Signed and dated on rock, lower center: F. POST/165[5?]
Oil on wood, 18¼ x 24¾ in. (46.5 x 62.9 cm.)

Collections: H. T. Höch, Munich (his sale, Munich, September 19, 1892, no. 167); Bayersdorfer; Germanisches Nationalmuseum, Nuremburg, by 1909; V. J. Mayring, Hollfeld, 1946; private collection, Switzerland; [David Koetser, Zurich, 1977].

Exhibition: The Hague, Mauritshuis, *So wijd de wereld strekt*, 1979–80, no. 107, repr.

References: Von Reber and Bayersdorfer, *Klassischer Bilderschatz*, 1897, no. 1050; T. van Frimmel, *Blätter für Gemäldekunde*, vol. 3, Vienna, 1907, pp. 124–25; *Katalog der Gemälde-Sammlung des Germanischen Nationalmuseums in Nürnberg*, Nuremburg, 1909, no. 396; Alfred von Wurzbach, *Niederländisches Künstler-Lexikon*, vol. 2, Vienna and Leipzig, 1910, p. 347; Robert C. Smith, Jr., "The Brazilian Landscapes of Frans Post," *Art Quarterly* 1, 1938, pp. 258–59; Rio de Janeiro, Museu Nacional de Belas Artes, *Esposicão Frans Post*, 1942, p. 14; Joaquim de Sousa-Leão, *Frans Post*, Rio de Janeiro and São Paulo, 1948, no. 18, repr. p. 29; W. Martin, *De Hollandsche schilderkunst*, vol. 2, Amsterdam, 1936, p. 468, fig. 246, 2nd ed., 1942, p. 468, fig. 246; Eduard Plietzsch, *Holländische und flämische Maler des XVII. Jahrhunderts*, Leipzig, 1960, p. 116, fig. 192; Erik Larsen, *Frans Post*,

Amsterdam and Rio de Janeiro, 1962, p. 103, no. 28, pl. 43; Joaquim de Sousa-Leão, *Frans Post*, Amsterdam, 1973, no. 22, repr.

Painted about a decade after Post had returned to Haarlem from his sojourn in Brazil (1636–44),[1] the Carter landscape recalls the pictures Post had executed in South America in its uncluttered composition and its sensitivity to the hot, tropical climate (fig. 1).[2] It is one of the few Brazilian views by Post that seems to capture a particular moment: two colonials on a shady balcony escaping the hot sun (fig. 3) while natives are dancing and working nearby. The open, sun-baked foreground, the dominant tawny-red tonality, and the close-up view of a relatively simple dwelling distinguish the Carter composition from the more elaborately contrived Brazilian landscapes the artist produced for twenty-five years after his return from the New World.

Post belonged to the group of artists, cartographers,

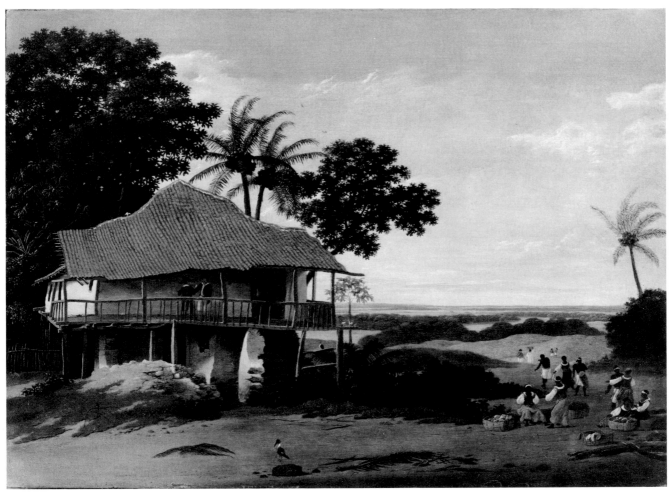

CATALOGUE NUMBER 19

FIGURE 1. Frans Post, *The Ox Wagon*, 1638. Oil on canvas. 24 x 34⅝ in. (61 x 88 cm.). Paris, Musée du Louvre.

and scientists who accompanied Count Johan Maurits van Nassau-Siegen (1604–1679) on the Dutch expedition to the territory of Brazil in 1636. Johan Maurits, sent to establish the operations of the Dutch West Indies Company and to suppress Portuguese and Brazilian resistance, revived the sugar industry and built the new capital, Mauritsstad, complete with canals and bridges, before he departed Brazil in 1644. A humanist as well as a soldier, he invited Frans Post, Aelbert Eckhout, and the cartographer George Marcgraf on the trip to record the terrain and the inhabitants of the new world.[3] Only six paintings made by Post in Brazil are known today, and even fewer drawings.[4] Yet he must have brought a great many sketches back to Haarlem, which would have been the source material for the South American scenes he painted subsequently.

The composition of the Carter landscape, with a building on one side and a panorama with natives walking or dancing down a path on the other side, is typical of many used by Post after his return from Brazil (fig. 1) and long after.[5] It is free, however, from the usual lateral "wing" of vegetation, sometimes inhabited by exotic animals,[6] that appears in most of Post's paintings, including the earliest (fig. 1), and gives them a somewhat stylized flavor. Here, in contrast, the foreground is open except for a few scattered reeds and a bird (fig. 2), and the artist assumes an unusually low and close vantage point; these devices give the Carter painting an immediacy and freshness that set it

apart from the bulk of Post's landscapes, which are elaborately composed and viewed from a greater distance. Its clarity and subtlety of color owe something to its excellent state of preservation.

The pictures Frans Post painted in Brazil show that he looked at South America with an eye trained by Haarlem landscape painters of a generation that cultivated simplicity of composition and color, the generation that included his older brother Pieter Post (1608–1699) and probably Cornelis Vroom as well. The paintings he made after his return make it clear that he continued to be affected by other artists' work; and although his own subjects were exotic, his compositions share many of the standard features of contemporary Dutch landscape, including the dark wedge of foliage he employs so often at one side of

FIGURE 2. Frans Post, *Brazilian Landscape with a Worker's House* (detail).

78

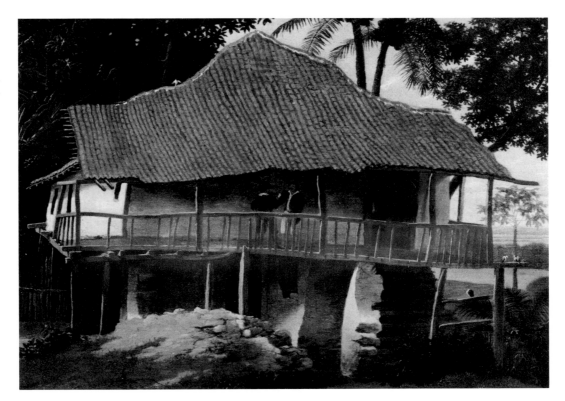

FIGURE 3. Frans Post, *Brazilian Landscape with a Worker's House* (detail).

his views (but not here) and the airy panoramic view of the distant countryside he accomplishes by summarizing its structure into a series of superimposed bands of differing tones. For much of his career, however, Post retained the old-fashioned Flemish device of distinguishing foreground, middleground, and background by zones of color —brown, paler green, and pale blue[7] respectively.

The rush-roofed house, whose balcony and eaves are supported by rickety wooden posts (fig. 3), is relatively

modest for a building in a Post landscape. Most often the artist represented churches, large plantation houses, or mills, more rarely the dwellings of the natives,[8] and only in the Carter painting the house of a *lavrador* (a worker, rather than the wealthy owner of a plant).[9] The *lavrador de cana* was hardly comparable to today's factory worker, however, as he owned slaves, and together with the *senhor de engheno*, or factory owner, he made up the white elite of seventeenth-century Brazil.

1. The date has generally been read as 1655, but the last digit is faint and might possibly be a 3. Robert C. Smith, Jr., ("The Brazilian Landscapes of Frans Post," p. 258) mistakenly gives the date as 1665.

2. Six works painted in Brazil have survived (Sousa-Leão, *Post*, 1973, nos. 1–6). According to Sousa-Leão another undated composition, lost in World War II (ibid., no. 60), was also executed in Brazil.

3. In a letter to Louis XIV dated December 21, 1678, Johan Maurits wrote that he had "Dans mon service le temps de ma demeiene au Bresil, six peintres, dont chacun a curieusement peint à quoi il était le plus capable" (Sousa-Leão, *Post*, 1973, p. 11). The identity of the other three is unknown; Sousa-Leão reports J. G. van Gelder's suggestion that Post, Eckhout, and Marcgraf each brought an assistant (ibid.).

4. See note 2; the only drawing surely made in Brazil is the *Sugar Mill* in Brussels (Sousa-Leão, *Post*, 1973, no. D21), used for one of Barleus's engravings. Sousa-Leão suggests that two other drawings were also executed in Brazil (ibid., nos. D20, D22).

5. For example, *A Village* of 1647 (Sousa-Leão, *Post*, 1973, no. 8), and such works of the sixties as *Engenho* of 1661 (ibid., no. 34), and *Engenho Real* of 1668 (ibid., no. 55).

6. For example, the pendants of 1649 in Munich (Sousa-Leão, *Post*, 1973, nos. 12, 13).

7. Clusters of pigment separated from the binding medium in these areas suggest that the paint has undergone a change from blue-green to pure blue, but it is probably wrong to claim that the change of color has been extreme, as does Sousa-Leão (*Post*, 1973, pp. 25–26).

8. *Huts in a Landscape*, 1659, Rio de Janeiro, Museu Nacional de Belas Artes (Sousa-Leão, *Post*, 1973, no. 30); and the drawing *Inghenio Maratapasipe in Brasil*, 1638, location unknown (Sousa-Leão, *Post*, 1973, no. D20).

9. The Hague, Mauritshuis, *So wijd de wereld strekt*, exh. cat., 1979–80, cat. by J. de Sousa-Leão, no. 107. Larsen's interpretation of the Carter landscape and the Rio de Janeiro *Huts in a Landscape* (note 8 above) as allusions to the imminent disintegration of Dutch power in Brazil and the dashed hopes of easy fortunes in the New World seems to us fanciful (*Post*, p. 103).

Adam Pynacker
1621–1673

The artist was born in 1621 in Pynacker, a village east of Delft from which he took his name. He is recorded in Delft in 1649, apparently lived in Schiedam in 1658, and later settled in Amsterdam, where he died in 1673. Houbraken reports that Pynacker spent three years in Italy. Whether or not he actually made the voyage, other Dutch Italianate painters, particularly Jan Both and Jan Asselijn, provided the example for his forest and harbor scenes and for the warm golden sunlight that pervades his pictures. His earliest dated works show that Pynacker developed his own version of the Italianizing style, whose hallmark was a detailed description of foreground vegetation. The sure draftsmanship of his figures was unequaled by any of the other Italianate painters; he was also a skilled painter of light and atmosphere, particularly in his harbor views, in which more than half the composition was devoted to sky and water. During the 1660s Pynacker's style hardened, his colors grew cooler, and his highlights became sharper and more pronounced. This late style has been criticized as unnatural and mannered, notably by Hofstede de Groot, who ranked Pynacker below the great "national landscapists" Salomon van Ruysdael and Philips Koninck. From Houbraken we know that Pynacker was highly praised during his lifetime, with no apparent distinction made between the early and late works.

20

View of a Harbor in a City (Schiedam?)

Signed on the bridge abutment, left center: AP
Oil on canvas, 21 3/4 x 17 7/8 in. (55.5 x 45.5 cm.)
Collection: [Newhouse Galleries, New York, 1974].

This composition is Pynacker's only known city view, and as an intimate harbor scene in an urban setting it is unique in seventeenth-century Dutch painting. Published here for the first time, the Carter painting exemplifies the ambitious, experimental nature of Pynacker's works from the early 1650s.[1]

The action in the painting is not entirely clear; the unlikely topography and the ambiguous attitudes of the two principal figures suggest that Pynacker was not interested in the description of a specific incident or place. A three-masted merchant vessel is moored at the quay in the background, her sails hoisted to dry in the light breeze, her decks laden with cargo. At the left a man reading aloud from a paper, possibly a news sheet or an inventory of the cargo vessel, has the attention of a group of listeners. In the foreground shallows is a ship's boat carrying a kedge

anchor and heavy line (which were intended to assist a ship, possibly the one in the background, to maneuver). The boatman appears to be discussing something with a man in fashionable regent's costume.

The most likely location for Pynacker's scene is Schiedam, close to Delft and Rotterdam, one of Holland's busiest seaports today and during the seventeenth century.[2] A deep-draft ship such as the three-master depicted by Pynacker could sail into Schiedam, but not into Delft or Amsterdam, where it could not enter the inner canals.[3] Curved drawbridges of the type in this painting were found in Schiedam. The unlikely combination of the shallow water and sandy ground in the foreground and the much deeper canal just beyond suggests that Pynacker's view may have been inspired by a location in Schiedam but that some of it may have been invented by the artist.

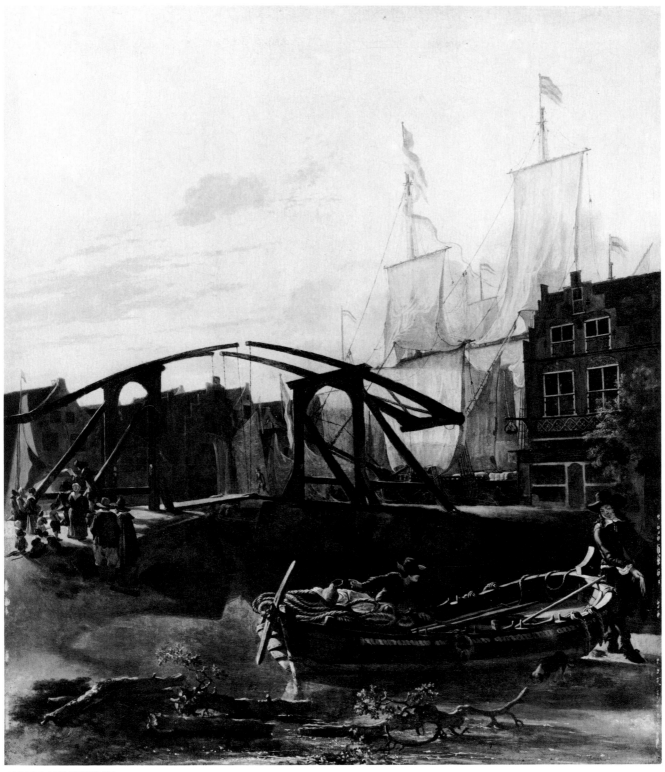

CATALOGUE NUMBER 20

FIGURE 3. Adam Pynacker, *Boat by a Stone Bridge*, about 1650–54. Oil on canvas, 30³/₈ x 24⁷/₈ in. (77 x 63.2 cm.). Private collection.

FIGURE 1. Adam Pynacker, *Landscape with Shepherd Blowing a Horn*, 1654. Oil on canvas, 81³/₈ x 68⁷/₈ in. (206.7 x 174.8 cm.). East Berlin, Staatliche Museen, Gemäldegalerie.

FIGURE 2. Adam Pynacker, *River View with a Boat*, about 1645–50. Oil on wood, 11³/₄ x 15³/₄ in. (30 x 40 cm.). Vaduz, Sammlungen des Regierenden Fürsten von Liechtenstein.

Several factors indicate a date in the early 1650s for the Carter painting: the golden light and warm tonality, the painstaking detail and sparkling highlights of the foreground branches, the still-insecure transition between the planes, and the exaggerated diminution of the size of the figures. In Pynacker's earliest dated work of 1654 (fig. 1) he also emphasizes the foreground staffage and does not entirely succeed in uniting the different parts of the composition. The masterful execution of the figures and the boat in the Carter painting is evidence of a more mature technique than that of the 1640s, when Pynacker must have painted the less-accomplished *Landscape with a House on the Water* (Berlin-Dahlem, Gemäldegalerie)[4] and the landscape in Vaduz (fig. 2). The strong outline of a bridge against the sky is a compositional device that Pynacker uses to advantage in other works of the early 1650s. In the *Landscape with a Bridge* (London, Dulwich College Picture Gallery) and the *Boat by a Stone Bridge* (fig. 3) Pynacker builds his composition around the arc of a bridge silhouetted against a sunny sky.

Although the picture seems to have been an isolated experiment for Pynacker, his attempt at a city view was part of a general trend in the 1650s toward urban subjects, pioneered by his Delft colleagues Carel Fabritius, Pieter de Hooch, and Joannes Vermeer.[5] Its upright format and intimate character have a certain affinity with compositions by de Hooch and Vermeer of the late 1650s and early 1660s. In later years the painted view of city

FIGURE 4. Reinier Nooms, *De Eenhoorn Sluys* from Various Views of Amsterdam, about 1650–55. Etching. Amsterdam, Rijksprentenkabinet.

harbors, a type of picture whose great masters were Jacob van Ruisdael and Emanuel de Witte, developed in quite different directions. Only in prints, such as Claes Jansz. Visscher's *Fishmarket* in his Profile of Amsterdam of 1611[6] or Reinier Nooms's series Various Views of Amsterdam of about 1655 (fig. 4), are compositions found that resemble Pynacker's combination of a bridge, tall ships, and city buildings. Unlike Pynacker's paintings, however, these prints are primarily topographically accurate portrayals of a particular site. Pynacker's poetic composition resists comparison except, perhaps, with his own paintings of fanciful Italian scenery in which he sets a bridge against an open sky.

1. J. N. Nieuwstraten, who is preparing a monograph on the artist, writes, "although its subject is wholly exceptional in the oeuvre of Adam Pijnacker, there can be no doubt that this view in a Dutch harbor town is an autograph work by this artist. . . . For stylistic reasons a date in the early fifties must be proposed" (letter, August, 1980). Another painting that shows the experimental nature of Pynacker's early works is a *Landscape with Boy and Dog* (The Hague, Nystad).

2. Nieuwstraten suggested Schiedam, probably somewhere along the passage between the Korte and Lange Havens, as the locale.

3. The large sailing vessel in Emanuel de Witte's *New Fishmarket in Amsterdam* of 1678 (Hartford, Wadsworth Atheneum) would, in fact, not have been able to pass through the lock in Amsterdam. See Hartford, *Wadsworth Atheneum Paintings: The Netherlands and the German Speaking Countries, Fifteenth–Nineteenth Centuries*, 1978, p. 178.

4. Blankert, *Italianiserende landschapschilders*, p. 189, no. 110, dates the painting to the 1650s. J. N. Nieuwstraten in his review of the

exhibition (*Burlington Magazine* 107, 1965, p. 272) dates it to the 1640s.

5. Carel Fabritius's *View of Delft* (London, National Gallery) is dated 1652; Pieter de Hooch settled in Delft about 1653 and his earliest dated works are from 1658; and Vermeer's *Street in Delft* (Amsterdam, Rijksmuseum) and *View of Delft* (The Hague, Mauritshuis) are thought to date from about 1661. Other town views from the 1650s are Daniel Vosmaer's and Egbert van Poel's views of Delft, and Saenredam's and Beerstraten's representations of the Old Town Hall in Amsterdam. Stechow considers Jan Wijnants's *View of the Herengracht, Amsterdam*, which he dates about 1660–62, to be "the first inner-city view by any Dutch artist of the Golden Age" (*Bulletin of the Cleveland Museum of Art* 52, 1965, p. 164).

6. M. Simon, *Claes Jansz. Visscher*, diss., Freiburg, 1958, pp. 101–3, 170–72, no. 160.

Jacob van Ruisdael
1628/29–1682

Born in Haarlem, Jacob van Ruisdael was the son and perhaps pupil of Isaack Jacobsz. van Ruysdael, a frame maker and dealer who reportedly also painted landscapes. In 1648 Ruisdael joined the Haarlem guild of painters. He traveled to the German border region near Westphalia in the early 1650s accompanied by Claes Pietersz. Berchem, his "great friend" according to Houbraken. By June 1657 Ruisdael had settled in Amsterdam, where he resided for the rest of his life, occasionally traveling within Holland. He was a prolific painter from the mid-1640s to the late 1670s, as evidenced by his more than six hundred surviving works. About a hundred drawings by him are known, and there are also thirteen etchings dating from before 1660. Ruisdael's early style shows the influence of Salomon van Ruysdael (cat. no. 22), his uncle and possibly his teacher, and of Cornelis Vroom. In the early 1650s he began to paint more extensive landscapes with more prominent and dramatic features, which reflect the example of the Italianate landscapists Both and Asselijn. His views of Bentheim Castle and its hilly surroundings from this period show Ruisdael's power to transform an actual site with his imagination. The waterfalls and Nordic scenery in his work after 1660 were based on Allart van Everdingen's paintings of Scandinavian motifs, but unlike van Everdingen Ruisdael never made the northern trip himself. About 1670 he adopted a novel upright format to accommodate the large proportion of sky in his famous panoramic views of Haarlem. Ruisdael also painted seascapes, beach scenes, and winter landscapes. He had a number of pupils, notably Meyndert Hobbema (cat. no. 14), as well as followers and imitators such as Jacob Salomonsz. van Ruysdael, Cornelis Decker, and Roelof van Vries. Ruisdael's vision of vigorous nature, and the powerful forces that animate it, worked for two centuries on the imaginations of landscape painters on the continent and in England.

21

View of Grainfields with a Distant Town

Signed, lower left: JvR (joined)...dael
Oil on canvas, 20 1/4 x 25 1/2 in. (51.5 x 65 cm.)

Collections: Freiherr von Brabeck, Söder, until 1814; Freiherr Andreas von Stolberg, Söder (his sale, Hanover, October 31, 1859, no. 230); Freiherr von Savigny, Berlin; [P. Cassirer, Berlin]; private collection, Sweden; private collection, Norway; [Frederick Mont, New York, 1970].

References: F. W. B. von Ramdohr, *Beschreibung der Gemälde-Galerie des Freiherrn von Brabek* [sic] *zu Hildesheim*, Hanover, 1792, no. 264; HdG 139a.

Although grainfields are not at all common in Dutch landscape painting, they had a particular appeal for Jacob van Ruisdael, who included them in more than twenty paintings from various periods in his career.[1] Here sunlight falls dramatically on a field that is still ripening and on another nearby that has been cut and bound in sheaves. Typically for the artist, the landscape is populated by a solitary traveler.

A field of grain appears in one of Ruisdael's early etchings, of 1648 (fig. 1), in a view restricted by the trees that border the field. The motif recurs in paintings of the 1660s and later, where it is sometimes relegated to the distance (fig. 2) and sometimes bisected by a road that recedes straight into the distance (fig. 3). In the Carter painting and a few others such as the one in the collection of the

CATALOGUE NUMBER 21

85

FIGURE 1. Jacob van Ruisdael, *The Field of Grain*, 1648. Etching and drypoint, 2nd state of 5. Amsterdam, Rijksprentenkabinet.

FIGURE 2. Jacob van Ruisdael, *The Cornfield*, about 1660–65. Oil on canvas, 24 x 28 in. (61 x 71 cm.). Rotterdam, Museum Boymans-van Beuningen.

Earl of Northbrook (fig. 4), the grainfields dominate the composition, but in no other picture is such a contrast made between two fields before and after the harvest. Ruisdael's paintings abound in potent contrasts between dark and light, near and far, empty and full, open and closed, and other polarities found in nature.[2] In the Carter composition many elements are counterposed, the uncut grain and the neatly bound sheaves, the green grass and the yellow grain, and the cultivated and uncultivated land. The treatment of the two fields of grain seems especially pointed, attracting attention to the human industry that has tilled the earth and to the specific season of late summer in which the grain is harvested.

Ruisdael, like other Dutch painters, made drawings outdoors but evidently composed and painted his pictures in the studio.[3] No drawing related to the Carter painting is known, and it is perfectly possible that the scene was largely invented.

This picture is distinguished from other versions of the theme not only by its emphatic geometrical organization but also by its delicate tonality, which is dominated by subdued gray-greens and the subtle grays of the clouds and is punctured by the warm hues of the grain struck by sunshine. The far-distant pastures and village, muted by the intervening atmosphere, are observed with great sensitivity.

None of the paintings of grainfields is dated, and Ruisdael's variations of style within any given period complicate the task of deducing dates for them. Some distinctions between them do, however, suggest a rough sequence. The Rotterdam landscape (fig. 2) probably dates from the early sixties, for its elaborate foreground dominated by a single tree can be seen as an evolution from such compositions of the fifties as the *Landscape with a Large Oak*[4] in Braunschweig that introduce monumental forms in the foreground. In other grainfield landscapes, such as the Carter painting and one in New York (fig. 3), the composition is generally more unified and the expanses of space are uninterrupted by shapes in the near distance. The cool tonality of the Carter painting also distinguishes it from the Rotterdam landscape and suggests a date for it in the late sixties or early seventies.[5]

J. T. Prestel (1739–1808) made a print after the Carter painting which he inscribed *Peint par J. Ruisdael . . . / Le Coup de Soleil/D'Après le Tableau Original de la Galerie de Soder appartenant à Mr. le Pr. de Brabeck . . .*" Prestel's title brings to mind Ruisdael's famous landscape called the *Coup de Soleil* in the Louvre, which had already been given its title by the early nineteenth century.[6] J. B. Descamps, who wrote about Ruisdael in 1760,[7] seems to have been the first critic to recognize the combination of imagination and reality in the artist's landscapes that inspired his admirers in the next century to invent such romantic titles as *Le Coup de Soleil* for his works.

The great critic and historian of Dutch art Théophile Thoré went to the Brabeck auction in 1859, where this picture was sold, and noted in his copy of the catalogue "usé et dur?"—not very accurately, but the question mark suggests that the picture may have been dirty or hard to see—and "vrai et original."[8]

86

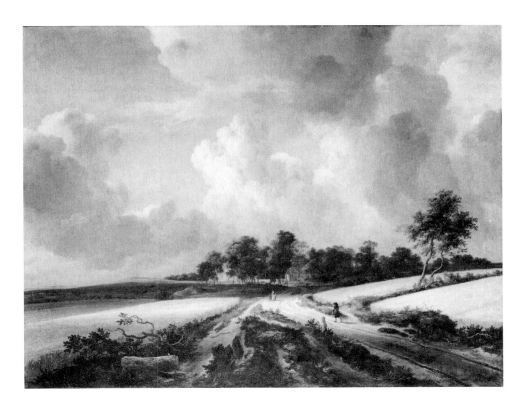

FIGURE 3. Jacob van Ruisdael, *Wheatfields*, about 1665–70. Oil on canvas, 39³/₈ x 51¹/₄ in. (100 x 130.2 cm.). New York, Metropolitan Museum of Art.

FIGURE 4. Jacob van Ruisdael, *The Cornfield*, about 1660–63. Oil on canvas, 17³/₄ x 28 in. (45 x 71 cm.). London, Earl of Northbrook.

1. Jakob Rosenberg, *Jacob van Ruisdael*, Berlin, 1927, nos. 71–92. Most closely related to the Carter painting are the works in the Thyssen-Bornemisza collection, Lugano (Rosenberg, no. 83), and in Rotterdam (Rosenberg, no. 92, our fig. 2).

2. For an analysis of Ruisdael's juxtaposition of opposites in the Rotterdam *Cornfield* (fig. 2), see R. H. Fuchs, "Over het landschap: een verslag naar aanleiding van Jacob van Ruisdael, *Het Korenveld*," *Tijdschrift voor Geschiedenis*, 1973, pp. 281–92.

3. About one quarter of Ruisdael's surviving drawings can be related to finished paintings. See Seymour Slive, "Notes on three drawings by Jacob van Ruisdael," *Album Amicorum J. G. van Gelder*, The Hague, 1973, pp. 174–77; and for a discussion of some literary evidence of landscape painters' thought and practice, see Fuchs, "Over het landschap," pp. 281–88.

4. Rosenberg, *Jacob van Ruisdael*, no. 74.

5. We are grateful to Seymour Slive for discussing the dating of the Carter picture with us and for sharing his collection of Ruisdael photographs.

6. Rosenberg, *Jacob van Ruisdael*, no. 413. The painting was known as *Le Coup de Soleil* when it first appeared in the literature (Filhol, *Galerie du Musée de France*, Paris, 1804; 1814 ed., no. 70, pl. 4).

7. J. B. Descamps, *La Vie des Peintres*, vol. 3, Paris, 1760, p. 11.

8. Preserved in the Rijksbureau voor Kunsthistorische Documentatie, The Hague.

Salomon van Ruysdael
1600/03–1670

Salomon van Ruysdael was born in Naarden sometime between 1600 and 1603, and in 1623 he joined the painters' guild of Haarlem. In his *Beschryvinge ende Lof der Stad Haarlem* of 1628, Samuel Ampzing mentions Ruysdael as a landscape painter in that city and praises him. Ruysdael served the painters' guild as overseer in 1647 and 1669 and as dean in 1648. He died in Haarlem in 1670. More than six hundred paintings dating from 1626 to 1669 are known, but no authentic drawings have survived. It is not certain who was his teacher, but his early works clearly depend on Esaias van de Velde (cat. no. 25). From the late twenties to the mid-forties he reduced the range of color in his landscapes and concentrated on effects of light and atmosphere, a development parallel to that of Jan van Goyen (cat. no. 11) and Pieter de Molijn. By the late forties he was painting more dramatic compositions with a greater variety of color, sharper contrasts of light and dark, and stronger structural accents, characteristics that became more pronounced in his later paintings. River scenes with ferries, already an important part of Salomon's work in the thirties, dominated his production after the mid-forties. His subjects also include market scenes, wagons halting at inns, winter landscapes, marines, beachscapes, a few equestrian battle scenes and religious subjects, a waterfall, and at the end of his career several powerful still lifes with dead birds. Ruysdael's son, Jacob Salomonsz. van Ruysdael, and Jan van Mosscher probably studied with him. His nephew Jacob van Ruisdael (cat. no. 21) may also have done so. François Knibbergen, Wouter Knijff, and Anthonie van der Croos are among his followers, as were a number of still-anonymous painters.

22

River Landscape with a Ferry

Signed and dated on ferry, lower left: S. v. Ruysdael 1650
Oil on wood, 20½ x 32⅞ in. (52 x 83.3 cm.)
Collections: Mrs. M. F. Brandt (Sale, London, Sotheby, November 16, 1955, no. 41); [L. Koetser, London]; A. E. Allnatt (his sale, London, Sotheby, December 6, 1972, no. 32); [Edward Speelman, London, 1972].
Exhibition: New York, Metropolitan Museum of Art, 1973.
Reference: Wolfgang Stechow, *Salomon van Ruysdael*, 2nd ed., Berlin, 1975, no. 363A, pl. 36.

A ferry laden with farmers and cattle glides across the river in this tranquil scene, which ranks among the finest and best-preserved paintings by the artist. Ruysdael is probably best known for his serene and majestic riverscapes of the 1650s, pictures that are distinguished by the freshness of their observation and their well-tuned harmony of form and color. In the Carter painting the shapes of the church and the tall trees leaning over the water are balanced by the ferryboat, while the upward curves of the trunks are echoed in the upswept, billowing clouds. The darkest colors, reserved for the trees, are countered by the warm, ruddy tones of the men and cows on the boat and by the pale harmonies of the distant shoreline. A detail of the ferry and horizon behind it (fig. 1) reveals the loose, spirited brushwork in this area and the tighter, more detailed strokes in the foreground.

The painted riverscape had been developed by Ruysdael and van Goyen in a series of remarkably similar compositions during the 1630s and 1640s, which depended in turn on the example of the earlier Haarlem artists Esaias van de Velde[1] and Pieter Molijn.[2] Although van Goyen took the lead in the late twenties,[3] Ruysdael soon followed in 1631

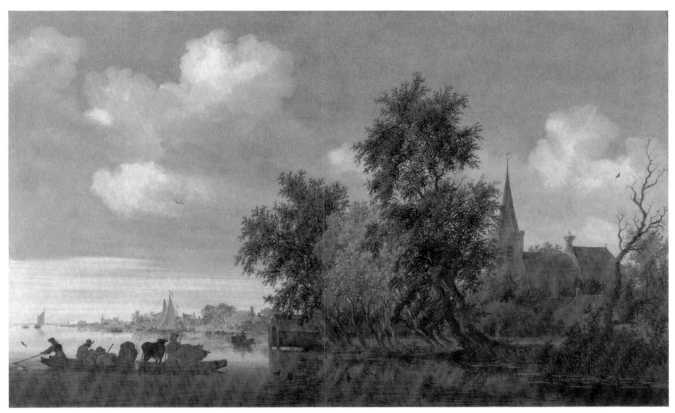

CATALOGUE NUMBER 22

FIGURE 1. Salomon van Ruysdael, *River Landscape with a Ferry* (detail).

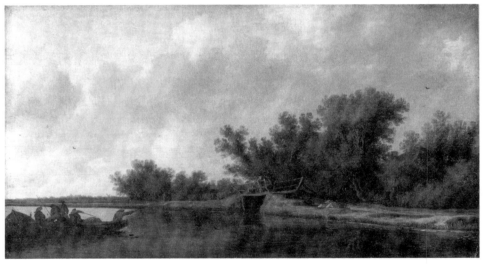

FIGURE 2. Salomon van Ruysdael, *River Landscape*, 1631. Oil on wood, 14³/₈ x 25³/₄ in. (36.5 x 65.5 cm.). London, National Gallery.

(fig. 2); he painted a number of especially successful variants on the theme in the forties and made it his specialty in the fifties.

The river landscape, with its combination of receding shoreline, a large body of water, and a substantial proportion of sky, offered a subject that proved as suitable as the Dutch dunes had been for the early experiments conducted by van Goyen and Ruysdael in simpler, more atmospheric landscape painting. The receding riverbank gave a natural perspective device; from the beginning, van Goyen and Ruysdael animated the shoreline by varying the size of the trees and by positioning houses in the clearings (fig. 2).

Despite the similarities between the paintings of the two artists in the 1630s, Ruysdael's can be distinguished by their softer and finer touch and by their cooler gray-green tonality.

The characteristics of Ruysdael's mature riverscapes of the 1650s[4]—in which he adopted a wider range of color, sharper contrasts of light and dark, a richer and thicker application of paint, and more complex compositions with strong horizontal and vertical accents—can already be discerned in the Carter panel. During the 1640s Ruysdael had complicated the compositional formula of the earlier riverscapes by introducing a sharp curve in the

water, causing the shoreline to disappear behind the immediate foreground and reappear in front of a distant bank. This device, first introduced in 1642[5] and fully realized by 1649, is repeated in a great many variations in Ruysdael's subsequent riverscapes, including the Carter painting. One such variant from the same year, and of nearly identical dimensions, has many of the same elements disposed in just the same way.[6] Yet it is the measure of Ruysdael's inventiveness that not one thing is repeated —sky, trees, buildings, ferry, animals, and figures are all different, as are the tonality and the interplay of landscape and clouds.

During the 1660s Ruysdael's expressive trees are even more prominent and the contrasts of light and dark more pronounced, but the structure of his river scenes remains the same. After his death there were no painters to continue Salomon's tradition of the peaceful river idyll, and it virtually disappeared from Dutch painting.[7]

The church in the Carter painting has not yet been identified, so we do not know the locale; realistic as it appears, the entire scene may simply be the artist's invention, for it is well known that Ruysdael sometimes placed recogniz-

FIGURE 3. Salomon van Ruysdael, *River Scene with Duck Shooting*, 1663. Oil on wood, 19⅞ x 27 in. (50.5 x 68.6 cm.). London, Terry-Engell Gallery, 1965. Photograph courtesy of the Witt Library, London.

able monuments in invented settings.[8] This same church, or one nearly identical to it, appears again in a painting of 1663 (fig. 3), this time situated in the open and placed parallel to the river.

1. Van de Velde's etching of about 1612–14, *The Brewery* (Ludwig Burchard, *Die holländischen Radierer vor Rembrandt*, Halle, 1912, no. 23), first employed the diagonal recession that later reappears in Ruysdael and van Goyen so frequently, although his two painted river scenes are composed more horizontally (*View of Zierkzee* of 1618, Berlin-Dahlem, Gemäldegalerie, and *The Ferry*, 1622, Amsterdam, Rijksmuseum). See Stechow, *Dutch Landscape Painting*, pp. 50–55.

2. The strong diagonal recession of Molijn's dune landscapes of the 1620s (*Sandy Road*, 1626, Braunschweig, Herzog Anton Ulrich-Museum) probably influenced the early riverscapes of van Goyen and Ruysdael.

3. Hans-Ulrich Beck, *Jan van Goyen 1596–1656*, vol. 2, Amsterdam, 1973, especially nos. 427, 432.

4. Notably the paintings of 1650, 1653, and 1655 (Stechow, *Salomon van Ruysdael*, nos. 363, 373, 401B, 374).

5. Hamburg, Kunsthalle (Stechow, *Salomon van Ruysdael*, no. 514).

6. The painting in the collection of A. Schwarz, Amstelveen, signed and dated 1650 (Stechow, *Salomon van Ruysdael*, no. 363; repr. in color in Dordrecht Museum, *Nederlandse landschappen uit de zeventiende eeuw*, exh. cat., 1963, no. 106, fig. 75).

7. One of the few river scenes in the spirit of Salomon van Ruysdael was etched by Jan van der Vinne (1663–1721), the view entitled *Te Scholenaar*, from the series *Gesigten buijten Haarlem*. See Irene de Groot, *Landscape Etchings by the Dutch Masters of the Seventeenth Century*, Maarssen, 1979, no. 247.

8. Ruysdael was not alone in doing so; see Stechow, *Dutch Landscape Painting*, pp. 8–9, for a discussion and literature.

Pieter Jansz. Saenredam
1597–1665

Son of the engraver Jan Saenredam, Pieter Saenredam was born in 1597 in Assendelft. He may have been first trained by his father, who died when the boy was ten years old. Two years later Saenredam went to Haarlem, where he was apprenticed to Frans Pietersz. de Grebber, a specialist in religious and historical subjects; in 1623 Saenredam entered the painter's guild there. He seems to have lived in Haarlem for the rest of his life, taking short trips to sketch the churches and other buildings of s'Hertogenbosch (1632), Assendelft (1633), Alkmaar (1634/35, 1638/39, and 1661), Utrecht (1636), Amsterdam (1641), and Rhenen (1644).

With the exception of several views of Rome based on drawings by Maerten van Heemskerk, the artist devoted himself to architectural subjects. By faithfully representing an architectural site, Saenredam broke with the prevailing tradition of fantasized architectural views, established in Antwerp in the late sixteenth century and continued by Saenredam's contemporaries Bartholomeus van Bassen and Dirck van Delen. Saenredam also deviated from tradition by not using architectural

23

Interior of the Mariakerk, Utrecht

Signed on the plinth, lower right: P.ʳ Saenredam fecit A: 1651
Oil on wood, 19 1/8 x 14 1/8 in. (48.6 x 35.8 cm.)

Collections: Mr. Alcott, Rugby; W. A. Coats, Edinburgh (Sale, W. B. Paterson, London, January 3, 1927, no. 175¹); Frits Lugt, Maartensdijk; Mrs. A. C. R. van Mandele-Vermeer, Bloemendaal, by 1927 (Sale, Amsterdam, Mak van Waay, November 15, 1976, no. 46); [London, Brod Gallery, 1976–77].

Exhibition: Utrecht, Centraal Museum, *Pieter Jansz. Saenredam*, 1961, English ed., no. 152a, pl. 153a.

References: W. A. Liedtke, "Saenredam's Space," *Oud–Holland* 86, 1971, p. 139, note 53; W. A. Liedtke, "The New Church in Haarlem Series: Saenredam's Sketching Style in Relation to Perspective," *Simiolus* 8, 1975–76, p. 164, note 62.

FIGURE 1. H. Tavernier, after Saenredam, *The North Side Apse of the Mariakerk, Utrecht*, about 1784. Pen and gray watercolor on paper, 19⅝ x 18¾ in. (50 x 47.5 cm.). The Hague, Koninklijk Huisarchief. Collection of Her Royal Highness Princess Juliana.

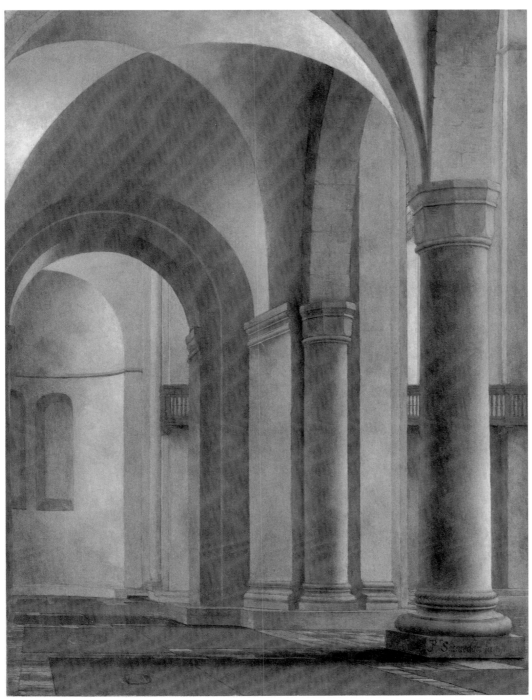

CATALOGUE NUMBER 23

93

scenes as backdrops for religious subjects, portraying architecture for its inherent interest instead. Occasionally he made allusions to contemporary political events and moralizing ideas in his pictures. He seems to have preferred medieval buildings, with their smooth surfaces and substantial parts, to seventeenth-century structures. For example, he depicted the old Town Hall in Amsterdam before and after the fire that destroyed it, but he seems never to have recorded van Campen's new Town Hall, a building renowned throughout Europe. Saenredam's compositions vary from grand views of the entire church to intimate glimpses down a side aisle. They result from a process of transforming a faithful sketch made on the spot into an elaborate drawing, which then became the basis for a coherent and satisfying painting. The sharp contrast of black and white in Saenredam's paintings of the thirties yields to a more subtle range of gray, yellow, and pink tones in his mature works. In his later works Saenredam's viewpoint becomes increasingly oblique, allowing him more freedom to manipulate spatial relationships. This subtle alteration of reality for pictorial ends was part of Saenredam's legacy to the next generation of architectural painters, led by Gerard Houckgeest and Emanuel de Witte (cat. nos. 28, 29). Other artists such as Isaac van Nickele and Adriaen van Ostade sometimes painted the figures in Saenredam's pictures.

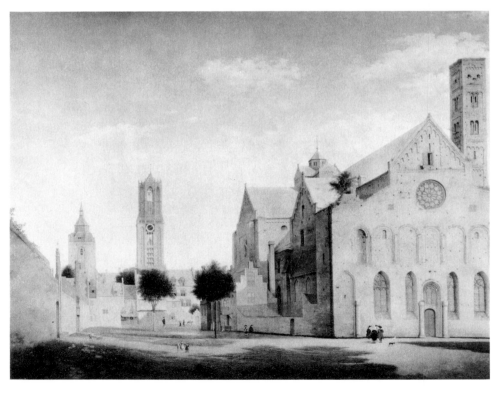

FIGURE 2. Pieter Jansz. Saenredam, *The Mariaplatts and Mariakerk, Utrecht,* 1663. Oil on wood, 43 1/2 x 54 3/4 in. (110.5 x 139 cm.). Rotterdam, Museum Boymans-van Beuningen.

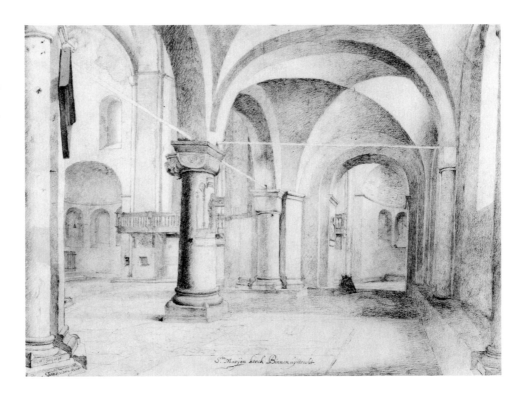

FIGURE 3. Pieter Jansz. Saenredam, *The Crossing and Side-Apses from the Southern Aisle, Mariakerk*, 1636. Pen and chalk, 12 x 15³/₄ in. (30.4 x 39.9 cm.). Utrecht, Gemeentearchief.

This panel is extraordinary in the purity of its concern with architectural form, color, and light. When it reappeared twenty years ago[2] it had figures, but these were obvious additions of the eighteenth century and were subsequently removed in cleaning. There are only a few other paintings by Saenredam that lack figures, and in two of these attention is drawn to notable monuments that adorn the churches.[3]

The painting shows the interior of the Mariakerk, a remarkable Romanesque building destroyed in the nineteenth century and whose appearance we know today largely from Saenredam's drawings and paintings (fig. 2). The view is down the north aisle toward the shallow side apse in the transept, with a glimpse of the choir screen at the right, above which soars the Gothic choir beyond. Although it is evidently quite faithful to reality, the painting is full of subtle adjustments that heighten its aesthetic and psychological effect. These are best measured by considering Saenredam's working method, which is now fairly well understood.[4] His surviving studies show that his habit was first to make a sketch in pen and watercolor on the spot and often to take measurements. Later, sometimes

many years later, he would prepare an elaborate construction drawing based on the sketch, his measurements, and the modifications he wished to introduce. The main lines of this construction drawing might then be transferred mechanically to the panel or canvas by blackening the paper on the verso and retracing them. Neither Saenredam's sketch nor his construction drawing for the Carter painting has been preserved, but fortunately an eighteenth-century copy of the sketch has come down to us (fig. 1).[5] The lost sketch for the Carter painting must date from Saenredam's only known visit to Utrecht in 1636, when he made numerous studies of the interior and exterior of the church that supplied him material for his paintings of the next twenty-five years.

A more finished sheet in Utrecht (fig. 3), representing the opposite side of the church and reversing the composition of our panel, demonstrates how carefully Saenredam chose the vantage point of the Carter picture. Although viewed from only slightly further down the opposite aisle (between the third and fourth bays), the Utrecht drawing encompasses a much wider view, demonstrating the extent to which Saenredam intentionally restricted the space in

95

the sketch (as it appears in Tavernier's copy) and in the painting.

The fact that the Carter panel lacks the customary bevels on all four sides of the back strongly suggests that it has been cut, but it is impossible to be sure where and how much. The Tavernier copy of Saenredam's sketch indicates, however, that the painting may have been trimmed at the left and the top.

Saenredam suppressed in the painting some details he had carefully noted in his sketch: the double string-course in the apse, the decorated blind window, and a few minor elements that would have detracted from the simplicity of the geometry. On the other hand, he added the peculiar low opening that accentuates the bottom of the wall to the right of the apse and emphasizes the shadows on the floor. He also opened the composition slightly on the right to include the barest suggestion of the choir wall beyond (suppressing the blind arcade that was actually there, but which would have broken the vertical stripe of light) to reveal the bottom of one of the high clerestory windows that light the choir. The relatively dim illumination and

heavy proportions of the Romanesque building are thus subtly contrasted with the airy brightness of its Gothic addition.

Recent investigations have shed light on the significance of many Dutch church interiors, in which parts of the building may be interpreted as religious metaphors,[6] as commemorations of an historical event and its implications for the present,[7] or as more general images of faith.[8] None of these associations or the familiar allusions to the theme of *Vanitas*[9] seem to apply to the Carter painting, where pictorial interests outweigh those of content. Lacking figures, symbolic details, or any prominent decorations, the Carter panel is an uncommonly spare and pure exercise in rendering volumes, voids, textures, and colors. Saenredam models forms by a subtle modulation of tones, and he discovers a marvelous variety of tints—pink, slate blue, gray, and tan predominating—in the masonry and the pavement as they reflect the gentle, diffuse light.

The significance of the Carter painting in Saenredam's development goes beyond that of an exceptional experiment in light and form. It exemplifies the trend in his work

FIGURE 4. Pieter Jansz. Saenredam, *Interior of the St. Laurenskerk, Alkmaar*, 1661. Oil on wood, 21 1/2 x 17 1/4 in. (54.5 x 43.5 cm.). Rotterdam, Museum Boymans-van Beuningen.

96

from the late forties onward toward simpler compositions animated by two-dimensional patterns of light and dark that culminates in the *Interior of the St. Laurenskerk, Alkmaar* of 1661 (fig. 4). In both we look down a narrow space through which alternating patches of light and dark lead to an illuminated far wall, and each has on the right side a narrow but significant view of another part of the church. By 1661, however, Saenredam's manipulation of space was even more sophisticated: not only does he show a view through a series of open doorways, but he also suggests a slight curve to the right through the positioning of the arches and doors.

1. The catalogue cannot be located; the information comes from the notes of Frits Lugt, kindly supplied by Carlos van Hasselt.

2. The painting was discovered after the close of the Saenredam exhibition in Utrecht in 1961, but was added to the catalogue (Utrecht, *Saenredam*, no. 152a).

3. The *Interior of the St. Pieterskerk, Utrecht* of 1644 shows the organ built by Gerrit Pietersz. in 1520, and the *Interior of the St. Janskerk, s'Hertogenbosch* of 1646 shows the altar by Hans van Mildert and altarpiece by Abraham Bloemaert. Saenredam's other unpopulated painting, the *Interior of the St. Janskerk, Utrecht* of 1650–55, has no such single monument, but is much larger and more ambitious than the Carter picture (Utrecht, *Saenredam*, nos. 174, 94, 138). In addition, there are a number of paintings containing figures added later; for example, views of the *Buurkerk, Utrecht* (ibid., no. 123, dated 1654; no. 128, dated 1645) and one of the *Mariakerk* (ibid., no. 153, dated 1637) whose modest content is closest to that of the Carter composition.

4. F. W. Heckmanns, *Pieter Janszoon Saenredam: das Problem seinen Raumform*, Recklinghausen, 1965; Heinz Roosen-Rung, "Naer het Leven: Zum Wirklichkeitsgehalt von Pieter Saenredams Innenraumbildern," *Festschrift für Wilhelm Eiler*, Wiesbaden, 1967, pp. 467–88; B. A. R. Carter, "The Use of Perspective in Saenredam," review of Heckmanns, *Burlington Magazine* 109, 1967, pp. 594–95; Liedtke, "Saenredam's Space," pp. 116–41; Liedtke, "The New Church in Haarlem Series," pp. 145–66. On the study of underdrawings on Saenredam's panels by infra-red reflectography, see J. P. van Asperen de Boer, "De ondertekening bij Pieter Saenredam: twee voorbeelden," *Bulletin van het Rijksmuseum* 19, 1971, pp. 25–31.

5. The attribution to H. Tavernier and the dating 1784 are based on a comparison with the artist's other copies of drawings by Saenredam in the Koninklijk Huisarchief, The Hague (see Utrecht, *Saenredam*, no. 152).

6. Gary Schwartz, "Saenredam, Huygens, and the Utrecht Bull," *Simiolus* 1, 1966–67, pp. 69–93.

7. See de Witte, *Interior of the Nieuwe Kerk in Delft with the Tomb of William the Silent* (cat. no. 28); and Arthur K. Wheelock, Jr., "Gerard Houckgeest and Emanuel de Witte: Architectural Painting in Delft around 1650," *Simiolus* 8, 1975–76, pp. 179–85.

8. Walter A. Liedtke, "Faith in Perspective," *Connoisseur* 193, 1976, pp. 127–133.

9. See de Witte, *Interior of the Oude Kerk, Amsterdam*, cat. no. 29.

Adriaen van de Velde
1636–1672

Son and brother respectively of the marine specialists Willem van de Velde the Elder and Willem the Younger, Adriaen van de Velde was baptized in Amsterdam in November 1636. He was probably first trained in his father's workshop. According to Houbraken he studied with Jan Wijnants in Haarlem, but Philips Wouwermans, who was also active in Haarlem in the fifties, may have exerted a more important influence upon Adriaen's early style. Van de Velde's collaboration with Wijnants in the sixties may account for the similarities in their mature landscapes. Paulus Potter seems to have set an example for van de Velde's forest scenes, his detailed renderings of animals, and the sharp, clear light in his works of the fifties. Aside from his Haarlem training Adriaen is not known to have left Amsterdam, where he is mentioned in 1657 and where he was buried in 1672.

Adriaen van de Velde was an extraordinarily versatile artist. Although best known for serene landscapes populated with animals and figures, his repertoire includes winter and beach scenes, portraits, genre paintings, an allegory, and religious subjects. A Catholic himself, van de Velde reportedly painted a Passion series for the Spinhuiskerk, a Catholic "hidden church" in Amsterdam. Other landscapists such as Jacob van Ruisdael (cat. no. 22), Jan Hackaert, and Frederick de Moucheron employed him to paint the staffage in their pictures. Landscapes with warm sunlight and Italianate motifs that reflect van de Velde's knowledge of the Italianate style appear throughout the artist's career and dominate his production from 1667 through 1672. Van de Velde made twenty-six etchings and many drawings, of which more than two hundred have survived. His preparatory studies demonstrate that he proceeded from a preliminary compositional sketch, to chalk studies of the animals and figures, to a finished drawing before executing a painting.

24

The Beach at Scheveningen

Signed and dated on boat, lower left: A v Velde f/1670
Oil on canvas, 15 1/2 x 19 3/4 in. (39.3 x 50.1 cm.)

Collections: Allegedly Pieter Stevens, Antwerp; de Guignes, Paris (his sale, Paris, January 17, 1846, no. 38); Leboeuf de Montgermont (his sale, Paris, June 16–19, 1919, no. 211, as dated 1630); A. Preijer (Sale, Amsterdam, November 8, 1927, no. 33); August Janssen (Sale, Amsterdam, F. Muller, November 30, 1932, no. 307); B. de Geus van den Heuvel, Nieuwersluis (his sale, Amsterdam, Sotheby Mak van Waay, April 26, 1976, no. 74); [G. Cramer, The Hague, 1976].

Exhibitions: Rotterdam, Museum Boymans, *Schilderijen . . . uit particuliere verzamelingen in Nederland*, 1939–40, no. 54, repr.; Rotterdam, Museum Boymans, *Het Nederlandse zee- en riviergezicht in de XVIIde eeuw*, 1945–46, no. 48, repr.; The Hague, Gemeentemuseum, *Zeven eeuwen den Haag*, 1948, no. 268; Schiedam, Stedelijk Museum, *Schilderijen . . . uit de verzameling van B. de Geus van den Heuvel, Amsterdam*, 1951–52, no. 80; Arnhem, Gemeentemuseum, *Collectie B. de Geus van den Heuvel*, 1960–61, no. 72, pl. 67; Dordrecht, Dordrechts Museum, *Nederlandse landschappen uit de zeventiende eeuw*, 1963, no. 125, fig. 114; San Francisco, Palace of the Legion of Honor; Toledo Museum of Art; Boston, Museum of Fine Arts, *The Age of Rembrandt*, 1966, no. 61, repr.

References: O. Hirschmann, "Die Sammlung A. Preyer im Haag," *Der Cicerone* 15, 1923, p. 136, repr.; Stechow, *Dutch Landscape Painting*, p. 108, note 29; L. J. Bol, *Die holländische Marinemalerei des 17. Jahrhunderts*, Braunschweig, 1973, p. 245, note 441.

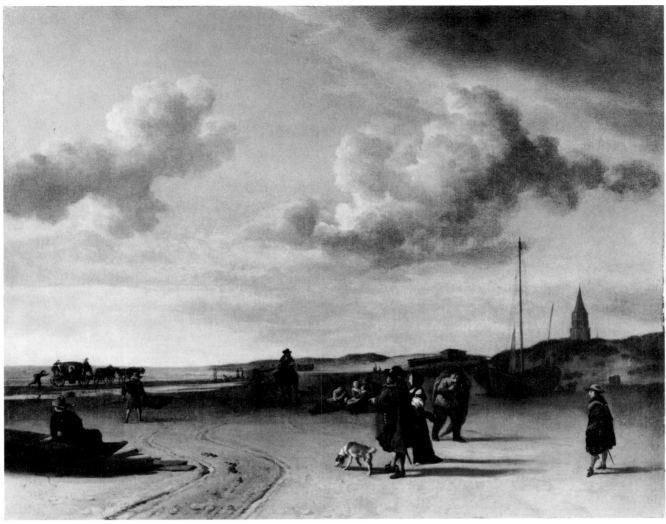

CATALOGUE NUMBER 24

This is the last of five beach scenes Adriaen van de Velde painted between 1658 and 1670. The group of beachscapes, tiny in proportion to the artist's output of landscapes with animals and figures, is nevertheless a great and original achievement. Van de Velde discovered a considerable range of human incidents and expressive devices in these five rather similarly composed pictures. The Carter example is the most somber of the group.

The scene is set on the beach at Scheveningen, the fishing village west of The Hague, looking north from a point near today's man-made harbor. From van de Velde's time until 1904, when the new harbor was dug, the fishing fleet was beached each day on the sands of Scheveningen and the catch traded on the spot. The beach was also a place of recreation, then as now, where people of all classes would stroll, ride, occasionally swim, and take the air. The earliest Dutch beachscapes—prints made to commemorate the stranding of whales—show crowds of citizens of all classes, from courtiers to common folk, witnessing the spectacle. A number of later beach views by such painters as Porcellis, de Vlieger, van de Cappelle, and Jacob van Ruisdael represent visits to the beach by well-dressed couples like the one in Adriaen van de Velde's painting.[1] These pictures, and the vogue for representations of fisher-

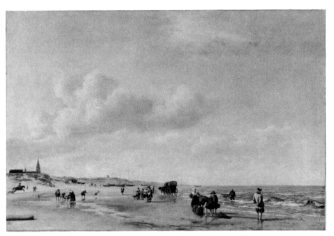

FIGURE 1. Adriaen van de Velde, *The Beach at Scheveningen*, 1658. Oil on canvas, 19⅝ x 28⅜ in. (50 x 72 cm.). Kassel, Staatliche Kunstsammlungen.

FIGURE 3. Adriaen van de Velde, *A Nobleman's Carriage on the Beach at Scheveningen*, 1660. Oil on wood, 14⅝ x 19¼ in. (37 x 49 cm.). Paris, Musée du Louvre.

FIGURE 2. Adriaen van de Velde, *The Coast near Scheveningen*, 1660. Oil on canvas, 17 x 21½ in. (43.2 x 54.6 cm.). London, Royal Collection. Reproduced by gracious permission of Her Majesty the Queen.

without blurring them."[3] This description applies best to the first of van de Velde's beach views (fig. 1), which shows various fisherfolk and a few visitors in patrician costume scattered across a wide expanse of shore, seen from a distance that reduces their scale and from a height that keeps them below the horizon. The paintings of 1660 in the Royal Collection and the Louvre are more animated and treat the encounters of the social classes more explicitly. The former (fig. 2) is full of activity: people walking, riding, swimming, playing, and lounging, while a prominently placed, well-dressed couple converses with a fisherman and a wagon carrying another city couple is greeted with a respectful gesture by a peg-legged old man. In the Louvre painting (fig. 3) the carriage of some great noble is followed by a train of footmen; like the other painting of this year it adopts a closer vantage point and fully reveals van de Velde's skill in painting figures. The picture of 1665 in the Mauritshuis (fig. 4) shows a group of peasants at one side of a composition dominated by an expanse of towering clouds and a sunny shore against which a man and two boys are silhouetted. In the Carter painting of 1670 the artist combines various elements he had used in the earlier beach scenes, but gives them a distinctly different flavor. There are few encounters between people: a boy chases a carriage in the background, a family converses on the beach, and an old fisherman looks in passing toward the city folk (fig. 5). Although no preparatory drawings for the painting are known, the carefully studied figures and relationships suggest that Adriaen

folk in prints and paintings, suggest that the beach may have sometimes represented more for city-dwellers than a place of clean air and amusement—perhaps a place where a freer and happier life could be led than in the town, a sentiment expressed by the prolific moralizing poet Jacob Cats in a verse of 1655, "On the Situation of a Young Woman of Scheveningen with a Basket of Fish on Her Head."[2]

Stechow wrote of the artist, "His day on the beach is the one which so many people miss on the Dutch beaches: the day when all forms stand out in unadulterated colors, bathed in fresh, clear light which softens their contours

FIGURE 4. Adriaen van de Velde, *Beach View*, 1665. Oil on wood, 16½ x 21¼ in. (42 x 54 cm.). The Hague, Mauritshuis.

may have followed his customary practice of preparing for the painting by a series of increasingly precise drawings.[4] The tone of the picture is set by the sharply silhouetted foreground figures looking out to sea (especially the boy at the far left) and by the declining afternoon sun and the subdued silvery tonality,[5] qualities shared by Jacob van Ruisdael's beachscapes of the seventies. In its air of still contemplation, it anticipates the moods of many nineteenth-century landscapes.

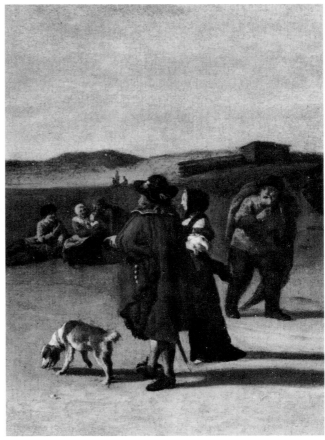

FIGURE 5. Adriaen van de Velde, *The Beach at Scheveningen* (detail).

1. Among others, the paintings by these artists in the Mauritshuis, The Hague: Porcellis's *Shipwreck off the Coast* of 1631 (cat. no. 969), de Vlieger's *Beach View* of 1643 (cat. no. 558), and van de Cappelle's *Ships off the Coast* (cat. no. 820). For the development of the beachscape, see especially Stechow, *Dutch Landscape Painting*, pp. 101–9.

2. Seymour Slive, *Frans Hals*, vol. 1, London, 1972, p. 144; Cats's poem was first associated with these pictures by Julius S. Held.

3. Stechow, *Dutch Landscape Painting*, p. 108.

4. For this process, see William W. Robinson, "Preparatory Drawings by Adriaen van de Velde," *Master Drawings* 17, 1979, pp. 3–23.

5. The painting is somewhat darker now than originally, owing to wear and to the normal process of increased translucency in the upper layers of paint, which have permitted the dark ground to become more visible than the artist intended.

Esaias van de Velde
about 1590–1630

Esaias van de Velde was born in Amsterdam about 1590, the son of a painter from Antwerp, Anthonie van de Velde, and the cousin of the printmaker and draftsman Jan van de Velde. Esaias' teacher is not known, but Gillis van Coninxloo (1544–1606) and David Vinckboons (1576–1632), both Flemings who settled in Amsterdam, influenced his early style. By 1610 van de Velde was living in Haarlem, where he married in 1611 and joined the guild in 1612. Six years later he moved to The Hague, where he lived for the rest of his life.

A key figure in the development of Dutch landscape, Esaias produced drawings and etchings from about 1612 onward that were novel in their low viewpoint, open skies, and cohesive compositions. He was the first artist to translate this new vision of landscape into paint. Van de Velde's small but potent pictures anticipate the atmospheric effects, the unifying tonality, and the humble subject matter of the next generation of the Haarlem landscape painters. After his move to The Hague, some of the multiplicity of color and detail characteristic of late-Mannerist landscapes reappears in certain of Esaias' paintings, but in the small sketchy pictures from these years he remains at the forefront of the new style. He also made purely imaginary landscapes, whose fanciful compositions and expressive contours have quite a different appeal. In addition, Esaias painted figure compositions, including some of the earliest and most unusual "merry company" scenes produced in Haarlem, as well as cavalry skirmishes and scenes of plunder, some of which are nocturnal. Van de Velde was an important influence on the early development of his pupil Jan van Goyen (cat. no. 11), and on the work of Salomon van Ruysdael (cat. no. 22) and Pieter de Molijn (1599–1661) as well.

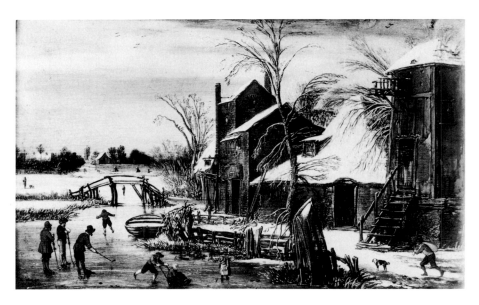

FIGURE 1. Esaias van de Velde, *Winter Landscape*, 1615. Oil on wood, 11 x 18⅛ in. (28 x 46 cm.). Leipzig, Museum der Bildende Künste.

CATALOGUE NUMBER 25

25

Cottages and Frozen River

Signed and dated, lower left: E. V. VELDE 1629
Oil on paper, mounted on wood, 8⅜ x 13¼ in. (21.2 x 33.5 cm.)
Collections: [D. Hoogendijk, Amsterdam]; private collection, Groningen, about 1948–80; private collection, Wassenaar, 1980; [Nystad, The Hague, 1980–81].

Van de Velde represents cottages by a river bank and gives a glimpse across the glassy surface of the river to a distant church tower. There are only a few figures, most of them engaged in mundane activities: a woman looks out the cottage door at a man who approaches, greeted by a barking dog; on the ice a man converses with another who has been pushing a sledge laden with firewood; a man skates; and in the background a few people walk toward the village.

The artist has made a sharp break with the conventions of earlier winter landscapes, in which the ice was a playground for the amusements of all classes, the snow and bare trees identified the season as midwinter, and there was little to obstruct an extensive view into the distance. A

comparison with Avercamp (cat. no. 1) demonstrates the change. Van de Velde has reduced the cast to a handful of people going about their ordinary occupations, has suggested the turn of seasons by the bare ground and green shoots on the branches, and has divided our attention between a view across the ice and a close-up study of fences, buildings, and trees. Color is reduced to browns, blues, greens, and a few touches of muted reds.

Esaias van de Velde's originality as a painter of winter scenes had been evident as early as 1614.[1] In the following year he painted a picture, now in Leipzig, for which he devised a compositional formula that he would again employ for the Carter painting and others, in which a group of buildings occupies half the picture and a frozen river the other half (fig. 1). He depicts the scene with a vigorous, suggestive handling of paint that differs greatly from that of Avercamp and the artists of his generation. A dozen-odd winter landscapes by Esaias followed in the years 1615–29, several of them variants of the intimate Leipzig

composition, such as the well-known picture of 1624 in The Hague. In 1629 van de Velde painted three such winter landscapes; in addition to the Carter example, there is a tiny panel in Cologne (fig. 2) and a larger one in Kassel (fig. 3). In all three the foreground is dominated by picturesque buildings, and the normal activities of the season, especially wood-gathering, are the main motif. Snow lies on the roofs and the ground in two of the pictures, but not in the Carter panel; it is this barrenness, relieved by the promise of new life in the branches, that gives the Carter picture its remarkable aspect. Van de Velde's pictures, like this one, are a significant contribution to the movement toward the new, sober, atmospheric painted landscape of which his younger contemporaries van Goyen and Salomon van Ruysdael were the chief exponents.

FIGURE 2. Esaias van de Velde, *Winter Landscape*, 1629. Oil on wood, 4³/₈ x 5⁷/₈ in. (11.2 x 14.9 cm.). Cologne, Wallraf-Richartz-Museum.

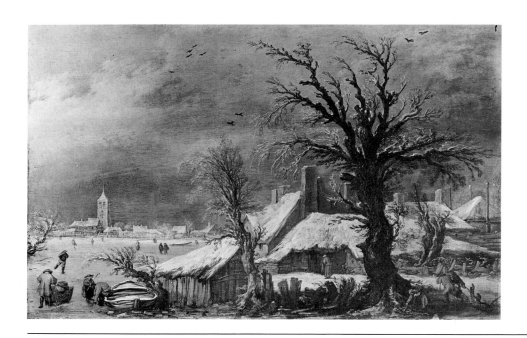

FIGURE 3. Esaias van de Velde, *Winter Landscape*, 1629. Oil on wood, 15¹/₈ x 23³/₈ in. (38.5 x 59.5 cm.). Kassel, Staatliche Kunstsammlungen.

1. In the painting in the North Carolina Museum of Art, Raleigh (Stechow, *Dutch Landscape*, p. 87, fig. 169). See also Esaias's etching *Winter Landscape with a Square Tower* (Ludwig Burchard, *Die holländischen Radierer van Rembrandt*, Halle, 1912, no. 34e), one of a series of landscapes of which one is dated 1614 (I. de Groot, *Landscape Etchings by the Dutch Masters of the Seventeenth Century*, Maarssen, 1979, no. 67). Stechow's characterization of Esaias's contribution to the winter landscape, pp. 86–87, is useful; also his "Esajas van de Velde and the Beginnings of Dutch Landscape Painting," *Nederlands Kunsthistorisch Jaarboek*, 1, 1947, pp. 83–93.

Willem van de Velde the Younger
1633–1707

Willem van de Velde the Younger was baptized in Leyden in 1633 and moved shortly afterward with his family to Amsterdam. His first teacher was his father, Willem van de Velde the Elder, a specialist in elaborately detailed marine drawings on panel and on vellum. His younger brother Adriaen (cat. no. 24) was also trained in his father's studio. Willem, however, adopted his father's specialty; the eclectic Adriaen did not. Willem the Elder frequently sailed with the Dutch fleet to record battles and historic events, and the Younger probably did the same. The artist's paintings of the fifties and sixties combine his father's painstaking accuracy of nautical detail with soft lighting and atmospheric effects that reveal the influence of Simon de Vlieger, with whom Houbraken claims Willem the Younger studied. This training may have occurred at Weesp, where de Vlieger seems to have resided in 1650 and where Willem met his wife, Magdalena Walravens, a native of Weesp. Van de Velde was married in Amsterdam in 1652. He appears to have remained there, aside from his probable forays with the Dutch fleet, until he left Holland for England in 1672, the year of the French invasion. In 1673 Willem painted several overdoors for Ham House. The following year he and his father were taken into the service of Charles II, the father to sketch sea battles, the son to make paintings from his father's drawings. Their tasks, however, were not so neatly divided. In his later years the Elder painted, and both artists were engaged in making drawings for tapestry designs in 1674. Except for short visits to Holland and the Younger's voyage with the fleet to the Mediterranean in 1693, the van de Veldes remained in England for the rest of their lives, first residing in Greenwich, where they were given the Queen's House as a studio, then later moving to Westminster. The Younger died in Westminster in 1707; his father had died fourteen years earlier.

Dated paintings by this prolific artist are known from 1653 to the year of his death. Twelve etchings and hundreds of drawings have also survived. The latter include fresh and summary impressions from nature as well as more meticulous studies of particular boats or events. After his move to England, van de Velde all but relinquished his earlier atmospheric seascapes for more formal, sometimes lackluster, portrayals of specific naval events. The van de Velde studio in Holland, and later in England, was highly influential for the later development of marine painting in both countries. Pupils completed or assisted with the master's paintings, a factor that complicates and qualifies judgments of authenticity. Willem the Younger has retained his high popularity since his death; he has always been particularly esteemed in England, where many of his paintings and the bulk of his drawings are located today.

CATALOGUE NUMBER 26

26

Beach with a Weyschuit Pulled Up on Shore

Signed on a piece of wood, lower center: WVV
Oil on wood, 12³/₈ x 17 in. (31.5 x 43 cm.)

Collections: Probably Richard Winstanley, by 1835 (his sale, London, Christie's, March 16, 1850, no. 57; [Holloway]; [Christie's, London]; [Alfred Grilten, London]; Major J. L. Curtis, Langford Hall, Newark, Nottinghamshire (his sale, London, Christie's, July 9, 1937, no. 95); [Horace Buttery, London]; [Thos. Agnew & Sons, London]; [P. de Boer, Amsterdam, 1962]; H. Becker, Dortmund, 1967–73.

References: Smith, *Catalogue Raisonné*, vol. 6, 1835, no. 150; HdG 344; R. Fritz, *Sammlung Becker, Gemälde alter Meister*, Dortmund, 1967, no. 89, repr.; Michael S. Robinson, *A Catalogue of Drawings in the National Maritime Museum Made by the Elder and the Younger Willem van de Velde*, vol. 2, Cambridge, 1974, no. 971.

This fresh and unusually spare beach scene probably represents the shore near Den Helder, an anchorage point for the Dutch fleet in the strait between the mainland and Texel at the entrance to the Zuider Zee north of Amsterdam.[1] Two *weyschuits* lie in the shelter of a groyne that extends into the sea; a larger one, which would have been used for fishing, has been rolled up on the beach. A man pulls a skiff into the water at the left, and at the right a ship's boat flying the six-striped "double prince" ensign approaches the beach, having been rowed to shore from a larger vessel. Four such ships are at anchor in the distance, two of them hidden except for the masts that peep above

106

FIGURE 1. Willem van de Velde the Younger, *A Weyschuit Hauled Up on Shore near Den Helder*, 1665. Pencil and wash on paper, 10 x 15 7/8 in. (25.2 x 40.3 cm.). Greenwich, England, National Maritime Museum.

the groyne. The picture is a tour de force of understatement, almost casual in its effect, by an artist best known as a master of the naval showpiece. The blond tonality unifies the scene, conveying the impression of sunlight muted by the clouds and the misty atmosphere and reflected by the warm yellow sand. A breathtaking touch is the tiny vista through the pilings at the left to the boats on the distant horizon.

Van de Velde used his drawing inscribed *Woonsdach den 20 Meij 1665* (fig. 1)[2] as a study for the painting. The inscription suggests that he made the drawing on the spot; he returned later to the sketch and worked it up into the Carter painting, a characteristic practice for him.[3] In the process he transformed a momentary sketch into a coherent composition with carefully distributed accents of light and dark and strategically positioned figures and boats, a kind of creative elaboration that recalls the working methods of earlier landscapists such as Jacob van Ruisdael (cat. no. 21).[4] The right side of the Greenwich sheet is empty except for the two boats faintly visible in the distance; van de Velde fills this space in the painting, balancing the figures on the right with the distant view on the left. The stocky figures are very different from those of Adriaen van de Velde, his younger brother, who sometimes painted the staffage in Willem's beach scenes. Although it seems certain that Willem painted the figures himself, he may have lifted a pose from Adriaen in the case of the man sitting on the beach, who appears to have been based on Adriaen's young boy seated on the skiff in the left corner of the Carter beach scene (cat. no. 24).

FIGURE 2. Willem van de Velde the Younger, *Sailboats Coming into Shore*, about 1670–74. Oil on canvas, 15 1/4 x 20 1/4 in. (38.7 x 51.3 cm.). Paris, Institut Néerlandais.

Probably about seven or eight years lapsed between the drawing and the painting, to judge from the uniformly pale tonality of the painting, which suggests a date after the late sixties, and from the "double prince" ensign, which fell out of use from about 1665 until 1673, when it was adopted again after Admiral Tromp returned to command the fleet.

A beach scene in the Institut Néerlandais, Paris (fig. 2), the only other painting by Willem van de Velde that is comparable to the Carter picture in composition and spirit, may have been based on the same drawing (fig. 1). By raising the vantage point to show the full panorama of

anchored vessels beyond the groyne, however, he produced a picture that lacks the casual intimacy and the subtle manipulation of views in the Carter painting.

The Carter picture is something of a novelty in the development of the Dutch beachscape. Since the early 1630s two types had developed, one showing a view out to sea from a high vantage point in the dunes, and another showing a view along the beach seen from a lower point.[5] Conforming to neither type, van de Velde does not give either the sweep of the beach or the distant expanse of the sea; instead he paints a slice of land and mere glimpses of the sea beyond the groyne, an arbitrariness that strikes today's spectator as distinctly modern and reinforces the lively sense of truth to nature it conveys.

1. The drawing on which the painting is based (see note 2) is inscribed on the back *voor de helder*. For help with topography, identification of the vessels, and van de Velde's chronology, we are indebted to Michael S. Robinson, who kindly gave us access to the manuscript of his forthcoming catalogue raisonné of van de Velde paintings.

2. Robinson, *Van de Velde Drawings*, vol. 2, no. 971.

3. Other examples of sketches that were used as studies for paintings are Robinson, *Van de Velde Drawings*, vol. 1, nos. 464, 465; vol. 2, nos. 1354, 1369.

4. See cat. no. 11; cat. no. 21, note 3; and cat. no. 22, note 8.

5. Of the first type, Porcellis's *Shipwreck off the Coast* of 1631 (The Hague, Mauritshuis) was followed by many others, including works by de Vlieger, van Goyen, van de Cappelle, and others; of the second, de Vlieger's *Beach near Scheveningen* of 1633 (Greenwich, England, National Maritime Museum) initiates a succession of examples by van Goyen, van Ruisdael, and Adriaen van de Velde, among others. See Stechow, *Dutch Landscape Painting*, pp. 101–9.

FIGURE 1. Willem van de Velde the Younger, *A Yacht and Other Vessels in a Calm* (detail).

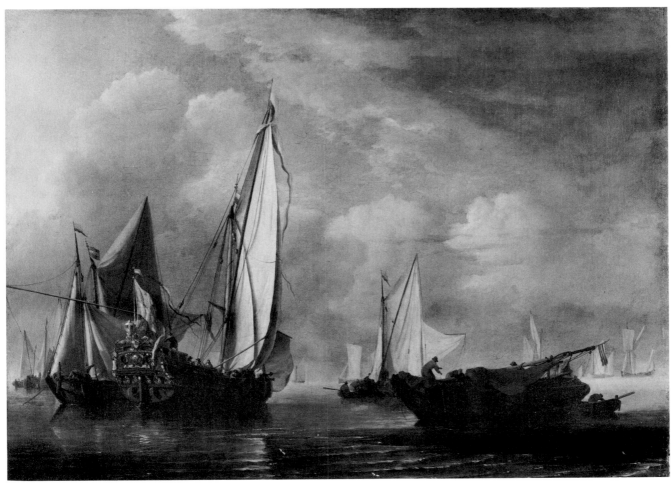

CATALOGUE NUMBER 27

27

A Yacht and Other Vessels in a Calm

Signed and dated on plank, lower right: . . . Velde 1671
Oil on canvas, 13 1/8 x 17 1/8 in. (33.3 x 43.5 cm.)

Collections: Despeniel, Paris, 1765;[1] Kalkbrenner (his sale, Paris, 1835); Nieuwenhuys; Joseph Barchard, by 1836 until 1842 at least;[2] sale, London, Sotheby, July 2, 1958, no. 35; [E. Speelman, London]; [Kleinberger & Co., New York, until 1959].

Exhibition: London, British Institution, 1836, no. 39.

References: Possibly Smith, *Catalogue Raisonné*, vol. 9 (supplement), no. 2; possibly HdG 263.

The elaborate decoration of the yacht's transom (fig. 1) identifies her as belonging to the United East India Company of Middelburg (the Vereenigde Ostindische Compagnie, whose initials are on the shield). A relatively light and speedy vessel, she was at the disposal of the officers of the company; here she ghosts along with sails barely full in the lightest of breezes, passing close to an anchored *kaag* (a small transport) and another *kaag* with rig lowered that lies close to a sandbank in the right foreground.

FIGURE 2. Willem van de Velde the Younger, *A Yacht and Other Vessels in a Calm* (detail).

FIGURE 3. Jan van de Cappelle, *A Small Vessel in Light Airs, and Another Ashore*. Oil on canvas, 13¾ x 18⅞ in. (34.8 x 48.1 cm.). London, National Gallery.

The picture teems with activity. Virtually every man is busy, ships are loaded or unloaded, sails are raised and lowered, and an anchor is handled (fig. 2). The steely-gray water reflects here and there the hulls, sails, and the massive clouds.

Van de Velde had been painting such calm seas and stately assemblages of ships since 1653,[3] taking as his model the paintings of Simon de Vlieger and Jan van de Cappelle (cat. no. 7). The Carter composition is very like one of Cappelle's that must date from some years earlier (fig. 3), although van de Velde elaborated the formula by the addition of many more ships. He had earlier painted a similar yacht seen from much the same vantage point in a picture dated 1654.[4] By 1671 van de Velde frequently adopted for these scenes of shipping in a calm the nearly square format he used here, and allowed himself a wider range of colors and values. There is a marked contrast between these more highly finished compositions and his beach views (cat. no. 26), which give an impression of greater spontaneity.

M. S. Robinson believes that the participation of van de Velde's studio assistants helps to explain the large number and variable quality of the paintings of this period, and that the artist may have had help in executing this picture.[5] The signature and date cannot be easily read, but a comparison of the picture with others of these years shows that a date of 1671 is perfectly reasonable.

1. The ownership from Despeniel through Joseph Barchard cannot be verified; information was provided by Kleinberger & Co.
2. The Sotheby sale catalogue of 1958 identified this picture as HdG 263, a painting Hofstede de Groot had not seen but for which he adapted the information from Smith (*Catalogue Raisonné*, vol. 9, no. 2). There are enough discrepancies in the dimensions and the description to make us uncertain that this is really the Carter picture.
3. The paintings in the Gemäldegalerie, Kassel, and the Hermitage, Leningrad (Stechow, *Dutch Landscape Painting*, figs. 238, 239). Stechow has a useful summary of Willem's career (*Dutch Landscape Painting*, pp. 119–21). See also L. J. Bol, *Die holländische Marinemalerei*, Braunschweig, 1973, pp. 231–44.
4. *A Fleet of Fishing-boats and a Yacht in Port in a Calm* (HdG 310), formerly Jonkheer H. A. Steengracht van Duivenvoorde, The Hague. According to the photograph mount in the Rijksbureau voor Kunsthistorische Documentatie, The Hague, it is signed and dated 1654.
5. We are indebted to Mr. Robinson for advice and for the use of his draft entry for the catalogue raisonné he is preparing, in which the ships are identified and the provenance examined.

Emanuel de Witte
1616/18–1692

Born in Alkmaar between 1616 and 1618, de Witte entered the St. Lucas Guild there in 1636. According to Houbraken he had been a pupil of the still-life painter Evert van Aelst in Delft, where he spent most of the 1640s before settling in Amsterdam about 1652. Plagued with financial difficulties, de Witte put himself under contract to a succession of patrons who served him as landlord and dealer. His first works from the early 1640s treat historical subjects, often in nocturnal settings. In the early 1650s de Witte and Gerard Houckgeest together transformed an earlier tradition of architectural painting in which views of the interiors of Dutch churches had been painted in a style of sober restraint. They developed in Delft a new type of picture characterized by an oblique view into the buildings, a free interpretation of the architectural site, strong contrasts of light and dark, and a vivid portrayal of activities in the church. De Witte specialized in church interiors after 1651, although he painted a few domestic interiors and harbor views and, after 1660, several market scenes that included portraits.

28

Interior of the Nieuwe Kerk in Delft with the Tomb of William the Silent

Signed and dated on the column, lower left: E. De Witte A 1653
Oil on wood, 32 3/8 x 25 5/8 in. (82.3 x 65 cm.)
Collection: [Newhouse Galleries, New York, 1978].

This painting, unknown until its recent reappearance,[1] is one of de Witte's most original works. It represents a view from the ambulatory of the Nieuwe Kerk looking westward through the screen of columns toward the large monument of William the Silent in the choir. Although the location was familiar to de Witte's audience, the extreme close-up view and the striking illusion of the swept-up curtain combine to produce a picture whose unprecedented boldness must have been as evident in the artist's own time as it is today.

By 1653 de Witte had already painted other views of the monument of William the Silent, and his Delft colleague Gerard Houckgeest had also done so (fig. 1).[2] It is not certain which of the two can claim credit for inventing the format that both employed, characterized by an oblique view through the columns into the choir and up into the space that soars above the monument. In any event the Carter painting is composed differently from these earlier views. The spectator stands close to the columns and al-

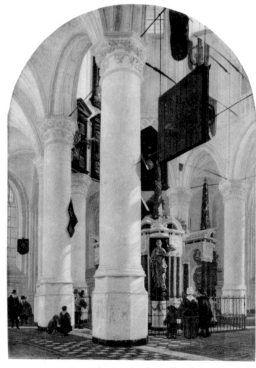

FIGURE 1. Gerard Houckgeest, *The Interior of the Nieuwe Kerk, Delft, with the Tomb of William the Silent*, 1651. Oil on wood, 22 x 14 in. (56 x 38 cm.). The Hague, Mauritshuis.

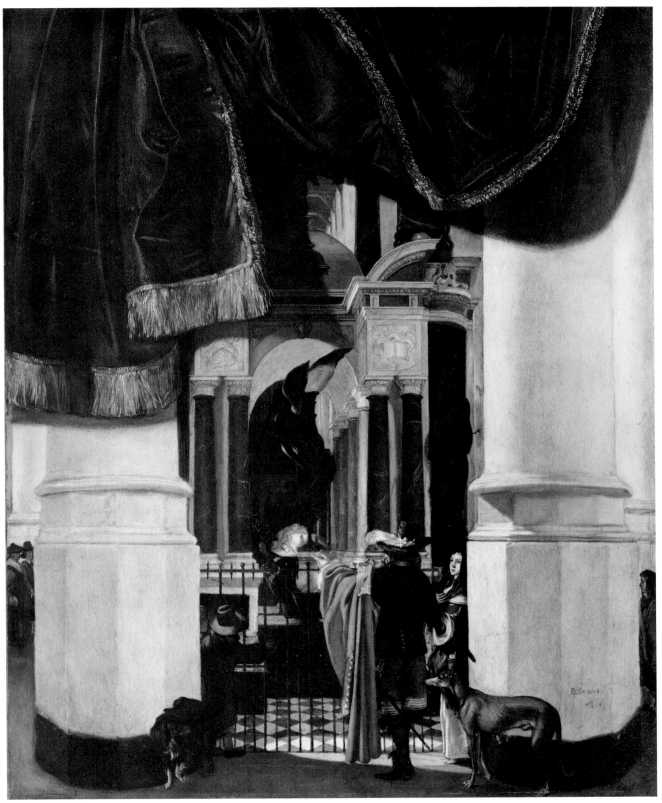

CATALOGUE NUMBER 28

113

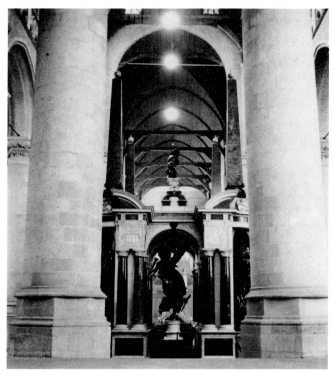

FIGURE 2. Interior of the Nieuwe Kerk in Delft with the Tomb of William the Silent (photograph: Thomas J. Schneider).

FIGURE 3. Emanuel de Witte, *Family Portrait*, 1678. Oil on canvas, 26 x 33 1/8 in. (66 x 84 cm.). Munich, Alte Pinakothek.

most exactly on the center line of the building, so that attention is focused on the sharply foreshortened monument and on the figures admiring it. The curtain blots out the vast space above and beyond the monument, allowing only a tantalizing glimpse of the nave vaulting, and further concentrates the view.

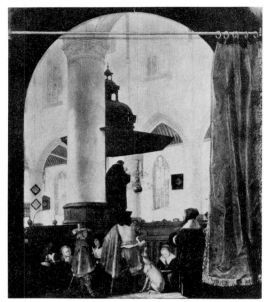

FIGURE 4. Emanuel de Witte, *The Interior of the Oude Kerk in Delft*, 1650–53. Oil on wood, 28 7/8 x 22 1/4 in. (73.5 x 59 cm.). Formerly Montreal, Mrs. William van Horne.

For de Witte, who often altered the architectural elements and distorted the space within his church interiors (see the *Interior of the Oude Kerk, Amsterdam*, cat. no. 29), this represents a relatively realistic view. The artist has only made one small change in the tomb: he has switched the positions of the reliefs above the double columns. Otherwise the church is portrayed accurately but seen from a low vantage point, as shown by comparison with a photograph of the site taken with a wide-angle lens (fig. 2). This low view enables the artist to emphasize the magnitude of the columns, which determine the unusually narrow scope of the composition. The unexpected viewpoint provides a perfect foil for the illusionistic curtain.

Since Dutch paintings were sometimes furnished with real curtains that could be drawn across the surface for protection against light and dust (fig. 3), artists occasionally painted imitation curtains to fool the eye.[3] Rembrandt's *Holy Family* of 1646 (Kassel, Gemäldegalerie) is the best-known example, but there are many others, including church interiors of the 1650s by Houckgeest, Hendrick van Vliet, and de Witte.[4] Not only does the curtain in this picture make a very early appearance in architectural painting, but it is also put to a rather different use than is common. We do not see the rod that is almost always shown supporting the curtain, usually emphasized by the choice of a curved top for the picture

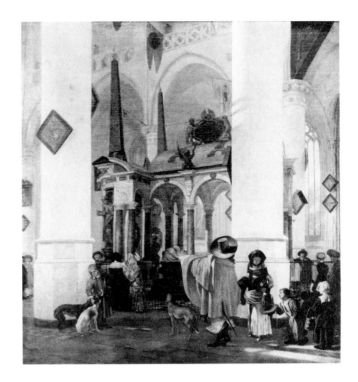

behind, so that the rod appears to extend across the painting from one frame edge to the other (fig. 4). Instead there is no rod visible, and the curtain is not drawn to one side but lifted up as though by an invisible hand. Rather than gently suggesting the intimate nature of the spectator's encounter with the picture, the curtain here resembles the rich swagged drapery placed above religious personages and important sitters in paintings from the Renaissance onward.[5] It asserts the artifice of the picture by its own robust form and by the strong shadow it seems to cast on what looks like the plane of the picture. The shadow seeks to distinguish the curtain from the two-dimensional painted image behind and implies that the curtain belongs to a world outside the painting, that of the spectator. In de Witte's only other painting in which a curtain casts a shadow, he mitigates the effect of the illusion by including the rod.[6] In our picture the curtain also gives honor and ceremonial significance to the scene represented.

In this painting, as in another of 1656 (fig. 5), a man gestures toward the tomb, evidently talking about it with his companion. The chronicler Dirck van Bleyswyck, de Witte's contemporary in Delft, urged his readers to visit tombs every day to contemplate death and the vanities of life (he might have added, even the death of princes).[7] It is easy to imagine that de Witte's couple are doing just this. His pictures frequently show graves and gravediggers (see

cat. no. 29), which are not only realistic touches but also aids to meditation on the brevity of life. Even such details as the dog relieving himself against the column seem to have been understood in the seventeenth century as allusions to the transitory nature of man and his creations.[8]

The monument was the Netherlands's most important shrine. Designed by the great sculptor Hendrick de Keyser, it was dedicated to Stadholder William I, Prince of Orange (1533–1584), who led the rebellion of the Northern Netherlands against Spain that eventually resulted in the creation of the Dutch Republic. It consists of a stone canopy, with bronze statues of Religion, Liberty, Justice, and Fortune at the corners, surmounting the marble figure of Prince William lying in state. Facing the nave is a bronze statue of William, represented seated and alert. At the feet of the recumbent effigy is a bronze figure of Fame blowing her trumpet to sound the eternal glory of the prince. It is this statue that is prominent in de Witte's picture.

There may have been a political motive for the production of so many paintings of the famous tomb by Houck-geest and de Witte in the 1650s.[9] William the Silent's grandson William II died in 1650 at the age of twenty-four after a brief, tumultuous reign in which he had angered the States of Holland and inflamed anti-Orange sentiment by trying to involve the Netherlands in a war with England. He was succeeded by his infant son William III,

leaving supporters of the House of Orange in great doubt about the future of the dynasty. As William II was buried in 1650 beneath the tomb of William the Silent, it is reasonable to suppose that paintings of this hallowed place, showing onlookers in respectful attitudes (fig. 1), not only honor the first Prince of Orange but reflect a nostalgia for the relative political stability of his era and may actually have been painted with an Orangist clientele in mind.

1. Ilse Manke (*Emanuel de Witte, 1617–1692*, Amsterdam, 1963, nos. 29–33) lists representations of the Nieuwe Kerk with the Tomb of William the Silent recorded in the seventeenth and eighteenth centuries and whose dimensions are unknown. The Carter painting may have been one of these.

2. Houckgeest's painting of 1650 (Hamburg, Kunsthalle) may be earlier than any of de Witte's versions of the subject, but there is an engraving after a painting of the *Interior of the Nieuwe Kerk, Delft, with the Tomb of William the Silent* credited to de Witte and dated 1650 (J. B. P. Lebrun, *Galerie des Peintres Flamands, Hollandais et Allemands*, Paris and Amsterdam, 1792, vol. 2, p. 31). For copies and variants, see Arthur K. Wheelock, Jr., "Gerard Houckgeest and Emanuel de Witte: Architectural Painting in Delft around 1650," *Simiolus* 8, 1975–76, p. 170, note 15. Lyckle de Vries ("Gerard Houckgeest," *Jahrbuch der Hamburger Kunstsammlungen* 20, 1975, no. 11) attributes this composition to Houckgeest. Since only the print and a number of variants and copies of unknown authorship survive, it is impossible to be certain about the inventor of the composition. Manke (*de Witte*, nos. 23, 24) attributes two other views of the Nieuwe Kerk to de Witte which she dates 1647–48 and 1650 respectively; Wheelock ("Architectural Painting," p. 170) doubts these attributions.

3. James A. Welu (*17th Century Dutch Painting: Raising the Curtain on New England Private Collections*, Worcester Art Museum, exh. cat., 1979, pp. 9–11) devotes a brief essay to this subject and cites earlier literature; see also C. Burda, *Das Trompe-L'Oeil in der holländischen Malerei des 17. Jahrhunderts*, diss., Munich, 1969, pp. 10–24.

4. By Houckgeest: *Oude Kerk, Delft, 165 . . .* , Amsterdam, Rijksmuseum; *Groote Kerk, Bergen-op-Zoom*, 1655, Copenhagen, Statens Museum. By de Witte: *The Interior of the Oude Kerk in Delft*, undated (early 1650s), formerly Mrs. William van Horne, Montreal, Manke, *de Witte*, no. 11, pl. 13, our fig. 4; *Oude Kerk, Amsterdam*, 1655, sale, Amsterdam (F. Muller), December 16, 1919, no. 104, Manke, *de Witte*, no. 73; *Oude Kerk, Amsterdam*, Kapstadt, Altes Stadthaus, Michaelis collection, Manke, *de Witte*, no. 54, pl. 37. By van Vliet: *Oude Kerk, Delft*, 1654, Leipzig, Museum der Bildenden Künste. No earlier church interiors with curtains are known. De Witte's painting in Montreal (fig. 4) is undated, and the last digit of the date of the Houckgeest in Amsterdam cannot be read (recent writers have supposed it to date 1654: Manke, *de Witte*, p. 22, fig. 14; and Timothy T. Blade, "Two Interior Views of the Old Church in Delft," *Museum Studies* 6, 1971, pp. 48–49, note 8).

5. Anne Hollander (*Seeing Through Clothes*, New York, 1978, pp. 23–58) discusses the evolution of the late-medieval Cloth of Honor into the background drapery of the seventeenth century.

6. *Oude Kerk, Amsterdam*, 1658, Kapstadt, Altes Stadthaus, Michaelis collection, Manke, *de Witte*, no. 54, pl. 37.

7. Dirck van Bleyswyck, *Beschryvinge der Stadt Delft*, Delft, 1667, vol. 1, pp. 270ff, cited in Wheelock, "Architectural Painting," p. 181.

8. Braunschweig, Herzog Anton Ulrich-Museum, *Die Sprache der Bilder*, exh. cat., 1978, pp. 171–72, no. 40.

9. Wheelock, "Architectural Painting," pp. 179–85.

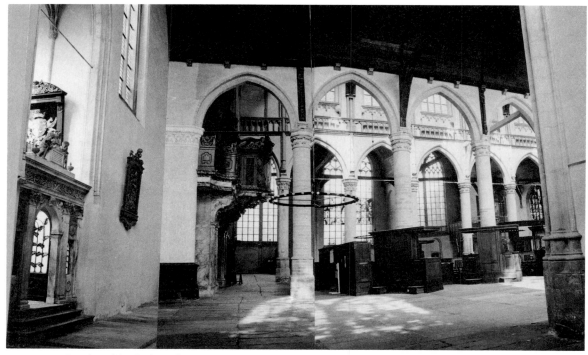

FIGURE 1. Interior of the Oude Kerk, Amsterdam (composite photograph: Thomas J. Schneider).

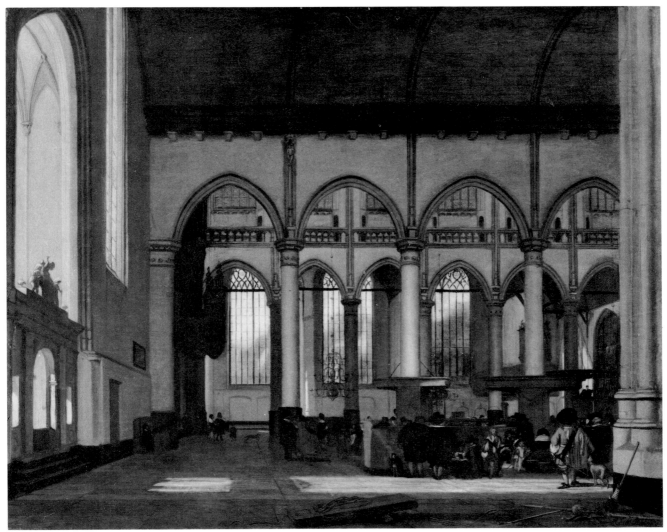

CATALOGUE NUMBER 29

29

Interior of the Oude Kerk, Amsterdam

Signed and dated on a paving stone, lower center: E. De WIT... 165...
Oil on wood, 18⅛ x 22⅛ in. (46 x 56.2 cm.)

Collections: Wierman, Amsterdam, 1762 (his sale, Amsterdam, August 18, 1762, no. 106);[1] N. Nieuhoff, Amsterdam (his sale, Amsterdam, April 14–17, 1777, no. 242); Wagenaer, Amsterdam; Sir H. Bedingfeld, (his sale, London, Christie's, May 31, 1902, no. 102); François Boucher, Paris; M. Salavin, Paris; [Frederick Mont, Inc., New York, 1968]; [Newhouse Galleries, New York, 1968].

Exhibition: Paris, Musée Carnavalet, *Chefs d'oeuvre des collections parisiens*, 1950, no. 85.

References: Edouard Trautscholdt, "Emanuel de Witte," in Thieme-Becker, vol. 36, p. 125; Ilse Manke, *Emanuel de Witte 1617–1692*, Amsterdam, 1963, no. 44, fig. 39; Wolfgang Stechow, "A Church Inte-rior by Emanuel de Witte," *Bulletin of the Cleveland Museum of Art* 59, 1972, p. 232, fig. 9.

De Witte represents a view in the Oude Kerk in Amsterdam from the south aisle across the west end of the nave toward the north aisle. The congregation listens to a sermon by the preacher, a tiny figure in the pulpit at the far right, while other people outside the stalls pay more or less attention to the service.

Among de Witte's paintings this one is remarkable for the sense of vast open space it imparts and for its strict

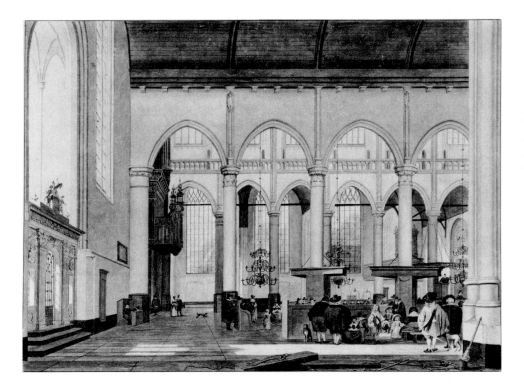

FIGURE 2. Cornelis Pronk, after Emanuel de Witte, *Interior of the Oude Kerk, Amsterdam.* Ink and wash, 12¼ x 17⅝ in. (33.6 x 44.9 cm.). Amsterdam, Koninklijk Oudheidkundig Genootschap.

planar organization. More than most works of the artist it recalls the more austere paintings of de Witte's predecessor Pieter Saenredam (see cat. no. 23).

De Witte chooses to render actual architectural details quite faithfully here. The leaves that decorate the column capitals are shown accurately, for example, while in other paintings of this church they are arbitrarily replaced by a pattern of interlocking wavy lines.[2] But the artist exercises his characteristic freedom to manipulate and alter the scene at his own convenience by exaggerating the length and width of the building. A composite photograph shot with a wide-angle lens (fig. 1) shows how much narrower the aisles and nave really are and, in particular, how much closer the entrance to the chapel of Cornelis de Graeff[3] is to the south wall and to the pews in the center of the church.

The apparent accidents of light and the seemingly casual placement of figures disguise the artist's knowing design of the composition. The dazzling light that fills the arc of the de Graeff chapel plays across the empty floor in a horizontal band and picks up the bright red cloak of the man at the right edge, a stock figure in de Witte's pictures. Here he helps to establish visual equilibrium while directing attention to the service at the rear. The volume of the building is made believable by the scale of figures in stra-

tegic places, such as the little family and the dog in the nave at the left (who are actually only halfway across the church from our vantage point).

The extreme foreground is marked by a newly lifted grave slab, tools, and skull, common motifs in Dutch paintings of church interiors, where they carry the obvious reference to human mortality.[4] Nearby are young children, one of whom studies a book with his mother, perhaps a suggestion of industry or piety to serve as a foil to the inevitability of death.

Although the last digit of the date cannot be read clearly, Manke was probably right in supposing it to be a 9.[5] The composition and technique are typical of de Witte in the late 1650s, having the wider open spaces, strongly horizontal organization, smaller figures, and tighter brushwork that characterize the other views of this church dated 1659, 1660, and 1661.[6] One of the most beautiful observations in the picture, the vague pink shapes in the windows made by the trees and houses outside—a motif already used in Netherlandish paintings of the fifteenth century[7]—is found in a number of de Witte's pictures of 1659–61 and becomes a rarity afterward.

A date of 1659 is supported by a bit of topographical evidence. By that year renovations of the small organ, located at the corner of the crossing close to the pulpit,

were finished.[8] Before the alterations de Witte had recorded its appearance in several pictures of the mid-1650s, a slender columnar form with no wings and a narrow loft. The new organ, with folding wings painted by Cornelis de Brisé and a much broader loft, is shown from various angles in a series of pictures beginning in 1659.[9] The organ in the Carter painting, although closed and obscured by the column to the left of the preacher, is obviously the renovated instrument.

The Carter picture was copied in a careful watercolor drawing by Cornelis Pronk (1691–1759) which differs in some respects from the original but is faithful to the appearance of the church (fig. 2).[10] In a number of instances the watercolor records details that are now obscure or worn away in de Witte's painting—for example, the planks of the wooden vaulting and the iron struts that support the canopy to the left of the preacher. In other instances it delineates features of the church that de Witte had evidently suppressed or treated summarily, but which Pronk, who knew the church well and whose interests may have been as much antiquarian as aesthetic, chose to introduce: for example, the iron gate and the elaborately carved marble screen of the de Graeff chapel at the left, or the statue that surmounts the third rib just below the vault at the right.

1. Gerard Hoet and Pieter Terwesten, *Catalogus of Namlyst van Schilderijen . . .* , s' Gravenhage, 1770, p. 270, no. 106.

2. See the example of 1686 in Detroit, for instance (Manke, *de Witte*, no. 46, fig. 108).

3. Originally a baptismal chapel of the late fifteenth century, it was purchased by Cornelis de Graeff for his family in 1648. Jacob van Campen has been credited with the design of the tombs and the entrance, and the young Artus Quellinus with the statues above the door (E. Nuerdenburg, *De zeventiende eeuwsche beeldhounkunst in de noordlijke Nederlanden*, Amsterdam, 1948, p. 195). P. T. A. Swillens, however, does not mention the chapel (*Jacob van Campen*, Assen, 1961).

4. Braunschweig, Herzog Anton Ulrich-Museum, *Die Sprache der Bilder*, exh. cat., 1978, pp. 171–72, no. 40.

5. Manke (*de Witte*, no. 44, "165(4 eher 9)") suggests 1659 as more likely. Trautscholdt ("de Witte," p. 125) notes that the copy by Cornelis Pronk is allegedly dated 1654. In fact the copy is not dated.

6. A view of 1659 is in the Kunsthalle, Hamburg (Manke, *de Witte*, no. 70, fig. 38); another of about 1660 was formerly with Mortimer Brandt, New York (ibid., no. 65, fig. 46); and another of 1661 is in the Oude Kerk, Amsterdam (ibid., no. 50, fig. 50).

7. For example, in the *Annunciation* in Dirck Bouts's *Adoration of the Magi* triptych in the Prado, Madrid.

8. The exact date of the renovation is uncertain. According to M. Fokkens (*Beschrijvinge der Wijdt-Vermaarde Koop–Stadt Amstelredam*, Amsterdam, 1662, pp. 186–87; cited in Manke, *de Witte*, p. 41, note 1) the large organ was reconstructed in 1660–61 and the small organ two years earlier. In any case de Witte's pictures show that the renovation of the small organ was completed by 1659.

9. The earlier organ can be seen in two paintings dated by Manke about 1655 in Strasbourg (*de Witte*, no. 66, fig. 29) and in a New York private collection (ibid., no. 64, fig. 28). After the renovations de Witte showed it closed, thus displaying the decoration by de Brisé, in the painting in Groningen of 1659 (ibid., no. 74, fig. 44), and open in another picture of 1659 in Hamburg (ibid., no. 70, fig. 38).

10. A. Bredius and H. Brugmans, *Amsterdam in de zeventiende eeuw*, The Hague, 1897, p. 8, repr.

Los Angeles County Museum of Art

120

County of Los Angeles

A Mirror of Nature was typeset in Linoterm Sabon at The Stinehour Press in Lunenburg, Vermont, and printed on Warren's Lustro Offset Enamel paper at The Meriden Gravure Company, in Meriden, Connecticut. The book was designed by Freeman Keith.

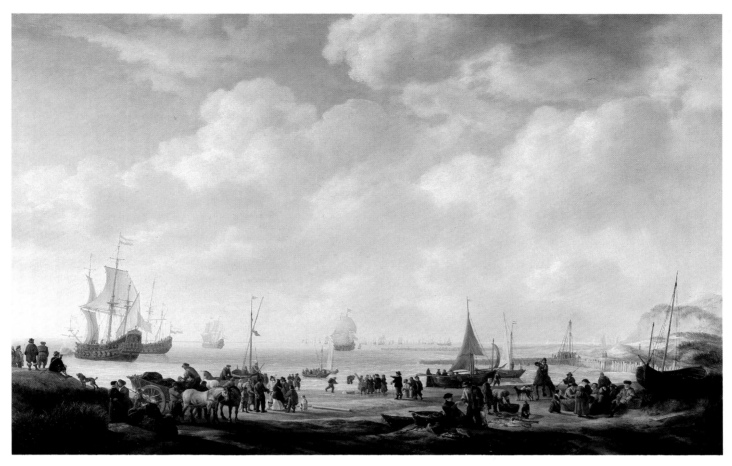

SIMON DE VLIEGER *View of a Beach* 1646 35 x 53 in.

ADDENDUM TO *A Mirror of Nature*

Dutch Paintings from the Collection of
Mr. and Mrs. Edward William Carter

by JOHN WALSH, JR., and CYNTHIA P. SCHNEIDER

FIGURE 3. Simon de Vlieger, *Beach View*, 1643. Oil on wood, 23⁷/₈ x 32⁷/₈ in. (60.6 x 83.5 cm.). The Hague, Mauritshuis.

Flushing. Prince Frederik Hendrik had in fact led an assault on Antwerp in 1646, the year of the Carter beach scene; the attack was supported by the Dutch fleet under Admiral Maerten Halpertsz. Tromp, whose flagship *Aemilia* is shown at the far left.[1] But nothing in the picture actually suggests this specific event, nor are any of the people identifiable. It is more probable that by including the *Aemilia* de Vlieger intended to dignify an unusually large and imposing beachscape with an allusion to important current events and to the makers of history.

De Vlieger's painting recalls the crowded beachscapes of an earlier northern tradition that began with Jan Brueghel and was carried on during the first half of the seventeenth century by Adam Willaerts (1577–1664) and his son Abraham (about 1603–69). That de Vlieger actually had such pictures in mind may be demonstrated by comparing the Carter painting with a beach view by Adam Willaerts (fig. 2), so similar in composition that it may have served de Vlieger as a model.[2]

The Carter painting is the largest and one of the finest in a series of beach scenes de Vlieger painted in the 1640s. His beachscapes of the previous decade represent views

that are less extensive and are pervaded by a grayish tonality derived from the example of Jan Porcellis (cat. no. 18). In the 1640s the artist sometimes adopts a great expanse of beach and water, as he does in the celebrated picture of 1643 (fig. 3), in which the silvery light comes from behind the clouds and floods the warm brown sand, creating a lively interplay of cool and warm.[3] In the Carter painting the effects of light are even more varied and complex. Extensive areas of half-shadow in the foreground are full of subtle gradations of tone and hue; in the middleground blond light bathes the sand, which serves as backdrop for the crisp forms of the figures. Broad shadows cast by the towering clouds play across the sea beyond. Despite the animation of life on the beach, de Vlieger's scene has the air of stately calm that pervades the most successful paintings of his last years. By 1649 de Vlieger (fig. 4) and van de Cappelle had created a splendid new kind of marine painting, characterized by a multiplicity of incident and a binding structure and atmosphere, that has much in common with the Carter picture.

FIGURE 4. Simon de Vlieger, *Visit of Frederik Hendrik to the Fleet at Dordrecht in 1646*, 1649. Oil on wood, 28 x 36¼ in. (71 x 92 cm.). Vienna. Kunsthistorisches Museum.

1. Jan Kelch kindly identified the ship and suggested the possibility that Frederik Hendrik's campaign of 1646 might be connected to this picture (in a letter of March 1, 1981). Three years later de Vlieger painted a visit by the Stadholder to the fleet in 1646 (fig. 4).

2. Kelch proposed this picture as de Vlieger's prototype (*ibid.*). Kelch's views on the iconography and sources of the Carter composition

will shortly be published in his monograph *Simon de Vlieger, die Gemälde.*

3. For a discussion of de Vlieger's development see Stechow, *Dutch Landscape Painting,* pp. 104, 115–17, and L. J. Bol, *Die holländische Marinemalerei des 17. Jahrhunderts,* Braunschweig, 1973, pp. 176–90.